BUILDING A MASTERPIECE

MILWAUKEE ART MUSEUM

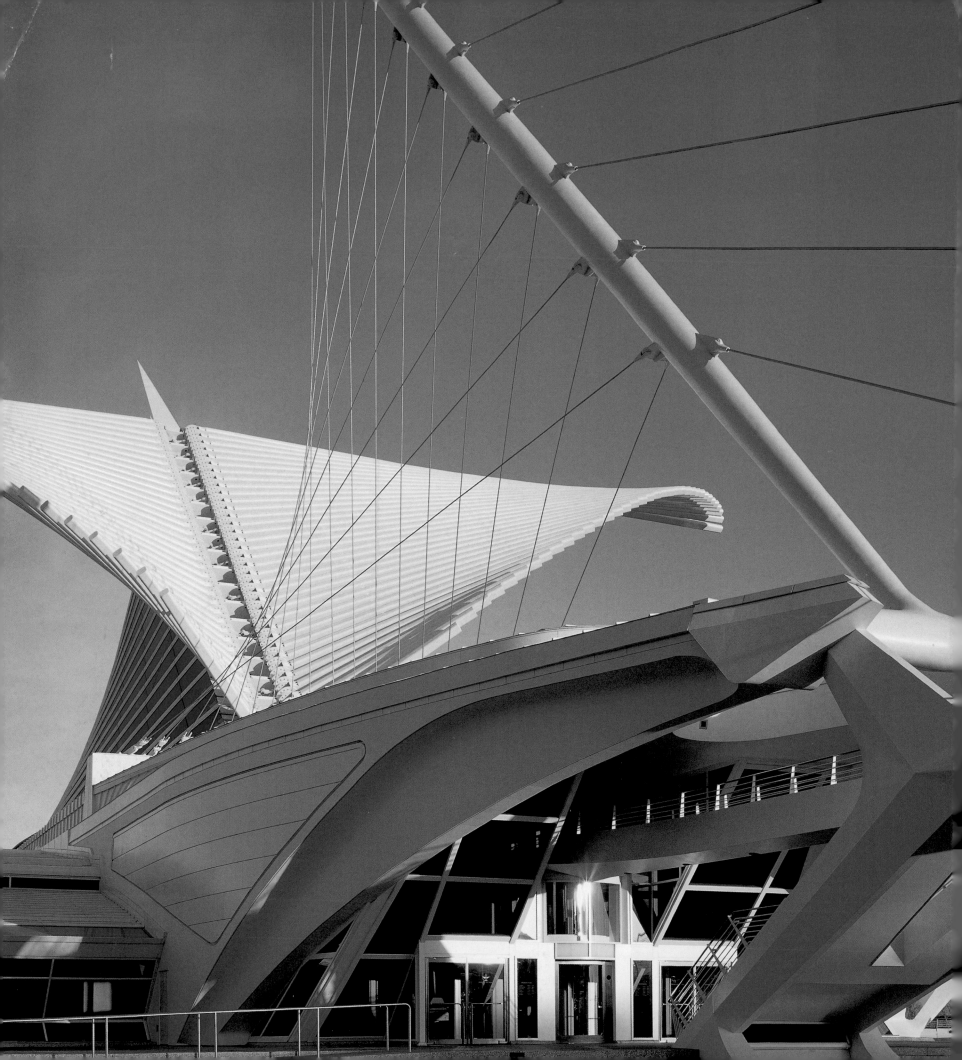

BUILDING A MASTERPIECE

MILWAUKEE ART MUSEUM

Introduction by Russell Bowman
with an Essay by Franz Schulze

Hudson Hills Press, New York
in association with Milwaukee Art Museum

Second printing

© 2001 by the Milwaukee Art Museum,
700 North Art Museum Drive, Milwaukee, Wisconsin 53202
Published in the United States by Hudson Hills Press, Inc.
P.O. Box 205, 3556 Main Street, Manchester, Vermont 05254
Distributed in the United States, its territories and
possessions, and Canada by National Book Network.
Distributed outside of North America by Antique Collectors' Club, Ltd.

Publisher & Executive Director: Leslie Pell van Breen
Founding Publisher: Paul Anbinder

Coordinated and edited by Terry Ann R. Neff,
t.a.neff associates, inc., Tucson, Arizona.
Designed and typeset by Michael Dooley, Milwaukee Art Museum.

Manufactured in Singapore by Dai Nippon Printing Company.

Cover: Milwaukee Art Museum, Jeff Millies
Page 2: Entrance, Milwaukee Art Museum, Timothy Hursley

The Library of Congress has catalogued an earlier printing as follows:

Library of Congress Cataloguing-in-Publication Data

Milwaukee Art Museum.
 Building a masterpiece : Milwaukee Art Museum /
with an essay by Franz Schulze.—
 1st ed.
 p. cm.
 Includes bibliographical references and index.
 ISBN 1-55595-202-X (paperback : alk. paper)
 1. Milwaukee Art Museum—Catalogues. 2. Art—Wisconsin—
Milwaukee—Catalogues. 3. Buildings—Additions—Wisconsin—
Milwaukee. 4. Calatrava, Santiago, 1951– I. Title: Milwaukee Art
Museum. II. Schulze, Franz, 1927– III. Title.

N582.M5 A52 2001
727'.7'0977595—dc21

 2001039177

Contents

Acknowledgments

Just as with the new Quadracci Pavilion and the exhibitions and programs it will house, *Building a Masterpiece: Milwaukee Art Museum* is a collaborative project by many. This publication was particularly a museum-wide effort, and I would like to thank the entire staff of the Milwaukee Art Museum for their extraordinary contributions surrounding the opening of the Santiago Calatrava–designed addition. Far beyond those who can be cited here, the museum staff has been deeply dedicated to realizing both Calatrava's architectural vision and the exceptional commitment of our donors who made it possible. They have also rethought and reinvented the permanent collection housed in the earlier Saarinen- and Kahler-designed buildings and created a variety of new programs to bring ever-expanding audiences to the museum. The entire staff has my deepest appreciation, speaking both institutionally and personally; it could not have happened without them.

The efforts toward this publication were led by the Curatorial Department staff. Brian Ferriso, senior director of Curatorial Affairs; Laurie Winters, curator of Earlier Art; Kristin Makholm, associate curator of Prints and Drawings; Jody Clowes, associate curator of Decorative Arts; Tom Bamberger, adjunct curator of Photography; and Margaret Andera, assistant curator, are primarily responsible for the selections from the permanent collection as well as many of the entries describing individual works. Their contribution to the scholarship on the collection is incalculable. Other staff, former staff, and independent writers also contributed entries: former chief curator, Dean Sobel, now director of the Aspen Art Museum; former curatorial assistant for Prints, Drawings, and Photographs Terry Marvel; Curatorial Assistant Jennifer Chartier; Department Assistant Jane O'Meara; Lila Wallace Readers Digest Research Assistant Saadia Lawton; and independent scholar and writer Frank Lewis. In the areas of Asian and African art, entries were provided by colleagues at The Art Institute of Chicago who have served as consultants to those developing collections: Stephen Little, curator of Asian Art, and Kathleen Bickford Berzock, curator of African Art. I would also like to acknowledge staff members who made particular suggestions regarding the essay on the history of the museum:

Executive Director Christopher Goldsmith; Senior Director of Financial Development Lucia Petrie; and especially Chief Educator Barbara Brown Lee, who, with more than thirty-five years at the institution, serves as its oral historian. Finally, Marilyn Charles, executive assistant to the director, brought her usual helpful coordinating skills to the project.

Also taking a leadership role in the realization of this publication were Michael Dooley, former director of Design and Publications; and independent editor and publication manager Terry Ann R. Neff. Mike Dooley was responsible for the exceptional design of this publication and resolved many issues on the road to publication. Terry Neff made many invaluable contributions both to the visual and written form of this publication and served as production coordinator and liaison with Hudson Hills Press. The staff team is indebted to the contributions of both of them.

I would like to acknowledge Franz Schulze, emeritus professor of art at Lake Forest College and well-known critic and historian of art and architecture, for his perceptive essay on Santiago Calatrava and his design for the museum addition. Mr. Schulze recognized the contributions of the Calatrava building both to recent developments in architecture and to the Milwaukee area, even during the construction phase. Also, we are grateful for the support of Paul Anbinder of Hudson Hills Press, whose participation ensures that this publication brings a broad international audience to a further understanding of the Milwaukee Art Museum's history and collections. Finally, I would like to acknowledge the support of Jane Bradley Pettit, her son, David Uihlein, and daughter, Lynde Uihlein, in the realization of this publication. Their generosity continues a tradition reaching back to Mrs. Pettit's parents, Mr. and Mrs. Harry Lynde Bradley. It is to the two generations of exceptional vision and generosity of Mrs. Bradley and Mrs. Pettit that this publication is dedicated. They, along with so many donors and staff, past and present, are part of truly building a masterpiece.

Russell Bowman, Director
Milwaukee Art Museum

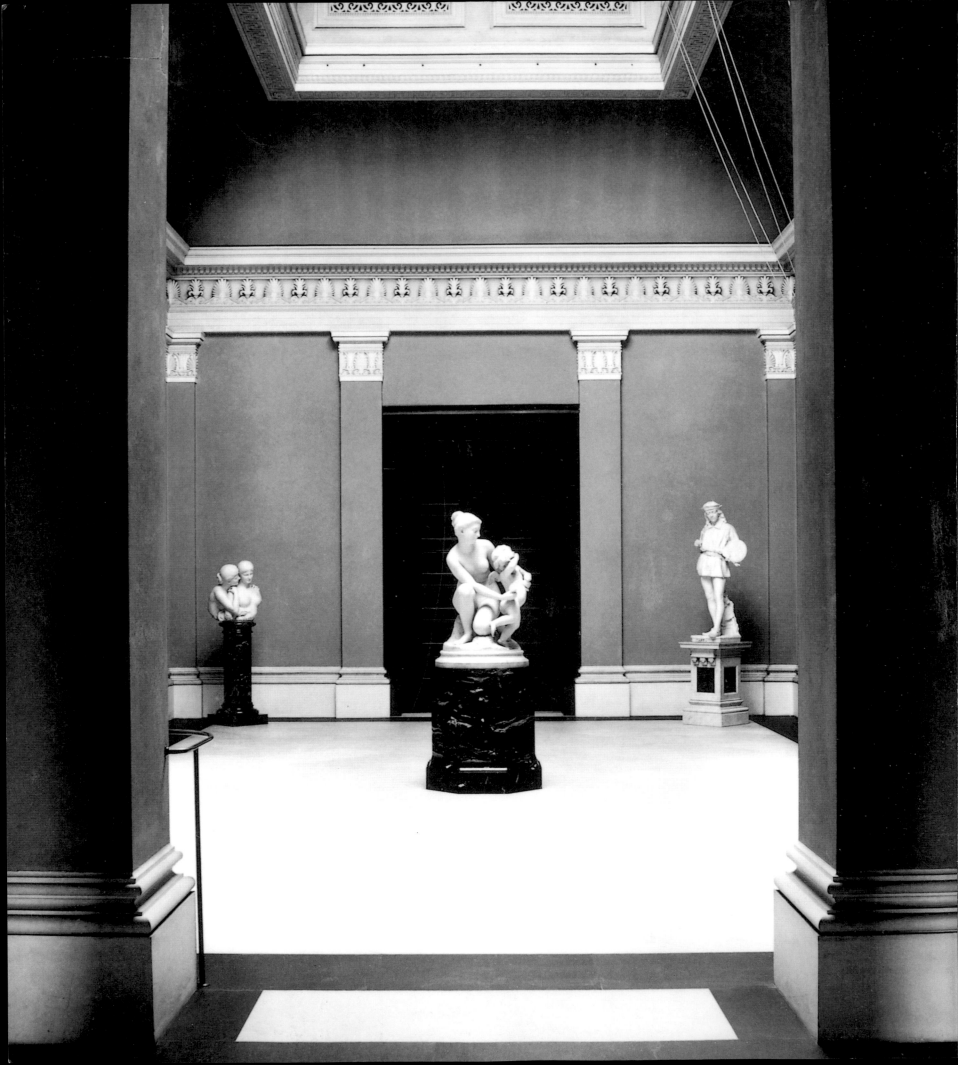

An Introduction to the Milwaukee Art Museum—Past and Future

Russell Bowman

Though it has a distinguished history beginning in 1888, the Milwaukee Art Museum today is at a moment of transformation in its institutional history. With the Santiago Calatrava–designed Quadracci Pavilion addition, the museum is indeed building an architectural masterpiece. But the deeper meaning of this moment goes far beyond bricks and mortar (or concrete, steel, and glass, in Calatrava's case). The Milwaukee Art Museum is building toward masterpiece status in the range

and depth of its collections, the quality of its exhibitions, and the engagement of its community through publication, education programs, and a wide range of activities. The museum seeks to be a "gathering place" not only in terms of bringing together objects of the highest cultural, historical, and aesthetic significance, but also by bringing people together with them in meaningful ways. Thus the concept of the masterpiece, as in "Milwaukee's Masterpiece" or "Masterpiece on the Lakefront," connotes both the most important art and the commitment to make it meaningful in people's lives. As we begin a new century, it is a masterpiece that the whole community is engaged in building.

The architecture of the Quadracci Pavilion is the symbol of this defining moment. Designed by Santiago Calatrava to be both a pragmatic extension and a visual symbol of transformation, the building, with its pedestrian bridge, functions as an actual bridge to the city. Aligned with Milwaukee's primary institutional and commercial street, Wisconsin Avenue, the Calatrava building forms both the apex of the urban vista eastward toward Lake Michigan and a bridge between the city and the lake, between the man-made world and nature. And the building itself, built low to pre-

serve views of the lake, expands—indeed transforms—itself through the Burke Brise Soleil, the moving sunscreen that encloses and protects its central reception hall. As the brise soleil extends, the building literally opens itself up, metaphorically extending its wings to the city, inviting people inside. In addition to its dramatic visual appeal, the building is impressively functional, including in its 142,000 square feet, temporary exhibition galleries, gallerias connecting to the earlier buildings which house the collections and to the War Memorial, an auditorium, restaurant, shop, meeting and class rooms, and indoor parking—in short, the full range of facilities expected of an art museum today. (Renovation of the existing buildings to create new galleries in spaces freed by the addition has provided some thirty percent more exhibition area for collections.) But most importantly, the Calatrava building has been embraced by the city, even before its completion, as an urban landmark and a symbol of the vitality and forward-thinking quality of Milwaukee as it enters the new millennium.

Beyond its role as an actual link and a visible symbol for the city, the museum seeks to be a cultural link to a wider national and international community. Since its incarnation

Fig. 1 H. H. Bennett, *Central Gallery, Layton Art Gallery, Milwaukee,* 1893 (detail). Albumen print. Gift of H. H. Bennett Studio Foundation, Inc.

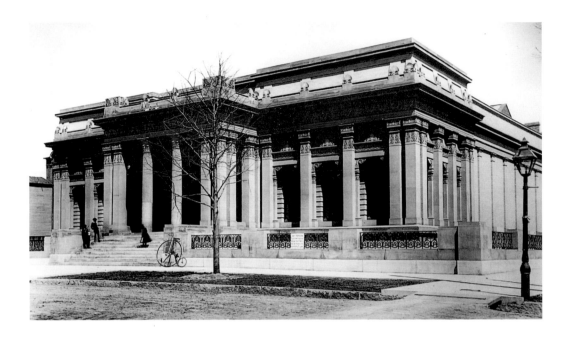

Fig. 2 Exterior of the Layton Art Gallery, designed by William J. and George Ashdown Audsley of London, and opened in 1888.

as the Milwaukee Art Center in 1957, the museum has been a leader in developing exhibitions circulated throughout the United States. In recent years it has frequently been among the top ten American museums in terms of revenue earned from traveling exhibitions. The museum has also circulated exhibitions to Europe and in 1994–95 sent important examples of its twentieth-century collections to six institutions in Japan. The opening exhibition in the Quadracci Pavilion, "O'Keeffe's O'Keeffes: The Artist's Collection," which recognizes a Wisconsin native and the fact that the Milwaukee Art Museum houses the nation's fourth largest collection of Georgia O'Keeffe's work, is traveling in the United States and Europe. Finally, the museum is increasingly taking a global perspective–building the first Santiago Calatrava–designed work in the United States and expanding its collections to include the art of Asia and Africa.

The transformed Milwaukee Art Museum, an edifice consisting of three buildings, Eero Saarinen's War Memorial Center of 1957, the David Kahler–designed addition of 1975 (still the repository of the majority of the museum's collections), and now Calatrava's Quadracci Pavilion, would not be possible without its more than 100-year history. The present museum is the outgrowth of the Milwaukee Art Center, itself formed in 1957 from two predecessor institutions, the Layton Art Gallery, and the Milwaukee Art Institute. The

Layton Art Gallery opened in 1888, a gift to the city from meat packer Frederick Layton. While Layton's taste gravitated to the accepted academic art of his time, the works that formed the core of his gallery, European paintings by Bouguereau, Bastien-Lepage, Tissot, Alma-Taddema, and Leighton; and American works by Homer, Johnson, and others, provide a key portion of today's nineteenth-century collections. While Layton's choices were not adventurous, his penchant for works of a moralizing or uplifting tone set the precedent for an institution directed toward the public good. Frederick Layton stated in his address at the gallery opening: "I have done my very best . . . to build a beautiful structure, such as should stand for ages to come, and to open it with a good, though small, collection of paintings by well-known artists; and I trust the standard will not be lowered in the future, but rather raised. My gift to the public will, I trust, be a benefit to our working people, as well as to the more wealthy, since all may come and find pleasure and recreation in paying a visit to the gallery." Certainly Layton's words continue to serve as a guide for today. After his death in 1918, the Layton Art Gallery turned its focus to a school, founded in 1920, which became the predecessor of today's Milwaukee Institute of Art and Design.

The Milwaukee Art Institute developed from the Milwaukee Art Association, an artists' group founded in 1887. As the

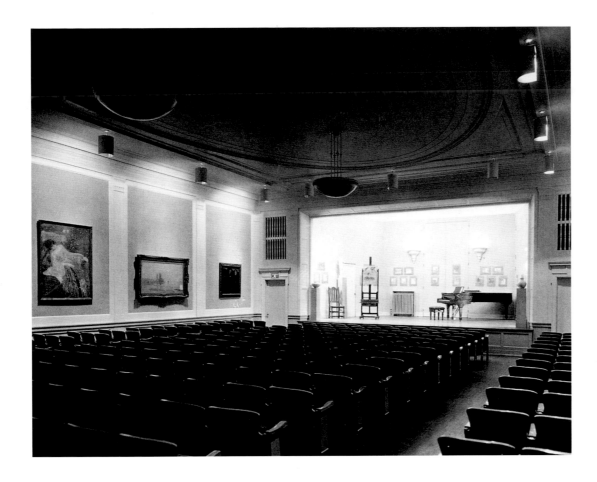

Milwaukee Art Society, it moved to permanent quarters on Jefferson Street near the Layton Art Gallery in 1911 and took the name Milwaukee Art Institute in 1916. Unlike the early Layton Art Gallery, the institute was not committed to collecting, but to programs and wide-ranging exhibitions: Old Masters in 1912, "The Modern Spirit" in 1914 (just one year after the Armory Show introduced Modernism to America), an exhibition of African-American artist Henry Ossawa Tanner in 1913, exhibitions of Henri and Manship in 1916, and in 1918 an adventurous show of American Modernist art. Important collections did come to the institute: the Samuel O. Buckner Collection in 1919 included Henri, Luks, and other important American artists; the Gertrude Nunnemacher Schuchardt Collection founded the collection of prints; the Ernest Copeland Bequest of 1929 contributed a number of important Wisconsin artists; and the Christian Doerfler Bequest in 1933 provided an endowment for the purchase of living Wisconsin artists, forming the cornerstone of the museum's significant collection of

works by artists from the state. During the years between the wars, the institute's many provocative exhibitions included German Expressionism (1924), Impressionism (1928), Frank Lloyd Wright and Thomas Hart Benton (1930–31), and with the fledgling Museum of Modern Art in New York, "Modern Architecture: International Exhibition" in 1933 and "Fantastic Art, Dada and Surrealism" in 1937. Interestingly the institute presented an exhibition of so-called degenerate art and Bauhaus work in 1939. Another important aspect of the institute's program was its commitment to providing art education for schools through its director, Alfred Pelikan, who also served as head of the art program for Milwaukee Public Schools.

In concert with the climate fostered by the Washington, DC–based Commission of Living War Memorials in 1944, three Milwaukee women's clubs, Altrusa, Zonta, and the Business and Professional Women's Clubs, proposed building a community war memorial/cultural center. Later that

year, Metropolitan Milwaukee War Memorial was incorporated to raise funds for the proposed memorial, and Eliel Saarinen was hired to study possible sites. By 1947 both the Layton Art Gallery and Milwaukee Art Institute had committed to move to a new memorial center. In 1952 the Layton School of Art relocated out of the Layton Art Gallery building, and with the resignation of long-time Layton Director Charlotte Partridge, the two institutions were administered jointly. A number of important exhibitions were held at the institute during the war years and into the 1950s: The Museum of Modern Art's Picasso retrospective (1942), a major Frank Lloyd Wright show (1945), a Kandinsky retrospective (1946), and Calder (1955). The Max E. Friedman Bequest of Old Master drawings in 1954 and Mrs. Edward R. Wehr's gift of American paintings by artists such as Marin, O'Keeffe, and Davis entered the institute in 1954 and 1957 respectively.

In 1955 ground was broken for the War Memorial and Eero Saarinen took over the design of the building following the death of his father. The building was formally called the Milwaukee County War Memorial, and Milwaukee County provided for building maintenance, utilities, and security services while the two institutions agreed to bring their collections and programs into the new center. It opened in August 1957 with an exhibition titled "Six Great Painters" (El Greco, Rembrandt, Goya, Cézanne, van Gogh, and Picasso), which received unprecedented attention and attendance. That year also saw the formation of the museum's major support group, the Friends of Art. The change of the Milwaukee Art Institute name to Milwaukee Art Center occurred in 1958 and a new era for the institution began.

From its 1958 emergence as the Milwaukee Art Center to its renaming in 1980 as the Milwaukee Art Museum, the institution underwent exponential growth, including an addition in 1975 that quadrupled its physical space, and the formation of many of the collections. In 1958 Director Edmund H. Dwight and the Board of Trustees determined to add earlier art to the institution's primarily nineteenth- and early twentieth-century European and American collections, acquiring Zurbarán's *St. Francis*. The Layton Art Collection's ongoing American acquisitions included a Charles Willson Peale portrait, and the Friends of Art inaugurated their commitment to contemporary art with a Ben Nicholson work.

During the tenure of Director Tracy Atkinson (1962–76), very significant growth took place in the museum. In 1963 René von Schleinitz began his donations of nineteenth-century German genre painting, Meissen porcelain, and Mettlach steins. The 1967 gift of the David Adler–designed 1920s Villa Terrace (separately administered by Milwaukee County beginning in 1984) allowed the museum to build its collections of American decorative arts. Most important for the development of the institution, however, was the promise in 1969 by Mrs. Harry Lynde Bradley of her entire collection of modern European and American art and the commitment the following year to provide, along with the Allen Bradley Foundation, $1 million as a challenge toward developing a significant building expansion. The expansion, designed by Milwaukee architect David Kahler, opened in 1975 and brought the facility to approximately 160,000 square feet. It housed the Bradley collection, American decorative arts, and the loan collection of Haitian art from the Flagg Tanning Corporation, as well as a display of the full range of the museum's collections, temporary exhibition galleries, and an education center. Most of the Bradley collections were donated before Mrs. Bradley's death in 1978, making her the second great patron in the museum's history following Frederick Layton.

Other important events were the acquisition of Fragonard's *The Shepherdess* (1974), the establishment of the Virginia Booth Vogel Acquisition Fund (1976), and the formation of the Prairie Archives with a gift of Frank Lloyd Wright/ George Mann Niedecken materials from the former Niedecken-Wallbridge firm (1977). Exhibitions included "Art USA Now" (1962); "Art Treasures of Turkey" (1967); first one-person museum exhibitions for Fernando Botero and Cy Twombly (1966 and 1968 respectively); "A Plastic Presence" (1969); a Man Ray photography show that traveled to New York's Metropolitan Museum of Art (1973); "Collecting the Masters" (1977), from which several significant acquisitions were made; and "An American Architecture" (1978). In 1962 Director Atkinson had entered the museum stating a specific commitment to education, and by 1967 a program to enrich social studies curricula through museum tours had been funded by the Federal Cooperative Education Service Agency. The docent program, volunteer guides providing tours of the collection and exhibitions, was significantly expanded in the 1960s–70s

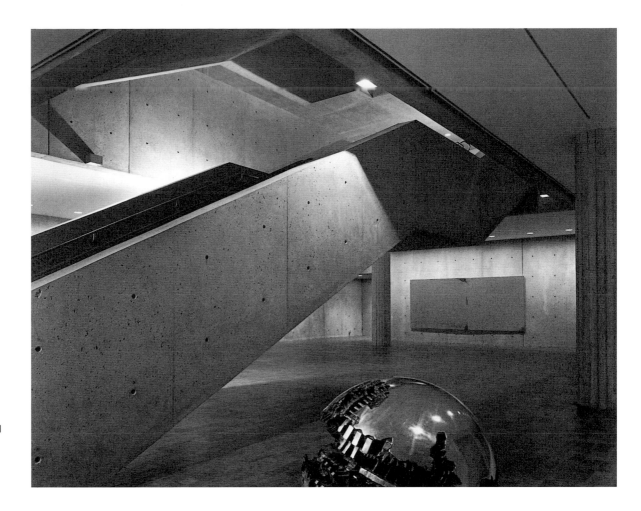

Fig. 4 View showing the powerful concrete forms of the lower level of the David Kahler–designed addition to the Milwaukee Art Center, 1975.

and remains the cornerstone of the museum's educational function. In 1976 two programs, the Wisconsin Regional Scholastic Art Awards exhibition and Satellite art classes for Milwaukee Public Schools and suburban systems, began more than twenty-five-year tenures at the museum. Combined with a very active offering of art classes and Family Sundays events for children and families that began in 1986, these programs are the core of the museum's outstanding Department of Education. Finally, the Friends of Art held their first Bal du Lac in 1957 and began the Lakefront Festival of the Arts in 1963, two annual fundraisers which still form the backbone of their extraordinary support for the museum, particularly for acquisitions. Special interest groups formed within the Milwaukee Art Institute, the Garden Club (1921) and the Collectors Corner for American decorative arts (1944), continue their significant

roles today. The Photography Council was organized as an advisory group to the Art Center in 1970, and in addition to instituting photography acquisitions and exhibitions, became the predecessor of today's photography support group.

While the period of the Milwaukee Art Center saw unprecedented expansion of both the collection and the facility, the era beginning with the redesignation of the institution as the Milwaukee Art Museum represents its coming to full maturity. Under the leadership of Director Gerald Nordland (1977–84), the institution changed its name (1980) and expanded and reorganized its collections, particularly of prints and photography; committed to expanding its representation of twentieth-century sculpture; increasingly professionalized its staff and policies; and in 1983 received full accreditation from the American Association of

Museums. Christopher Goldsmith joined the staff in 1982 as executive director in charge of development and financial operations; and Russell Bowman, chief curator since 1980, became director in 1985 with a directive to increase collections, national recognition, exhibitions and publications, and significantly expand the museum's audience. The goal of the Board of Trustees was to create a flagship museum for Wisconsin that would have substantial impact in the region and beyond and attract the audience, membership, and financial support needed to carry the institution into the twenty-first century. Aligned with this goal was the creation of a number of additional interest groups to support the museum's collecting and educational efforts in specific areas: Print Forum in 1981, Contemporary Art Society in 1982, Fine Art Society (for art before 1900) in 1987, a revitalized Photography Council in 1988, American Heritage Society in 1993, and the African American Art Alliance for the expansion of African and African American art in 1997. These groups have not only provided critical acquisitions in their respective areas and thus acted as a significant addition to the collection support of Friends of Art, but also have developed dedicated, long-term advocates for the full range of the museum's activities.

Collection development in the Milwaukee Art Museum years focused on a revitalization of the earlier European art holdings, expansion of the American decorative arts into the nineteenth and twentieth centuries, substantial building of the prints, drawings, and photography collections, a continued commitment to contemporary art, essentially new collections of folk and Haitian art, and, in 2000, commitments to Asian and African art. Through the beneficence of generous donors, whole collections have entered the museum: the Floyd and Josephine Segel Collection of Photography in 1986, the Michael and Julie Hall Collection of American Folk Art in 1989, the Flagg collections of European decorative arts and Haitian art in 1991, the Landfall Press Archive in 1992, important European and American silver from Dr. Warren Gilson in 1995 and 1998, and a group of ten major works by Georgia O'Keeffe given by The Georgia O'Keeffe Foundation and the Jane Bradley Pettit Foundation in 1997–98. Just in the year 2000, the Richard and Ethel Herzfeld Foundation made a multiyear gift for the development of the photography collection, while Marcia and Granvil Specks of Chicago donated a group of some 450

German Expressionist prints, one of the most significant collections of its kind. The Specks collection, along with the René von Schleinitz Collection and the additions of major nineteenth-century German works on paper through the René von Schleinitz Memorial Fund, the strong holdings of German Expressionism in the Bradley collection and from other donors, and acquisitions of contemporary works make the museum one of the nation's strongest repositories of modern German art—an interesting connection to Milwaukee's history as a major destination for German immigration in the nineteenth century. During the 1980s and 1990s, the museum also added masterworks by Nardo di Cione, Giovanni Benedetto Castiglione, Joseph Anton Koch, Odilon Redon, and Maurice Prendergast, as well as more recent works by Robert Motherwell, Jasper Johns, and Donald Judd, and a group of some fifty works by contemporary artists.

Also during the last two decades, the museum has made a commitment to developing exhibitions and publications of the highest caliber that reach a national and international audience. Among the significant nationally traveling exhibitions were "Philip Pearlstein: A Retrospective" (1983); "Fiber R/Evolution" (1986); "Warhol/Beuys/Polke" (1987); "Word as Image: American Art 1960–1990" (1990); "Painters of a New Century: The Eight" (1991); "Jackie Winsor" (1991); "Common Ground/Uncommon Vision: The Michael and Julie Hall Collection of American Folk Art" (1993); "Jim Nutt" (1994); "Latin American Women Artists" (1995); and "Gabriele Münter: The Years of Expressionism 1903–1920" (1998). "From Expressionism to Resistance: Art in Germany, 1909–1936," an exhibition of the Milwaukee-based collection of Marvin and Janet Fishman, traveled to three venues in Europe and three in the United States in 1990–91, while twentieth-century masterpieces from the collection toured Japan in 1994–95. Recently the exhibitions of European decorative arts from the Flagg collection and of contemporary art from the museum's collection have had wide national tours. While these exhibitions and their accompanying catalogues have earned recognition for both the institution and the city, the museum has also brought to Milwaukee an array of exhibitions from other institutions. And in addition to exhibition catalogues, the museum has published its permanent collection, in the *Guide to the Permanent Collection* (1986); *1888: Frederick Layton and His World* (1988); *American*

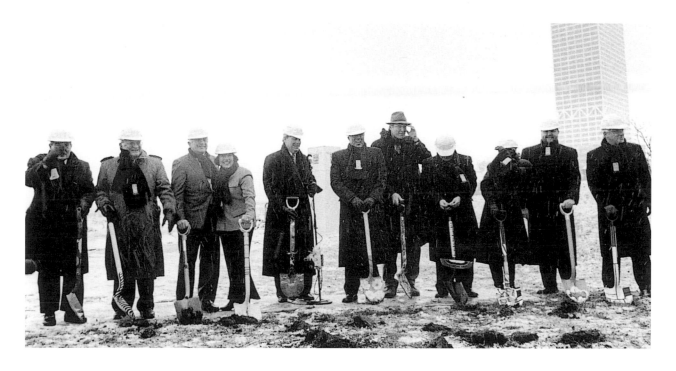

Fig. 5 Ground-breaking for the Santiago Calatrava–designed Quadracci Pavilion, December 1997 (left to right: Frank J. Pelisek, F. Thomas Ament, Harry V. Quadracci, Betty Quadracci, Russell Bowman, Donald W. Baumgartner, John O. Norquist, Kenneth Szallai, Karen M. Ordinans, Christopher Goldsmith, and P. Michael Mahoney).

Furniture with Related Decorative Arts, 1660–1830/The Milwaukee Art Museum and the Layton Art Collection (1991); *Common Ground/ Uncommon Vision: The Michael and Julie Hall Collection of American Folk Art* (1993); *Landfall Press: Twenty-five Years of Printmaking* (1995); the award-winning *A Renaissance Treasury: The Flagg Collection of European Decorative Arts and Sculpture* (1999); and numerous smaller catalogues dedicated to drawings, prints, photography, and decorative and folk art. These publications represent a substantial growth of scholarship on the museum's collection and the opportunity to share these works with audiences worldwide.

As the museum enters a new century, the collections are being entirely reinstalled to allow for a clearer path through the museum and through the history of art. A collaboration with the Chipstone Foundation brings expanded curatorial support to the American decorative arts area and the nationally known Chipstone collection into interplay with that of the museum. The new Richard and Ethel Herzfeld Print, Drawing and Photography Study Center provides improved storage and greater accessibility to these collections, while new galleries allow a tripled area for their display.

Exhibitions such as "O'Keeffe's O'Keeffes" bring the museum and its collection strengths to larger audiences, while the "Leonardo da Vinci and The Splendor of Poland" exhibition planned for 2002 brings Milwaukee fully into the realm of organizing major international shows. The educational offerings of the museum are being significantly enhanced through random access audio guides and by a broad array of programs in the new Marianne and Sheldon B. Lubar Auditorium. The $100 million campaign to develop the Santiago Calatrava–designed addition, led by an exceptional challenge gift of Harry and Betty Quadracci and met by more than 2,300 donors, represents extraordinary community support for the museum and its programs. A growing operating endowment established in 1985 gives the museum stability to build for the future. Over 16,000 members now offer their direct support and commitment, and ever larger audiences are anticipated upon the museum's reopening. With these levels of growth, support, and, most importantly, belief in the power of art to enrich the human spirit, the Milwaukee community is truly building a masterpiece, one that will continue to provide meaning for generations to come.

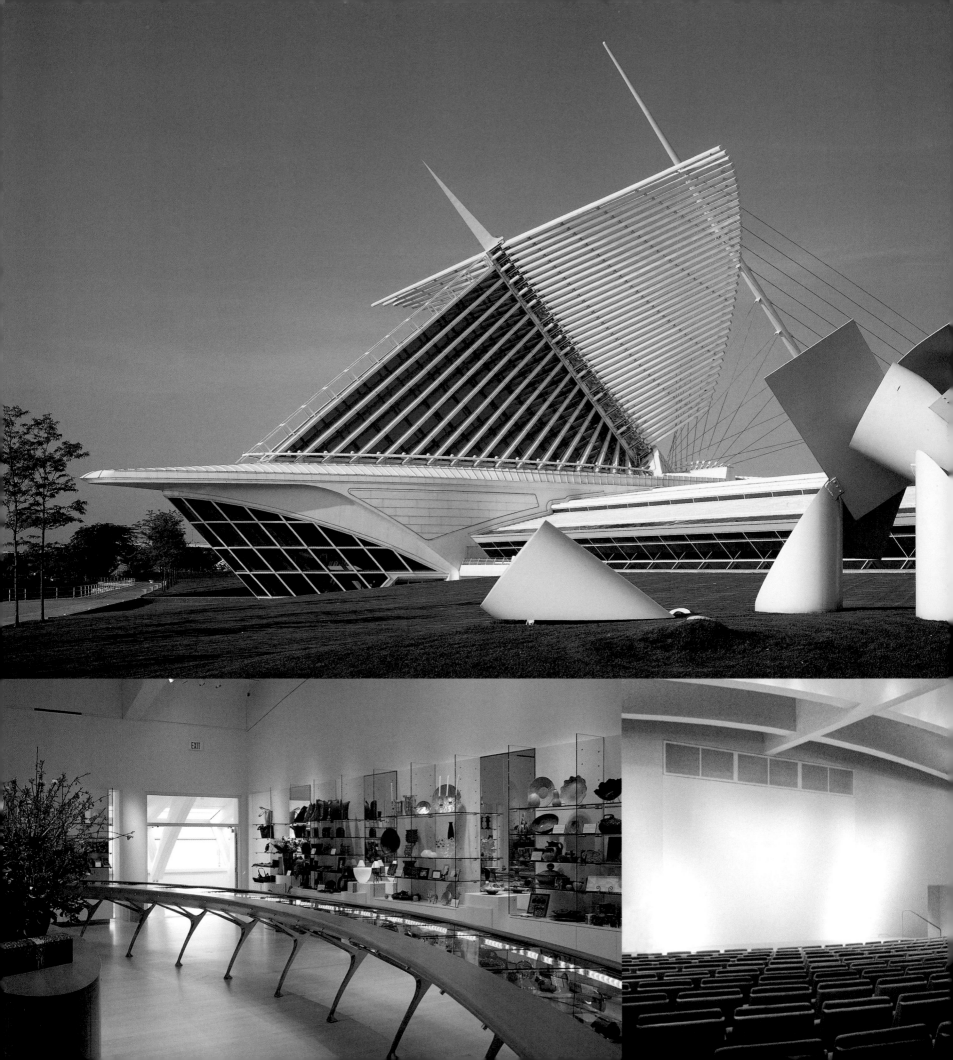

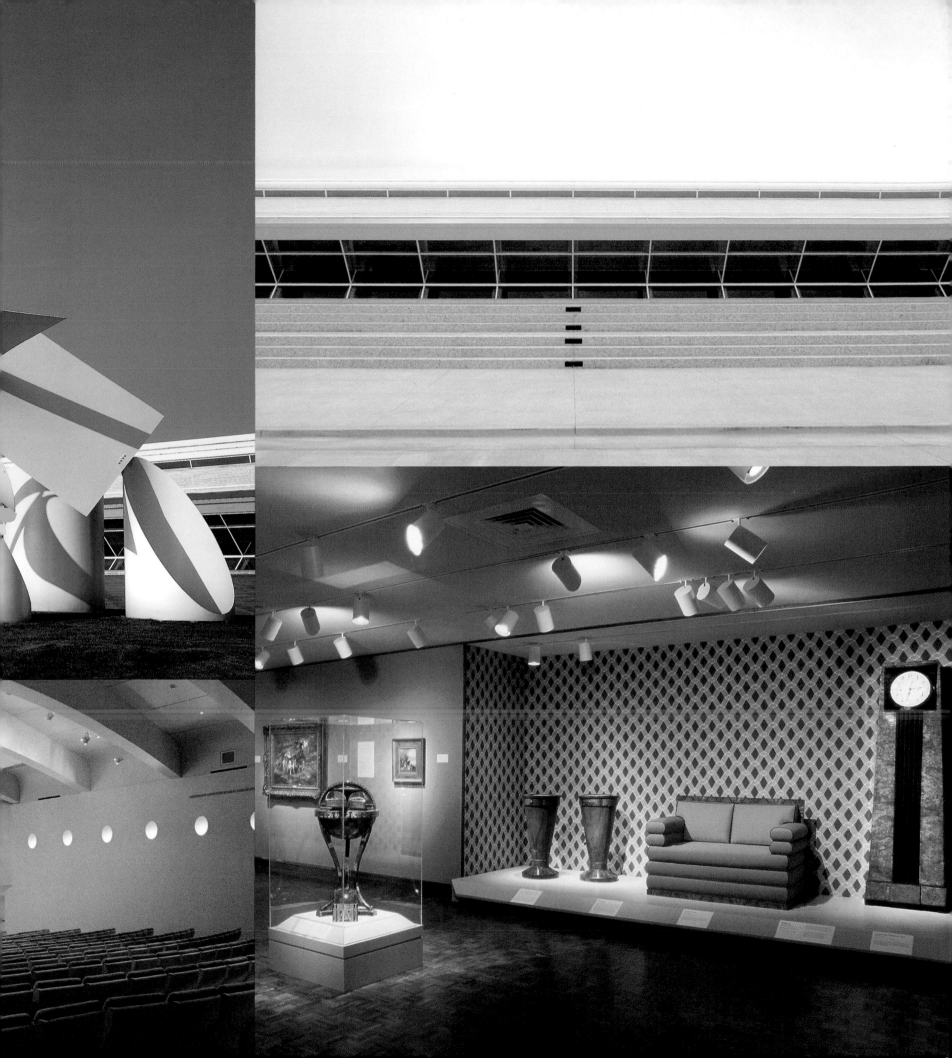

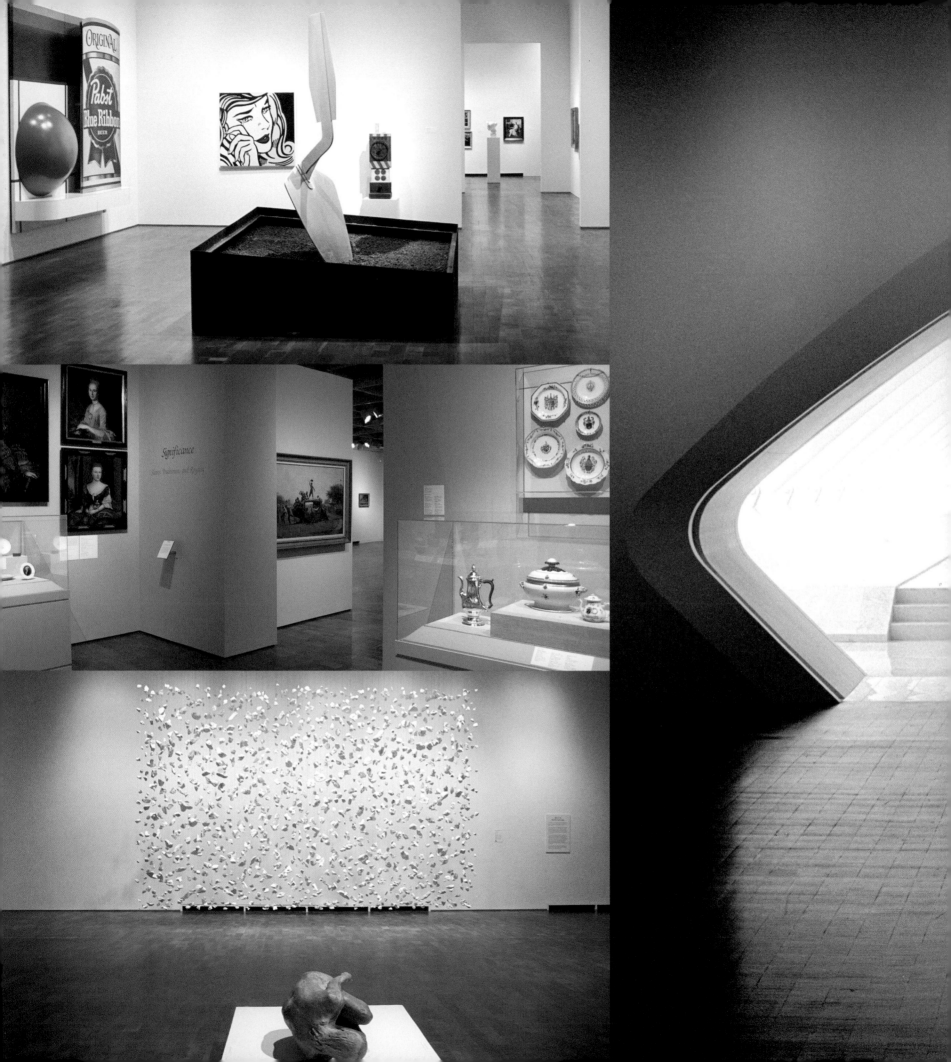

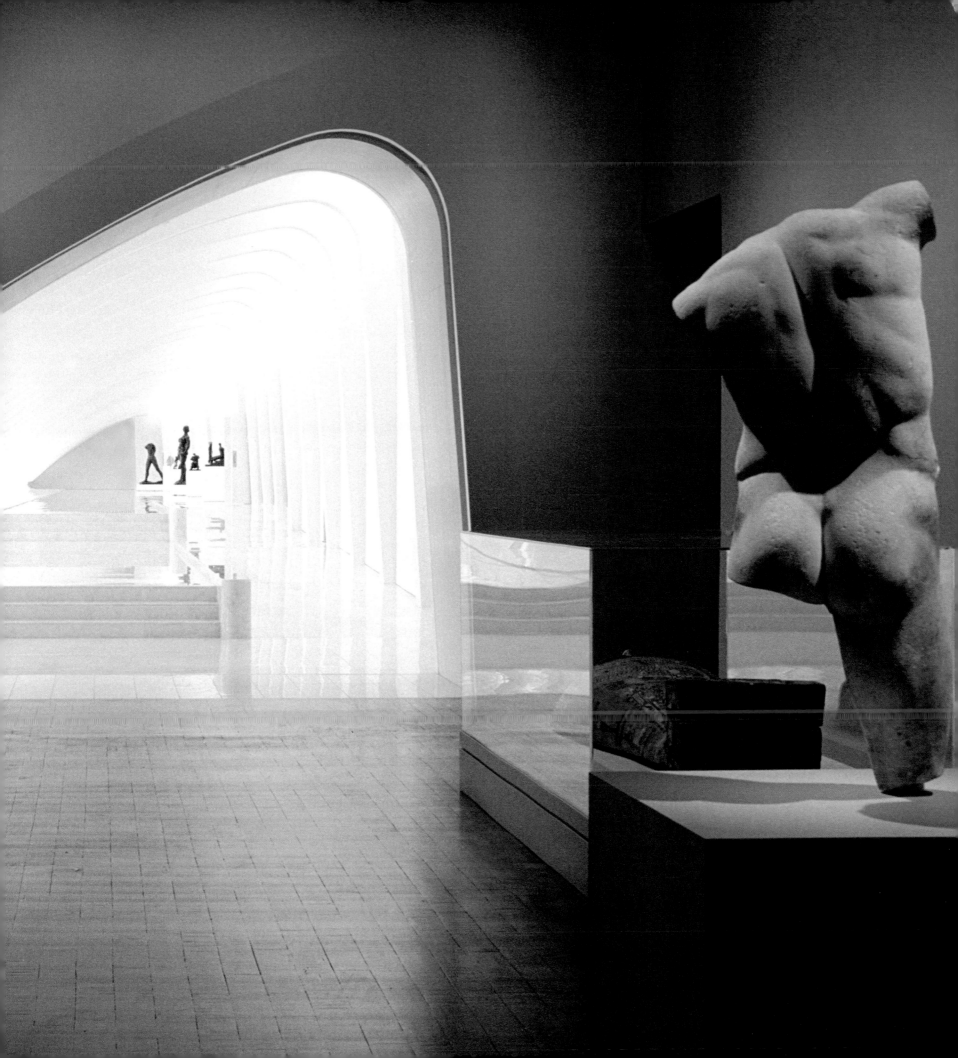

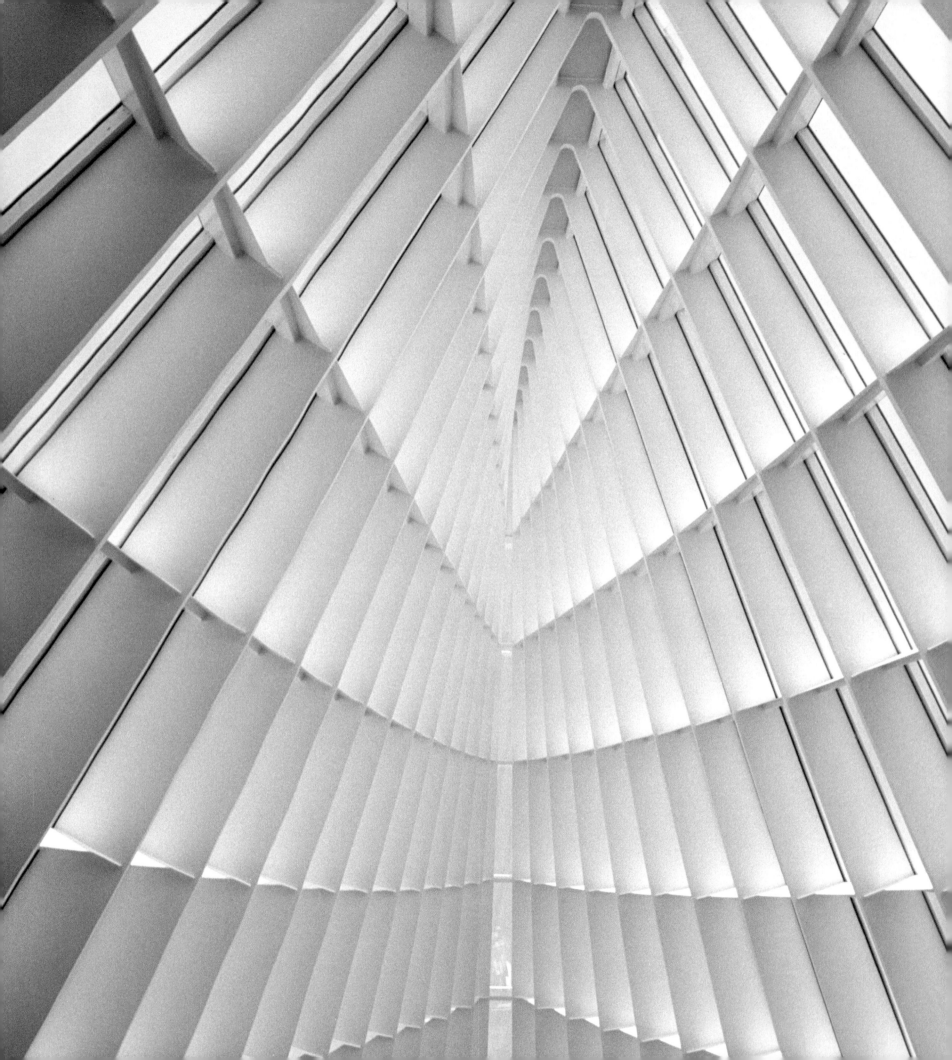

Disclosing Santiago Calatrava's
Milwaukee Masterpiece

by Franz Schulze

Among its many exceptional attributes, the work of the Spaniard Santiago Calatrava has a look about it that prompts critics and historians to employ a vocabulary rare in the architectural lexicon. Words like "flower" (often unfolding), "bird" (often in flight), "vertebrae," and "carapace," to mention but a few, seem not only appropriate, but nearly unavoidable in discussing Calatrava's achievements. His buildings frequently remind the viewer of forms drawn from the world of living creatures, and while

such a comparison has its own tradition—it is commonplace to invoke the term "biomorphic" in referring to such well-known works as Le Corbusier's Chapel at Ronchamp and Jorn Utzon's Sydney Opera House—Calatrava has inspired a quantity and variety of metaphors unique in contemporary architectural commentary. Without doing violence to the concept, one can speak of him as a figurative architect, whose distinctive architectural productions are sometimes strikingly close in character to his own sketches of distinctly unarchitectural things, with the connection as imaginative as the finished work is impressive. In this regard the recently completed design for the addition to the Milwaukee Art Museum, one of the most important architectural monuments realized in the United States in recent years, provides an ideal starting point in tracing the process of Calatrava's thinking (fig. 1).

With all buildings the record must begin with the client, and the museum's own history warrants attention. Milwaukee's public art holdings date from 1888, when Frederick Layton, the local owner of a meat-packing business, was persuaded by the Milwaukee Art Association to establish the city's first public gallery, which bore his name and to which he gave a $100,000 endowment as well as thirty-eight paintings from his personal collection. In 1910 a separate organization, the Milwaukee Art Institute, was formed, and both institutions coalesced in 1957 as the Milwaukee Art Center.

Meanwhile, during the post–World War II years, several other citizens' groups pressed for the creation of a memorial to the servicemen who had died in the nation's wars. That cause led the members of the Milwaukee County War Memorial Development Committee to commission a building intended to fulfill their purposes. The originally designated architect, Eliel Saarinen, died in 1955 before completing his plans, whereupon the assignment was taken over by his son Eero, whose final design included a space on the lower level large enough to accommodate the Milwaukee Art Center. Opened in 1957 atop a greensward overlooking Lake Michigan, the War Memorial, as the building was officially called, consisted of a floating cruciform mass with four cantilevered arms (fig. 2), a work that drew the attention of the international architectural world to Milwaukee as surely as to itself.

Fig. 1 Santiago Calatrava, Atrium of the reception hall,
Milwaukee Art Museum, 2001.

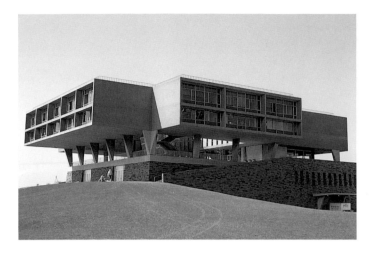

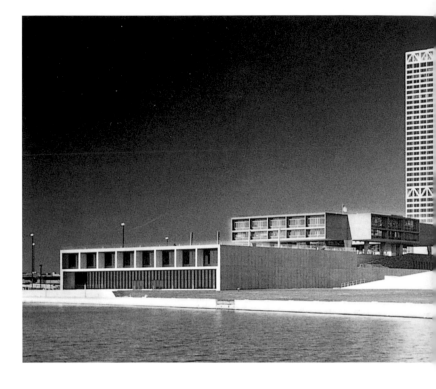

Fig. 2 (above) Eero Saarinen, Milwaukee Art Center and War Memorial, 1957

Fig. 3 (right) Kahler, Slater & Fitzhugh Scott, Milwaukee Art Center Addition, 1975

The building accommodated its two tenants well enough, although in little more than a decade the Art Center was made suddenly aware that it was about to outgrow its allotted space. In the late 1960s, Peg Bradley, wife of Harry Lynde Bradley, the cofounder of Milwaukee's Allen-Bradley Company, made a gift to the Art Center of her collection of 600 modern art works. To that donation she added a $1 million challenge to the city, which, if met, would finance the construction of a major addition to the War Memorial. More than $7 million eventually was raised, and the Milwaukee architectural firm of Kahler, Slater & Fitzhugh Scott was engaged to design the new structure. Sited on the land between the War Memorial and the lakefront, the addition opened in 1975, with room on the upper level for the Bradley collection and a multimedia theater, and on the lower levels for temporary exhibitions, a café, and greatly expanded gallery space (fig. 3).

Five years later the Art Center, responding to its steady increase in size, scope, and variety of activity, elected to rename itself the Milwaukee Art Museum. It was granted full accreditation by the American Association of Museums in 1983, and in short order its administration was enlarged and reorganized to include two chief officers. Russell Bowman was elevated in 1985 from the rank of chief curator to that of director, and Christopher Goldsmith, appointed in 1982, took on the title of executive director. By 1988, the 100th anniversary of the founding of the Layton Art Gallery, the museum found itself faced with another significant self-assessment, one that was certain, yet again, to affect it architecturally. The collection's continued growth through gifts and purchases had been paralleled by a comparably augmented art education program. Attendance had doubled and membership tripled in the period following the completion of the Bradley addition. More space was called for to accommodate these assorted functions and operations as well as others that were likely to develop in the future. With all this in mind, and aware not only of the requirements but of the equivalent opportunity they represented, the museum took steps to select an architect worthy of the task.

That process began in 1994, with the appointment of a group of professional consultants, one of whom, Marcy

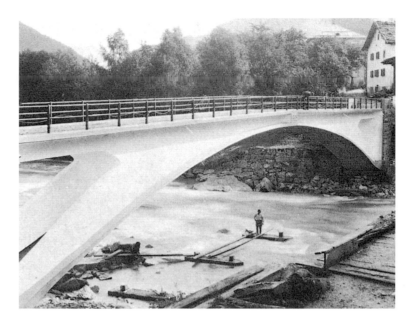

Fig. 4 Robert Maillart, Tavanasa Bridge over the Vorder Rhine River, Tavanasa, Switzerland, 1905. Photo by M.-C. Blumer-Maillart, reproduced in David P. Billington, *The Tower and the Bridge* (Princeton, NJ: Princeton University Press, 1983), p. 159, fig. 9–4.

Goodwin, previously involved in the selection of Mario Botta of Switzerland as the designer of the San Francisco Museum of Modern Art, assembled a list of the most successful new museum designs in America and abroad. Thereafter Joan Darragh, a member of the staff of the Brooklyn Museum, offered suggestions pertinent to the programmatic needs that have become commonplace among art museums, old and new, at the turn of the twenty-first century. Darragh saw Milwaukee's priorities headed by the need for a visually engaging entry pavilion and more specialized galleries, as well as an upgraded education center, a new auditorium, a top-flight restaurant, and an amply stocked gift shop.

The next requirement was the definition of the criteria relevant specifically to the requirements of the Milwaukee Art Museum. Since the new building was sure to be attached or close to the War Memorial and the 1975 addition, it would have to be respectful of that relationship as well as of the proximity of the city's lakefront, an invitingly open, untrammeled site that called for an appropriately dramatic architectural response. Moreover, the two preexisting structures suggested a building in the Modernist mode, free of the historic allusion associated with the Postmodern aesthetic that dominated much of the 1980s.

Once these labors were completed by the Milwaukee selection committee (headed by Board of Trustees President Allen L. Samson), seventy architects with international reputations were invited to submit examples of their work for evaluation. Fifty-five responded, a number eventually whittled down to eleven: from the United States, Gunnar Birkerts, Frank O. Gehry, Charles Gwathmey, Thom Mayne, Cesar Pelli, Mack Scogin, and James de Stefano; from Great Britain, Sir Norman Foster; from Spain, Santiago Calatrava; from Japan, Arata Isozaki and Fumihiko Maki.

Curiously, in view of his eventual selection, Calatrava had not originally been among the fifty-five, and how he was added is worthy of note. Russell Bowman was paging one day through a heap of architectural periodicals in the office library of Milwaukee architect David Kahler (chief designer of the Bradley addition) when he came upon an article devoted to the work of Calatrava, with which he was not

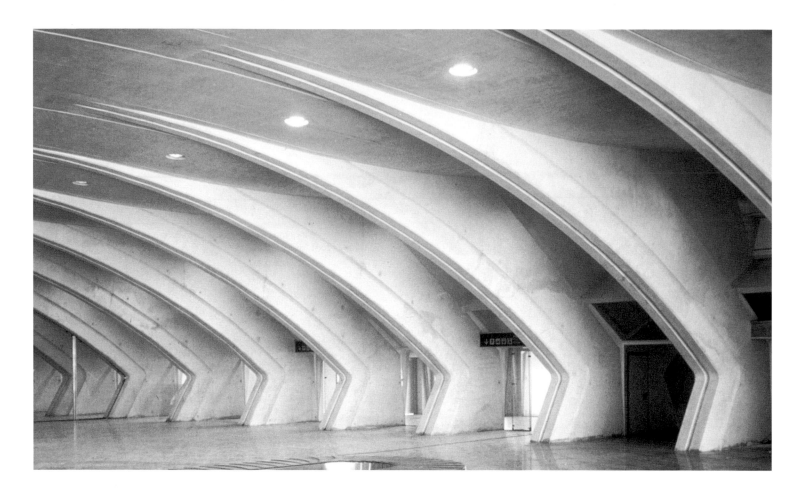

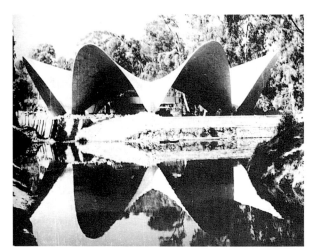

Fig. 5 (above) Santiago Calatrava, Sondica Airport, Bilbao, Spain, 1990–2000.

Fig. 6 (left) Felix Candela, Xochimilco Restaurant roof, near Mexico City, 1958. Photo by Felix Candela, reproduced in David P. Billington, *The Tower and the Bridge* (Princeton, NJ: Princeton University Press, 1983), p. 191, fig. 10–7.

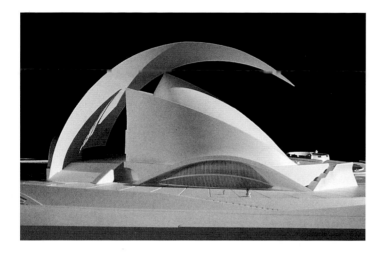

Fig. 7 Santiago Calatrava, Tenerife Opera House, Santa Cruz de Tenerife, Canary Islands, Spain, 1991–2001 (model).

familiar at the time. Reflecting anew on the criteria the museum had lately drawn up, he was persuaded that the Spaniard should be added to the list. That view was conveyed to the selection committee, whose members not only approved it, but found it so persuasive that they ultimately placed Calatrava alongside Isozaki and Maki as the final trio of candidates. The final phase of the selection, a procedure customary in such instances, consisted of visits by the committee to the buildings all three designers had put up on the North American continent. On December 19, 1994, committee chair Samson announced that Calatrava had been awarded the commission, with the Milwaukee firm of Kahler, Slater named as the architect of record charged with the duty of implementing the design and construction of the finished building. By the following summer, Calatrava had arrived at a preliminary proposal, which was refined but changed only slightly in the final version unveiled and presented to the Milwaukee community in March 1996. It met with an enthusiastic reception. On December 10, 1997, ground was broken.

Since the completed building is certain to add luster not only to the city, but to the architect's reputation, it seems appropriate to discuss his background and the evolution of his objectives.

Santiago Calatrava was born in Valencia in 1951. He studied art and architecture in his native city, with graduate work in urban studies and civil engineering. His PhD was taken in technical science at the Swiss Federal Institute of Technology in Zurich, where he wrote a thesis on the foldability of space frames, a subject as exotic as it is likely to be puzzling to the average layman, but one that has grown more graspable as Calatrava's built forms have provided a more lucid illustration of his expressive goals than might be expected of any academic argument.

Calatrava began his practice in Zurich in 1981 and later opened offices in Valencia and Paris as well. It is clear from his early production that he had learned greatly from his experience in Zurich, since engineering played as significant role as architecture in the Federal Institute's educational program. Such historic figures as Robert Maillart and Christian Menn worked at the institute, where in the early twentieth century a tradition of bridge building developed that is treated as respectfully in books on architecture as in engineering texts. In fact, Maillart was featured in a one-person show at New York's Museum of Modern Art in 1947, an event that recognized, among other things, his revolutionary efforts in building bridges of reinforced concrete, a material with which he accomplished ends that neither stone nor metal could match (see fig. 4). One glance at the elegantly slender form of the bridge that connects the Milwaukee Art Museum's addition with O'Donnell Park at the foot of Wisconsin Avenue is enough to make evident what Calatrava has learned from Maillart's epochal work.

But he has been alert to other examples as well. His treatment of ribbed vaulting, apparent in such diverse works as his Sondica Airport in Bilbao (fig. 5) and the project for the roof of the Muri Monastery (1989), meant for the Canton

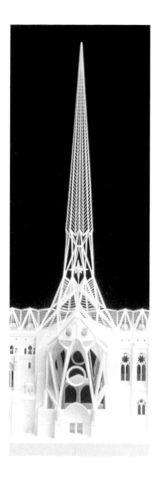

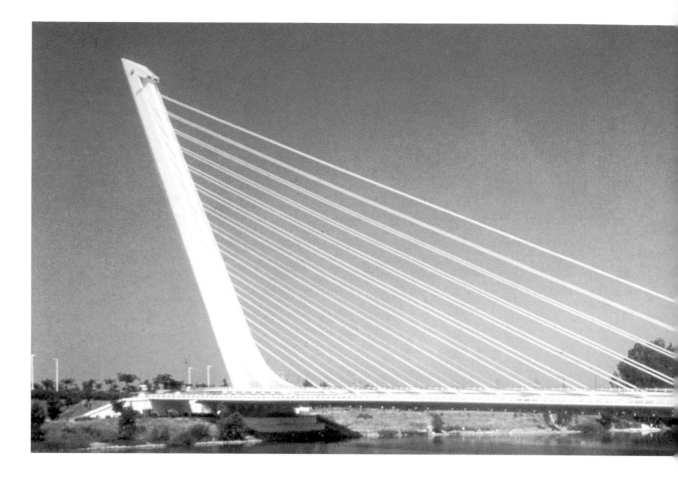

D'Argovia in Switzerland, owes much to the pioneering efforts of the Italian Pier Luigi Nervi. In turn the delicate curvilinearities associated with the shells of Felix Candela (see fig. 6) and Eduardo Torroja (and again, Maillart), are recalled by the Tenerife Opera House in the Canary Islands (fig. 7). Calatrava has personally acknowledged learning from Eero Saarinen's TWA Terminal at Kennedy Airport in New York and Dulles Airport in Washington, DC, as biomorphic in form as any designs produced in the United States. Yet an awareness of pre-twentieth-century antecedents, especially of Eugène Viollet-le-Duc's neo-Gothic exercises, is also perceptible in the skeletal, glass-topped framework of Calatrava's 1991 project for the renovation of the transept in New York's Cathedral of St. John the Divine (fig. 8).

Other sources could be cited, but in the final analysis none of them is as important as Calatrava himself. For the synthesis he has fashioned of those various influences is differ-

ent from any and all of them. It is forever recognizable as his own, an attribute all the more remarkable in view of the fact that he has designed an uncommonly large number of projects and completed buildings in a comparably wide range of building types.

The bridge, of course, is the genre most often identified with his name. He has produced dozens of examples, including footbridges, swing bridges, suspension bridges, and spans supported by single or multiple arches. Probably the most famous is the Alamillo Bridge in Seville (fig. 9), its most distinctive feature the form of the single pylon, four hundred and sixty-six feet high and inclined fifty-eight degrees from the horizontal, that supports the two-level bridgeway by thirteen pairs of cables in tension. (The upper level serves vehicular traffic, the lower, pedestrians and bicyclists.) The profile of the Alamillo Bridge has been likened to a harp, another of the many figurative metaphors that Calatrava's works inspire.

Fig. 8 (far left) Santiago Calatrava, Cathedral of Saint John the Divine: Transept Project, New York, 1991 (model).

Fig. 9 (left) Santiago Calatrava, Alamillo Bridge and Cartuja Viaduct, Seville, Spain, 1987–92.

Fig. 10 (below) Santiago Calatrava, Lyon Airport Station, Satolas, Lyon, France, 1989–94.

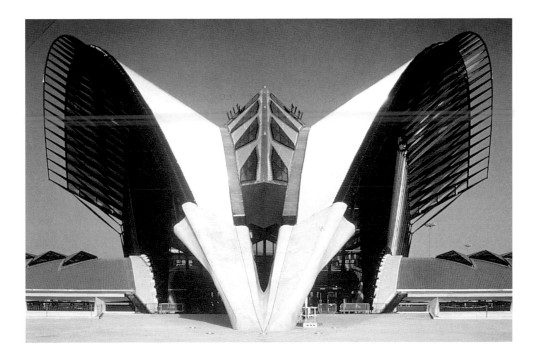

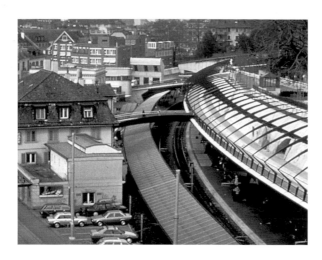

Fig. 11 (above) Santiago Calatrava, Stadelhofen Station: Expansion and Redefinition Project, Zurich, 1983–90.

Fig. 12 (below) Santiago Calatrava, Valencia Opera House, Valencia, Spain, 1996– (model).

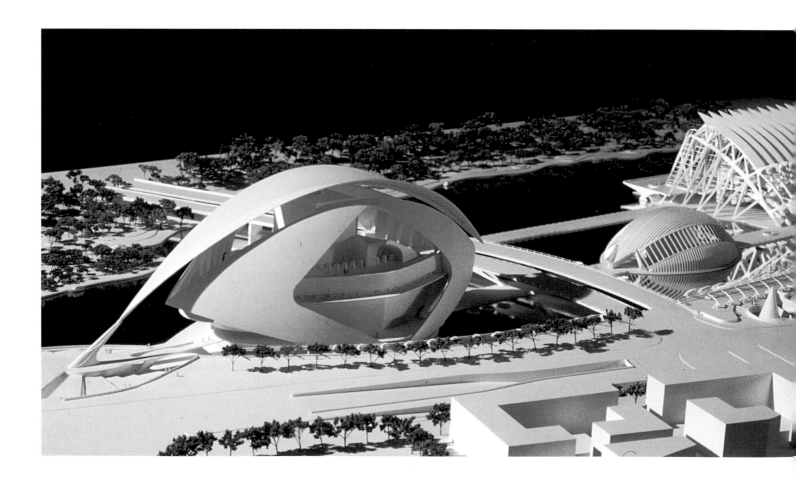

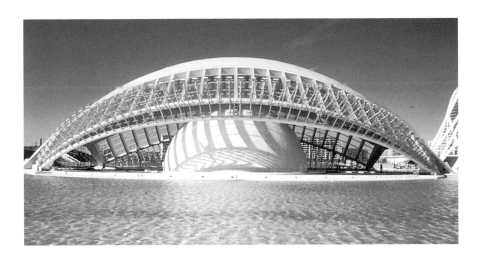

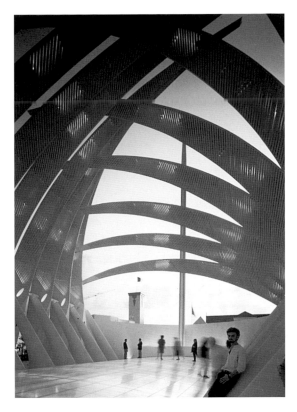

Fig. 13 (above) Santiago Calatrava, City of Science: Science Museum and Planetarium, Valencia, Spain, 1991–2000.

Fig. 14 (right) Santiago Calatrava, Kuwait Pavilion, World's Fair–Expo '92, Cartuja Island, Seville, Spain, 1991–92.

Buildings serving transportation make up a category that includes some of his most famous designs. A substantial amount of global attention has been focused on the Satolas Airport Train Station outside Lyon in France (fig. 10), a structure whose main hall, triangular in plan, is covered with a steel roof resting on a massive arched spine. Extending outward from the spine is a pair of diagonal overhangs that immediately bring to mind a near-naturalistic sculpture called *Bird,* one of Calatrava's numerous creations in that medium. The title could easily be applied to the Satolas Station when seen from head-on, a view that discloses a form taut with energy and reminiscent of a large avian animal about to spring. Such implication of movement at momentary rest seems further appropriate to the station, since it is a stopping-off point for the famous high-speed bullet trains that run between Paris and Lyon.

Critical attention has also been paid the Stadelhofen Railway Station in Zurich (fig. 11), a building whose gentle curve follows the contour of the hill behind it. It is constructed on three levels, the two lower ones accommodating the tracks, the uppermost functioning as a pedestrian walkway. A series of steel pergolas is marked by continuous

spines that have reminded viewers (once again, the metaphor) of the rib cage of a stegosaurus or the interior of Jonah's whale.[1]

Calatrava's rail stations and airports are outnumbered by his exhibition and cultural spaces, although the latter have been concentrated in Spain. Common to the Valencia Opera House (fig. 12), the Tenerife Opera House, the Valencia City of Science, a combined museum and planetarium (fig. 13), and the Kuwait Pavilion in Seville (fig. 14), a building meant to provide information about Kuwait, a country whose culture is still little known in the Atlantic community, is Calatrava's grandiloquent use of curved forms, which he handles in a unique manner that has led some commentators to observe that he consciously and effectively defies the axiom that the shortest distance between two points is a straight line. The arched roofs dominating the two opera houses and the City of Science are at once hefty in the sweep of their massing and delicate in the treatment and detail of their surfaces. At the same time the most notable difference between the Kuwaiti pavilion and the opera houses is the factor of movement, in the case of the former of a kind literally not at rest. Machinery in the base of the

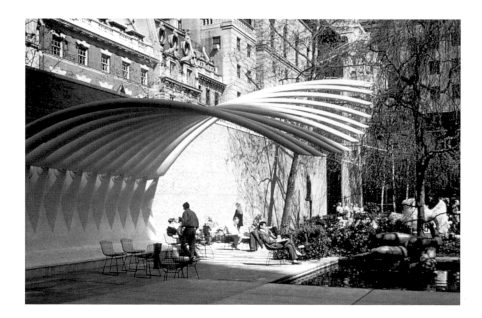

Fig. 15 Santiago Calatrava, *Shadow Machine*, molded precast concrete, 1988–92, exhibited at The Museum of Modern Art, New York, 1992.

pavilion can alternately hoist the huge, talonlike spines flanking the building into an upright position, opening the interior to natural light, and closing them down completely, so that the space is fully roofed over. Calatrava's kinetic architecture was brought to light in the United States for the first time in 1992, when The Museum of Modern Art staged an exhibition of his work that featured the *Shadow Machine* (fig. 15), an outdoor sculpture consisting of long, looping concrete "fingers"—variations on the Kuwait Pavilion spines—that slowly rose and fell in a synchronized rhythm, casting shadows (hence the title) on the pavement below. American sports fans would recognize the movement as similar to the collective "wave" motion popular among spectator crowds.

Calatrava has designed sports facilities, including competition projects for a football stadium for Reggio di Calabria (1991), an Olympic Sports Complex for Berlin (1992), a Velodrome Stadium for Marseilles (fig. 16), and an Olympic Stadium for Stockholm (1996). And despite the use of devices like arches and modular spine elements that stylistically unify most of his endeavors, he has been equally at home with towers—stationary structures that rise to the sky, usually performing communications services but secondarily, especially in the case of the Montjuic Communications Tower in Barcelona (fig. 17), functioning as a symbol of the city, a landmark visible from miles around.

The list of building types does not stop there. Transformations of preexisting buildings range from the structural repair of the thirteenth-century Spalenhof in the old city section of Basel, and the renovation of the Tabourettli Theatre within it (fig. 18), to the project for the conversion of Berlin's Reichstag (fig. 19). Calatrava participated in an invitational competition for a church and community center in Rome, meant for the Jubilee Year 2000 in observance of the world's Conference of Bishops. And in one of his relatively few designs for housing, he proposed and saw to completion a complex of row houses and independent units in Würenlingen, Switzerland (fig. 20), executed in concrete and elegantly worked out with emphasis on ribbed supports, curved walls, and bold overhangs, all of them recognizable hallmarks of his style.

This review of Calatrava's past performance, particularly in view of its emphasis on the figurative elements of his architecture, leaves something to say about one of the more noteworthy aspects of his personal creative process. As mentioned earlier, a close formal correspondence exists between one of his sculptures and one of his buildings, but another medium, drawing, bears a similar relationship with his architecture. Calatrava is one of the few major professionals who has worked toward his solutions by relying on pencil and brush as surely as on the computer, the instrument that has lately become the representational tool of choice among most architects. More to the point, however,

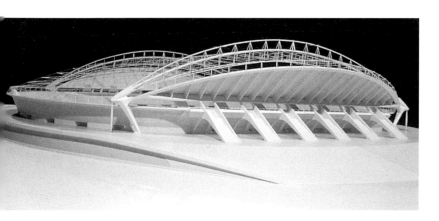

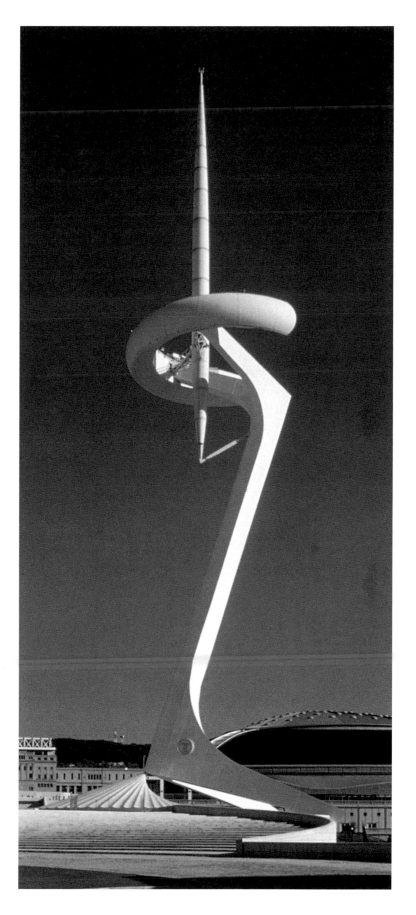

Fig. 16 (above) Santiago Calatrava, Velodrome Stadium: Conversion Project, Marseilles, France, 1995 (model).

Fig. 17 (right) Santiago Calatrava, Montjuic Communications Tower, Montjuic, Barcelona, Spain, 1989–92.

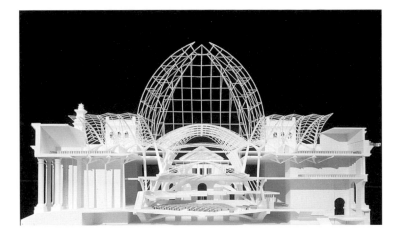

Fig. 18 (left) Santiago Calatrava, Tabourettli Theatre: Structural Repair and Refurbishment, Spalenberg, Basel, Switzerland, 1986–87.

Fig. 19 (above) Santiago Calatrava, Reichstag: Conversion Project, Berlin, 1992 (model).

Fig. 20 (below) Santiago Calatrava, Buchen Housing Estate, Buchen- and Eibenweg Würenlingen, Switzerland, 1989–97.

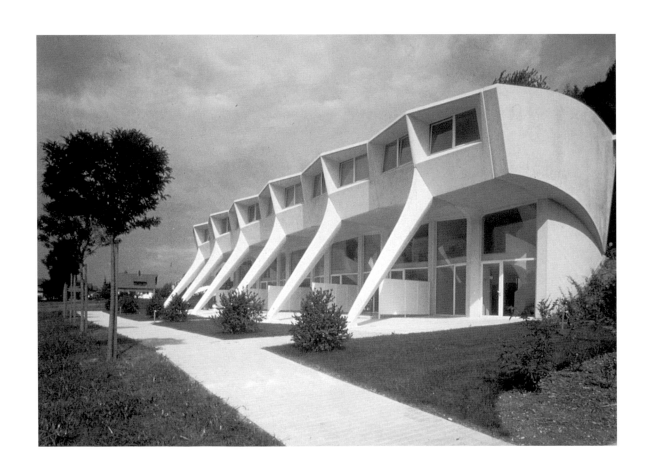

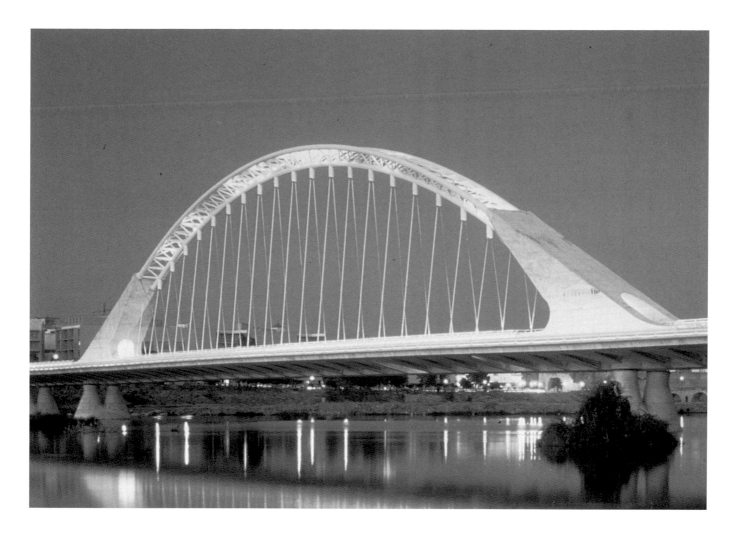

Fig. 21 Santiago Calatrava, Lusitania Bridge, Merida, Spain, 1988–91.

is the kinship of the subject matter of those drawings with the composition of his buildings. The British architectural historian Dennis Sharp has this to say: "Often the drawing of an object turns into a telling, simplified and symbolic device which becomes memorable at the artistic level, like the sketch of a flying bird or the skeleton of a dog (a model of which, incidentally, is often shown in Calatrava exhibitions)."[2]

It is enough to cite three instances that bear out Sharp's observation, all of them illustrated in Sergio Polano's *Santiago Calatrava: Complete Works*. The shape of the cross-sectional components of the Lusitania Bridge in Merida (fig. 21), may be read as an abstraction of a sketch of the head of a bull. A similar relationship can be made out in the drawing that seems to transform the profile of a horse into the section of the 9 d'Octubre Bridge in Valencia. And while the earlier discussion here of the Alamillo Bridge likened the form of its pylon and cables to a harp, a Calatrava sketch of the neck, body, and upwardly extending wing of a flying goose is a discernible figuration of the shapes of the pylon's connection with the bridgeway.

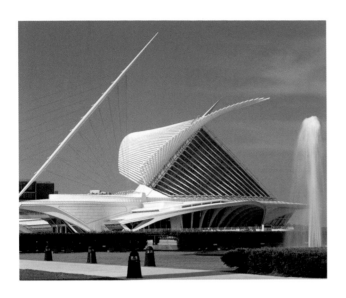

Fig. 22 Burke Brise Soleil that crowns the new Quadracci Pavilion of the Milwaukee Art Museum.

Fig. 23 The Reiman Pedestrian Bridge looking south from the Milwaukee War Memorial Center.

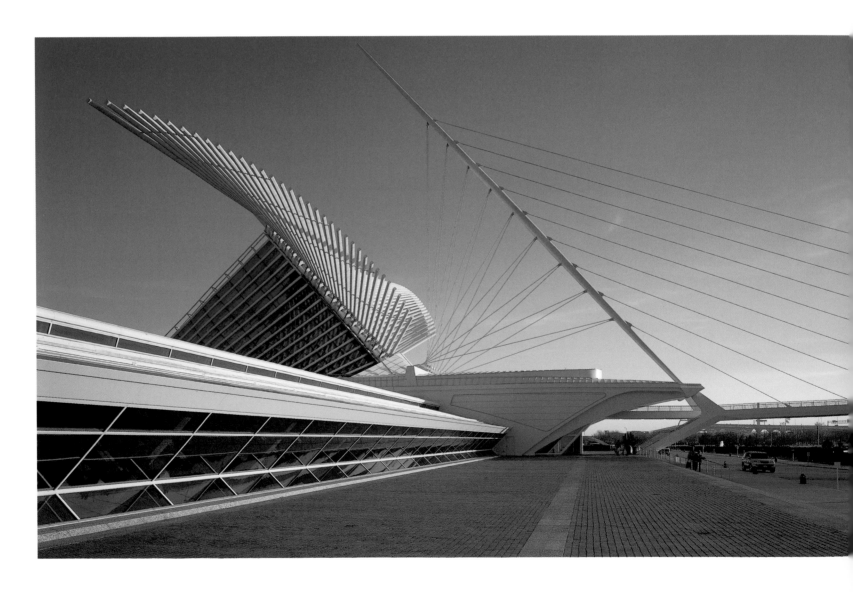

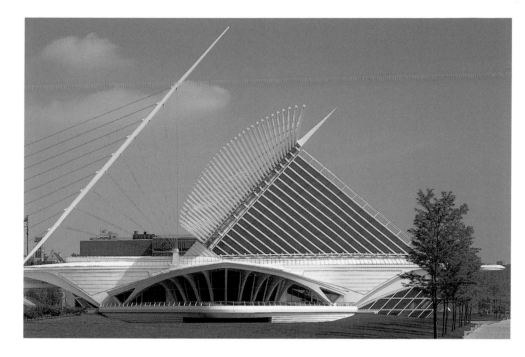

Fig. 24 Interior view of the spine running the length of the Quadracci Pavillion, Milwaukee Art Museum.

Fig. 25 Baumgartner Terrace and canopy of the Quadracci Pavilion.

This last likeness directs us back to the Milwaukee Art Museum addition, via a route that may best begin with a description of the building as we are likely to encounter it at a distance from O'Donnell Park. In the foreground a foot-bridge leads from the park across Lincoln Memorial Drive to the Calatrava addition. We are likely to spend only moments looking at it, for our attention is sure to be dis-tracted by the most dramatic component of the entire vista before us, the great brise soleil (fig. 22), a monumental con-struction likely to strike most onlookers as both extraordi-nary and beautiful, in equal measure. Since there will, or should, be time to explore it up close and at length, it would be wise to pay heed to the rest of the sprawling com-plex, returning our view to the bridge (fig. 23), whose west-ern end lies at the foot of Wisconsin Avenue, the city's chief east-west thoroughfare. That location is worthy of note, for the bridge, so situated, effects the most logical and graceful urbanistic connection so far achieved between the heart of Milwaukee's downtown and the lakefront.

A glance to the left (northward) reveals that the ribs of the long building extend downward and outward from a spine running along the apex of the arch (fig. 24). The west flank attaches at its north end to the War Memorial, the east flank to the Bradley addition, while at its south end the whole mass runs below the brise soleil to a shorter portion resembling the prow of a ship (fig. 25).

Closer inspection of Calatrava's intentions now requires crossing the bridge, whose support is provided by ten cables running from a pylon akin to the configuration in the Alamillo Bridge—with several important differences. The Milwaukee span ends short of the pylon, at which point a staircase descends to ground level, directly in front of the entrance. A broad platform somewhat higher than the bridge, though an extension of its easterly direction, is the launching pad from which the brise soleil takes flight—almost in a literal sense. That extraordinary construction is a system of louvers attached symmetrically to a second,

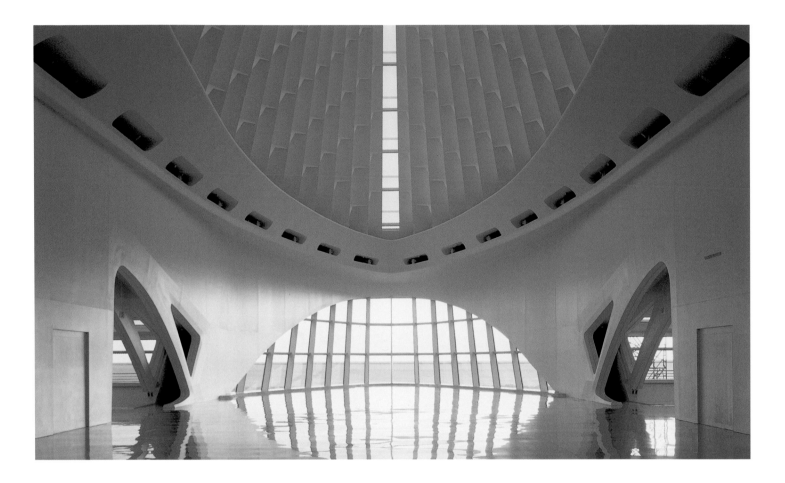

Fig. 26 View from the entry into Windhover Hall
of the Quadracci Pavilion.

more easterly inclined pylon. The louvers are motor driven
so that they open and close like the wings of a giant bird.
Their practical purpose is the calibration of the temperature
and the light levels of the interior spaces below, while sym-
bolically they may be used to signal the opening of a new
exhibition or similar major event.

In a still richer ceremonial sense, the brise-soleil is an insti-
tutional emblem, an icon standing for the Milwaukee Art
Museum and very likely, as the years pass, for the city itself.
Appropriately, it is constructed atop the entry pavilion, that
portion of the building given over to the amenities any
major contemporary exhibiting institution must offer its
public. Certainly all the drama is evident that had been
high on the list of the museum's original priorities. The

entry portal is located on a level below that of the bridge.
Access is gained on foot or from the parking garage, that is
built below grade, reachable from a roadway connecting the
new Art Museum Drive to Lincoln Memorial Drive.

Immediately within the entrance hall is a cylindrical glass
elevator that carries passengers down to the parking garage
or up to a pavilion that is taken up mostly by a lofty recep-
tion hall (figs. 26 and 27), from which the brise-soleil is vis-
ible above. The circularity of the elevator in section, as
well as that of an opening in the floor slightly behind it,
through which a mezzanine can be seen below, is consistent
with the shapes in the Alexander Calder mobile that is sus-
pended in the entry lobby.

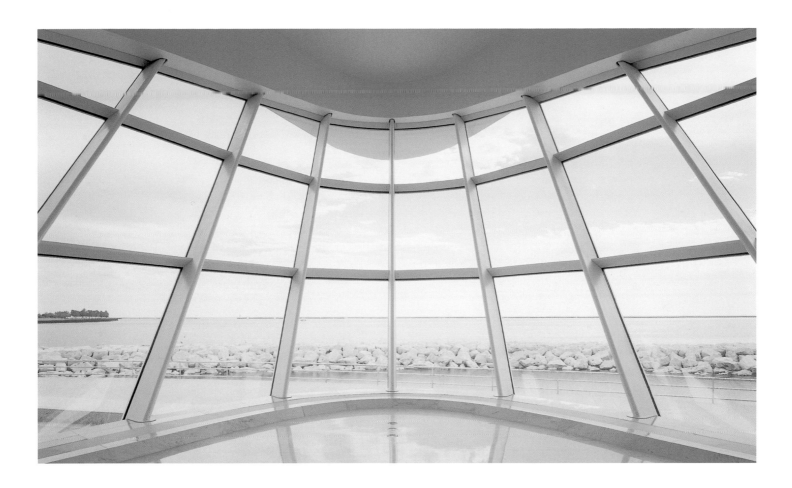

Fig. 27 View looking east toward Lake Michigan from inside Windhover Hall of the Quadracci Pavilion.

All perspectives available to the visitor in this complex space are different and all are engaging, each in its own way: southward toward the prow, eastward toward a view to the lake, westward toward the buildings of downtown Milwaukee, with the bridge crossing in front of them, and northward into the interior of the ribbed mass, itself divided into three exhibition areas: a pair of gallerias (the west containing contemporary art, the east, sculpture) and a vast, uninterrupted area between them, where partitions can alter the plan of temporary shows. Directly to the north of these exhibition areas is a museum shop and, adjacent to the Kahler addition, an auditorium equipped with 300 hundred seats. The lower mezzanine extends from a space below the platform of the eastern prow to an area below the southern prow. It is given over to a conference room and a hundred-seat restaurant, from which the lake is visible through a glass window pitched at forty-five degrees. The Board of Trustees' meeting room is also located at the south end of the building, in the upper mezzanine.

This overall description has dealt for the most part with form and space, having only touched upon an issue that is comparable in its importance to the success of the design: the materials in which the building is executed. Concrete dominates. The foundation, the portion built first, consists of a two- to four-foot-thick concrete slab, a so-called foundation mat, that was constructed instead of pilings or piers to support the building and provide it with the strength to resist the upward pressure of the water from the lake.

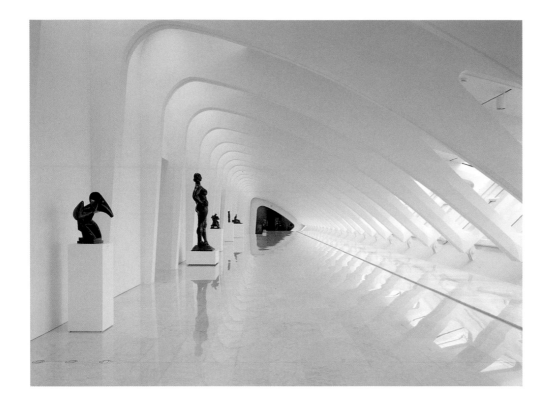

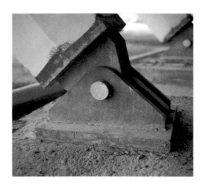

Fig. 28 View along the Baumgartner East Galleria looking south, Quadracci Pavilion, 2001.

Fig. 29 Detail of a rib joint from the Quadracci Pavilion, 2001.

Calatrava's reliance on reinforced concrete as the principal substance of the building recalls the lessons he learned from Robert Maillart. And he leaves no doubt about the value he himself places on the material:

> I mention concrete because it is the material I work with most and feel close to. In the Valencian language, my mother tongue, the word for concrete is "formigo," meaning something that can be given a form. Concrete to me is like a supple and malleable rock. Of all materials, it is the only one that can be moulded and sculpted directly on the site, under normal conditions.... Concrete, although an inexpensive material, when dealt with imaginatively can make beautiful buildings. It is, however, a difficult material and requires a great deal of expertise. And by this I mean not just technical knowledge, but also an understanding of the inner potential for poetic expression that materials possess.[3]

Crucial to that statement is the last sentence, which stresses the importance of aesthetics in the handling of materials while implicitly acknowledging that technical proficiency is no less vital to the success of the finished product. Every

part of the Milwaukee Art Museum addition attests to the aptness of Calatrava's observation. The concrete forms that run along the edges of the gallerias and the parking garage could stand as independent sculptures, yet repeated in rows as they are, and visible to the onlooker at a sharply acute angle, their profiles must be fitted so that they recede in space in perfect consistency with the laws of perspective (fig. 28). The architectural concept, that is, is central to the effect, but it depends just as surely on the precision of its constructed realization. Equally exacting is the workmanship in the brise soleil that helps turn it into a form of poetry in motion. Within the main mass of the building, no single detail better reflects the marriage of idea and substance than the joints at the base of the great ribs (fig. 29). There the steel that reinforces the concrete is openly shown, in a form as finely crafted as it is powerful. Credit for the quality of execution belongs to the firm of C. G. Schmidt of Milwaukee, which lived up handsomely to Calatrava's demanding specifications.

Yet the the strength of the steel hinge and the delicacy of the steel louvers of the brise soleil, reminds us of Calatrava's sensitivity to the possibilities of materials.

Fig. 30 Dan Kiley, The Cudahy Gardens, Milwaukee Art Museum, 1998–2001 (sketch and plan).

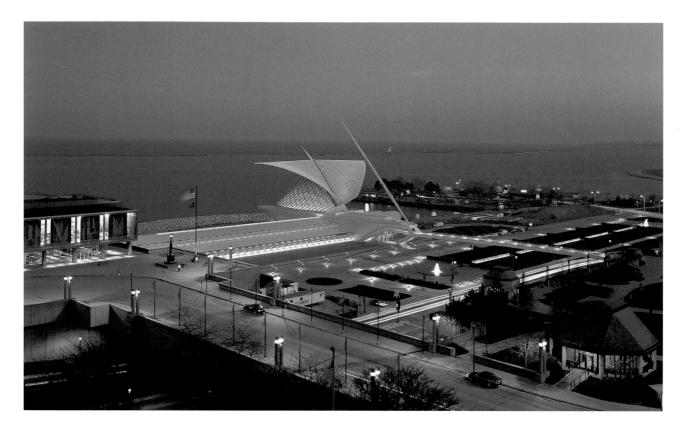

Fig. 31 View of the Milwaukee Art Museum complex showing the Santiago Calatrava-designed Quadracci Pavilion and the Dan Kiley-designed Cudahy Gardens.

In fact, Calatrava's way with glass has made it possible for a heavy, opaque material, concrete, to gain from a reciprocal relationship with glass, its transparent and implicitly immaterial opposite.

The measurements of the building are a mark of its size. It has added 142,000 square feet of space to the 160,000 square feet of the museum's two previous structures. Exhibition space has increased by 30,000 square feet. The length of the pylon supporting the bridge is 192 feet, and it rises to a height of 184 feet above the ground. The total length of the cables is 3,500 feet. The reception hall, with room for 1,000 people, is 90 feet high. The footbridge is 231 feet long and 16 feet wide. Weighing 350,000 pounds, it required 32,000 man hours to fabricate. The parking garage accommodates 100 vehicles. The cost of the building exceeds $75 million.

In view of these dimensions, Calatrava decided to keep the whole structure perceptibly lighter in value, thus in overall visual effect, by painting it white, except for the glass and the exposed steel parts. Color, in fact, has played a role not only in the addition, but in the treatment of the area around it. In this respect the contribution of another artist worthy of Calatrava's company deserves an accounting.

Milwaukee was wise enough to select one of the world's most distinguished landscape architects, Dan Kiley, to design the grounds around the Calatrava building. The color he has added to the prevailing white monochrome of

the structure underscores one of the most successful collaborations in contemporary American architecture (see fig. 30).

The elongated portion of the building between the old museum and the pavilion is now flanked by a plaza to the west that runs along Art Museum Drive, and by a grassy area between the building and the lakefront that has been made over into a north and south lawn. The latter spaces are separated by a plaza situated directly in front of the restaurant. Farther to the east is a walkway built along the water's edge; it is bordered by honey locust trees in pairs. The south lawn embraces the bend of a driveway that leads from Art Museum Drive to the parking garage, and the space between that access road and the drive is enlivened by a stand of Sargent crabapple trees with a periwinkle groundcover. An area south of the War Memorial, extending to Art Museum Drive, is planted with a grove of linden trees.

The most captivating portion of Kiley's design is the one most readily visible to anyone approaching the museum from the city. It is a formally organized rectangular area 600 hundred feet long and 100 hundred feet wide, located between and parallel to Art Museum Drive and Lincoln Memorial Drive (fig. 31). Two paved plazas, each marked by a majestic fountain, occupy the ends of a sequence of five square-shaped lawns that is bisected by a water channel three feet wide. Separated by evergreen hedgerows, the plane of each lawn is divided diagonally, with the inner half sloping gently toward the channel, in the process disclosing low retaining walls that run parallel to the base of the hedgerows. Thus each of the lawns contains two triangles, and, since the whole rectangular space descends gradually to the south, the triangular shape is repeated in the profile of the retaining walls. Walkways between each lawn traverse this garden area. Within the channel water jets are set that can rise to various heights, creating a wall of water which, since it rises and falls, is Kiley's contribution to the movement uniquely apparent elsewhere in the museum complex. To this one might add that the plane geometry of Kiley's landscape is a further collaborative gesture, since it reflects the solid geometry, as well as the dynamism, of Calatrava's building.

With a second access from Lincoln Memorial Drive to Art Museum Drive gained via a divided passage at the north end of the seven-part rectangle, space is left still farther north for a bouquet of littleleaf linden trees that rise from a euonymus ground cover. The one remaining area is a lawn, roughly in the shape of a triangle, at the east corner of the junction between Lincoln Memorial Drive and East Michigan Street.

The edges of Art Museum Drive and of the many walks that are laid about the site are lit at night by handsome Bollard lamps designed by David Kahler. At a height of twenty-four inches, they cast a light that brilliantly illuminates the ground immediately around them.

The origin of the word "museum" is obvious enough: it is derived from the muses, the nine sister goddesses of Greek mythology who presided over song, poetry, the other arts, and the sciences. With the 2001 opening of its new building and gardens, the Milwaukee Art Museum has not only lived up to the legacy of its name, but added significantly to its own substance and value. As surely as the city of Milwaukee will profit from the spectacular construction that has lately risen on its lakefront, the museum's sphere of global influence will grow proportionately. Its gain is the world's gain, with much of that traceable to the wisdom of the decision to hire two creative artists of the caliber of Santiago Calatrava and Dan Kiley. Separately and together they have done all that was expected of them, and then some. The addition is the first major building completed by Calatrava in the United States, and it seems more than likely that it will transform Milwaukee into a major cultural destination. And while the endeavor was not undertaken with any conscious anticipation of a major chronological conjunction, it is impossible to ignore the fact—and all the hopeful symbolism attaching to it—that it has opened its doors to the public at the beginning of a new millennium.

NOTES
1 Doug Stewart, "Transforming the Beauty of Skeletons into Architecture," *Smithsonian*, November 1996, p. 82.
2 Dennis Sharp, "Santiago Calatrava: Building Cultural Bridges," in *Calatrava*, ed. Dennis Sharp, 2nd ed. (London: E & FN Spon, 1994), p. 12.
3 Santiago Calatrava, Foreword, in *Calatrava: Public Buildings*, ed. Anthony Tischbauer and Stanislaus von Moos (Basel: Birkhauser Verlag), p. 6.

Highlights of the Collection

Author Guide

Margaret Andera MA
Tom Bamberger TB
Kathleen Bickford Berzock KBB
Russell Bowman RB
Jennifer Van Schmus Chartier JVC
Jody Clowes JC
Brian Ferriso BF
Saadia Lawton SL
Frank C. Lewis FL
Stephen Little STL
Kristin Makholm KM
Terry Marvel TM
Jane O'Meara JO
Dean Sobel DS
Laurie Winters LW

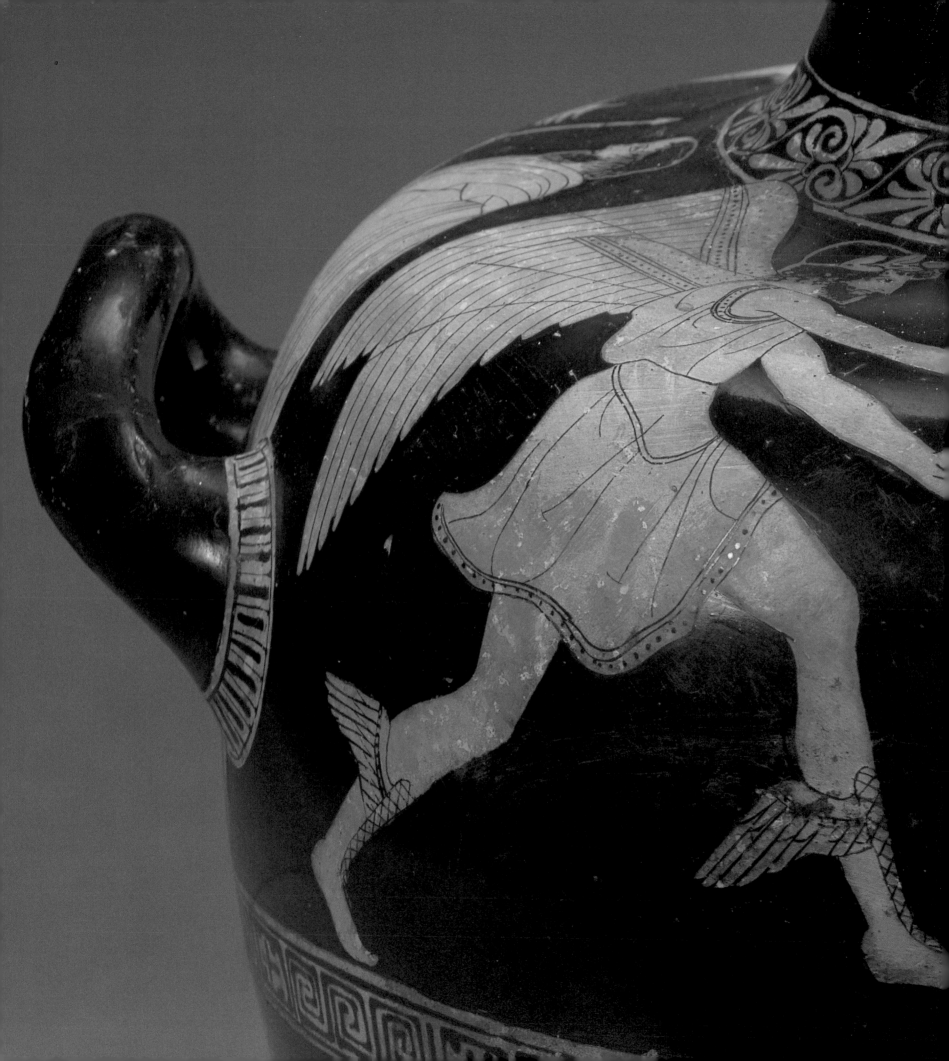

Ancient, Asian, and African Art

The Milwaukee Art Museum's collection of ancient art started in the 1960s. The original goal in acquiring antiquities was to build a collection that would provide an introduction to the development of Western art, and that would establish aesthetic and stylistic reference points for the museum's other collections, primarily of nineteenth- and twentieth-century art. Over the years the collection has not only fulfilled these initial intentions, but it has also surpassed them by becoming

in its own right a collection of objects of distinguished artistic refinement and elegance. Highlights include an ornately stylized Egyptian mummy coffin, an outstanding Greek red-figured hydria, and a powerful marble Roman torso.

The development of the Asian collection reflects the increased interest after World War II by American collectors, and, in particular, several Milwaukeeans, in the art of the Far East. Beginning in the 1940s with a set of eighteenth-century Chinese porcelain cups, the collection of Asian art grew during the 1950s with the addition of several high quality objects, including a sixteenth-century Chinese scroll depicting a scene from Hell given by one of the collection's most significant donors, Eliot Grant Fitch, and a wonderful Chinese lacquer stem cup from the Yuan dynasty of the fourteenth century. It expanded significantly during the 1970s with the acquisition of a number of works, including an important sixth-century Chinese bodhissatva from the Northern Wei dynasty, and several objects representing the Japanese Meiji period of the late nineteenth and early twentieth centuries given by the Margaret and Fred Loock Foundation.

The African art collection represents a commitment to building in this important area. In addition to offering examples of the sophisticated and wide-ranging aesthetic of African peoples and traditions, the collection presents links to both the museum's renowned Haitian art collection, part of the African diaspora, and the modern art collection, which includes paintings and sculptures strongly influenced by African imagery. Although some African art entered the collection during the 1970s through a notable collector of both modern art and African art, the museum has recently added several new works, including a superb Asante leopard stool given by the African American Art Alliance.

Building a Masterpiece provides a unique opportunity for the Milwaukee Art Museum to assess its ancient, Asian, and African art collections. Although not large in scale (approximately 300 objects), these collections contain key works that serve as historic and aesthetic focal points in our understanding of the cultures that produced them. The collections of Asian and African art, in particular, enlarge the scope of the museum by reaching into new collecting areas that allow the museum to present an expanding view of the world fueled by technology and a global cultural perspective. BF

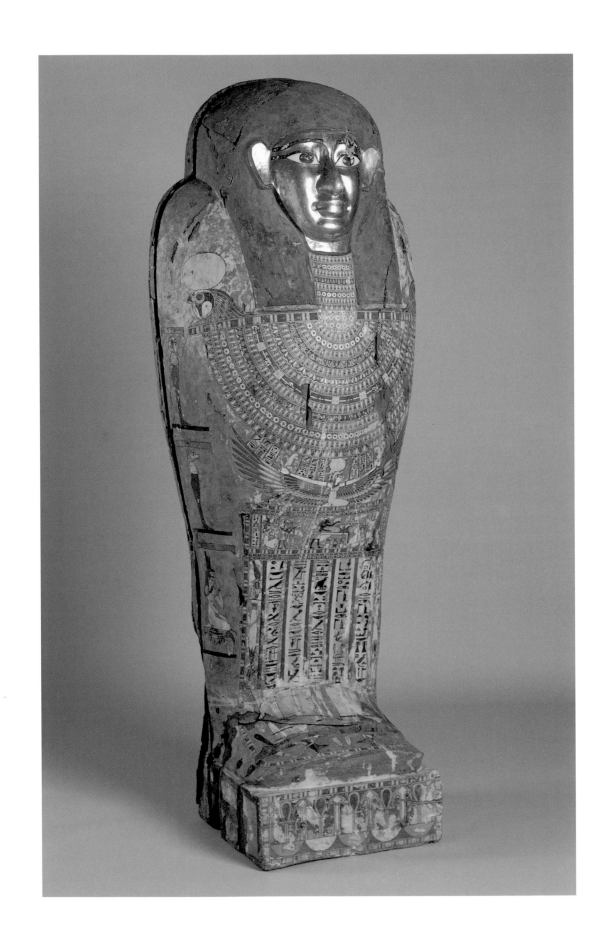

Egyptian
Mummy Coffin of Pedusiri, ca. 500–250 B.C.

During the course of its lengthy duration—more than 3,000 years of recorded history—ancient Egyptian civilization remained remarkably stable and conservative. Its art changed little and was primarily funerary in nature with strict religious conventions governing its form. The ancient Egyptians held complex religious beliefs about the afterlife that required the preservation of the physical body in order to ensure the survival of the spirit, or ka, in the next life. Thus, extreme measures in the form of embalming or mummification were undertaken to protect the corpse from eventual decay. This had nothing to do with a morbid fascination with death, but rather a genuine love of life and the need to ensure that it would continue beyond this world.

Aside from the pyramids, mummies and their coffins are the single group of objects most associated with ancient Egypt. The idea of preserving the dead probably originated with the observation that bodies placed in the dry sand of the desert dried out naturally and did not decay. As the process and desire to preserve the body became more important, the use of a container or small wooden box emerged as a natural solution to safeguarding the mummified corpse. The first coffins resembled houses, which may have led to the idea of the tomb as a house for the spirit. Over the course of Egyptian history, the box shape became rectangular and was then later modified to resemble the contours of the body, producing an anthropoid or human-shaped coffin that could accommodate the spirit should the mummy be destroyed. Secret stone tombs and complex burial chambers evolved as additional layers of defense in the preservation of the mummified body.

Milwaukee's anthropoid wood coffin is an excellent example of artistic and religious practices in the late Dynastic and early Greco-Roman periods. Its beautifully painted ornaments and hieroglyphs invoke the gods to protect the deceased—a man named Pedusiri, whose mummy has not survived. His prepared body was probably enclosed in a cartonnage—a casing of plastered, painted, and varnished linen—that was in turn placed in the present coffin. The exterior decorations consist of an idealized gold face mask, a blue-painted head cloth, and an exquisite funerary collar with hawk-headed terminals that hold the strands of beads in place. The registers across the body depict the sky goddess Nut with magnificent outspread wings and a rare scene detailing the mummification process of the deceased, attended by a ritual priest dressed as Anubis, the jackal-headed god of the afterlife. Below the embalming bed are the so-called Canopic jars, which were used to house the viscera removed from the mummified body; their lids are decorated with protective deities in the shape of a human, a falcon, a jackal, and a baboon.

Burial practices varied widely in ancient Egypt depending on the political or social position of the individual. In this case the extensive use of decoration and the gold face mask (remarkably still intact) indicate that Pedusiri occupied an important position in society, perhaps that of a high priest or an official, and was entitled to an elaborate burial. Presented with such extraordinary beauty and complexity, the ancient Greeks and Romans held Egypt to be the true originator of the arts and sciences. LW

Egyptian (late Dynastic Period or early Greco-Roman Period). *Mummy Coffin of Pedusiri*, ca. 500–250 B.C. Plastered, polychromed, and gilded wood. 84 x 30 3/4 x 13 3/4 inches. Purchase (M1967.20).

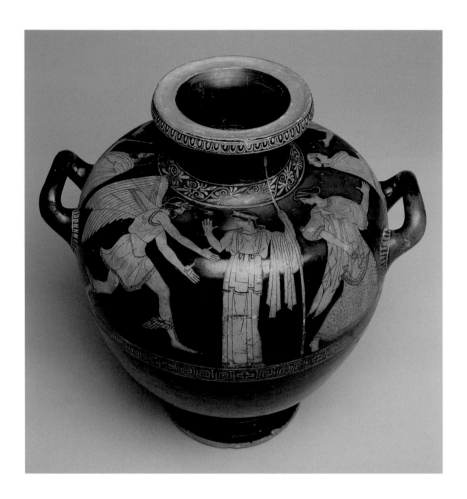

Niobid Painter
Red-Figured Hydria, ca. 460 B.C.

The art created in Greece during the fifth century B.C. established the standards to which Western art has aspired well into our own times. Indeed the word "classical" usually refers to those ideals of beauty and proportion developed in Greek figurative art of the fifth century. This beautifully shaped and decorated *Red-Figured Hydria* (three-handled water jar) is attributed to the Niobid Painter, one of the most gifted and inventive red-figure vase painters of the Early Classical period. The red-figured technique emerged in Attic vase painting around 530 B.C. in an attempt to create ever more expressive and credible renderings of human figures and situations. In the first half of the fifth century B.C., artists such as the Niobid Painter used the technique to help define what have become the principles of classical art in their experimentation with nearly anatomically correct human figures, overlapping, foreshortening, and strenuous movement.

The symbiosis between vase shape and decoration is extraordinarily displayed in this *hydria* by the Niobid Painter. Its subject illustrates the north wind Boreas abducting Orithyia, daughter of the legendary Athenian king Erechtheus. The narrative runs around the belly of the vase as the disheveled Boreas relentlessly pursues his beloved Orithyia, undaunted by the stalwart opposition of the goddess Athena. The Niobid Painter heightened the immediacy of his figures by placing them over the full curvature of the vase and by sharply silhouetting them against the nearly perfect consistency and sheen of the black glaze. The choice of the subject of Boreas was particularly appropriate to an Attic vase painter. The Athenians attributed the destruction of the Persian fleet to Boreas, and for this reason they established a cult in his honor in 480 B.C. He was widely celebrated in Athenian art and literature throughout the post–Persian War era. LW

Niobid Painter (Greek, active Athens, ca. 470–ca. 445 B.C.). *Red-Figured Hydria*, ca. 460 B.C. Terracotta. H. 16 1/4 inches; dia. 15 1/4 inches. Gift of Mrs. Douglass Van Dyke, in Memory of Douglass Van Dyke (M1964.36).

Roman
Torso of a Male Athlete (The Oil Pourer), first-second century A.D.

The ancient Romans admired Greek sculpture of every period and style, importing works by the thousands and copying them in even greater numbers. This spectacular marble *Torso of a Male Athlete* is a fragment of a Roman version of a lost Greek original from the fourth century B.C. The bronze original of *The Oil Pourer* (long since lost) was probably made by Lysippos or one of his immediate followers, between 340 and 300 B.C., during the Late Classical period in Greek art. The athlete's open stance and the slight torsion of the pose strongly reflect the stylistic innovations associated with the work of Lysippos, one of the great sculptors of the late fourth century B.C. His bronze original probably once stood proudly at an important Athenian or Olympian sanctuary dedicated to athletic competitions.

The subject of the young male nude—the ideal subject for many Greek artists—is shown not at the height of exertion, but in a calm preparatory moment, applying oil before an athletic event. The figure's robust musculature and the near magical sense of movement and proportion demonstrate the artist's complete understanding of human anatomy. Despite the lack of a head and limbs, this fragment remains an excellent example of the Greeks' use of *contrapposto*, the asymmetrical yet balanced posture of a figure standing with most of its weight supported on one leg. A visual harmony is created throughout the body by counter-balancing the tension of the weight-bearing leg and the raised left arm with the relaxed bent right leg and the relaxed but straight left arm. Movement and repose are in perfect harmony, and the torso itself is in perfect proportion. Ancient works of this type were widely admired and imitated by figurative artists from the Renaissance to the present day. LW

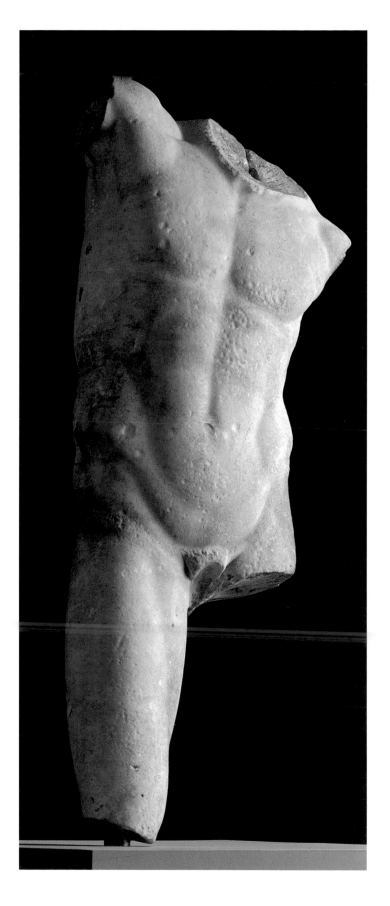

Roman (after a late fourth-century B.C. Greek original). *Torso of a Male Athlete (The Oil Pourer)*, first-second century A.D. Marble. H. 47 inches. Gift of Suzanne and Richard Pieper (M1994.285).

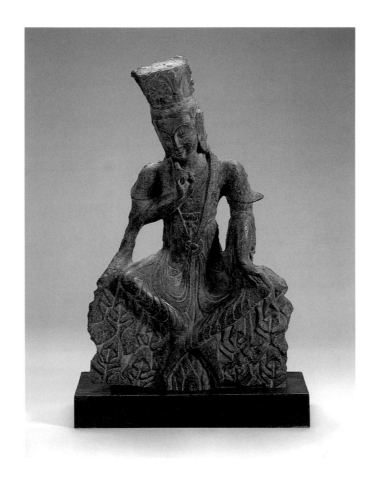

Chinese, Northern Wei dynasty
Seated Bodhisattva, ca. 500–530

In the world of Mahayana (Great Vehicle) Buddhism, bodhisattvas are spiritual beings who have attained Enlightenment, but who defer their entry into Nirvana and take a vow to help all sentient beings attain Enlightenment. The role of the bodhisattva is outlined in such Buddhist texts as the *Lotus Sutra*, which was translated into Chinese in the fourth century. In Chinese Buddhist art, bodhisattvas are usually shown dressed in princely robes with scarves and jewelry, and with a beatific expression.

This elegant *Seated Bodhisattva* originally formed part of the decoration of the late Northern Wei dynasty caves at the cave-temple complex of Longmen (Dragon Gate) near Luoyang in Henan province. With few exceptions, the members of the Northern Wei imperial family were great patrons of Buddhism and Buddhist art. The most important caves at Yungang in Shanxi and Longmen in Henan were commissioned by the imperial court, and it is possible that the Milwaukee bodhisattva comes from such a context. A very similar example is in the Avery Brundage Collection at the Asian Art Museum of San Francisco. Comparison with similar figures among surviving relief and free-standing sculptures suggests that the Milwaukee figure depicts Mile (pronounced Mee-luh; Sanskrit Maitreya), the bodhisattva who will be reincarnated as the Buddha of the future cosmic eon, or *kalpa*. Mile is often shown in Chinese art of the sixth century in the posture of the Milwaukee bodhisattva, with crossed ankles and resting his chin on one hand. STL

Chinese, Northern Wei dynasty. *Seated Bodhisattva*, ca. 500–530. Limestone. 23 5/8 x 14 1/8 inches. Gift of Eliot Grant Fitch (M1979.246).

Chinese, Ming dynasty
King of Hell with His Court, sixteenth century

Originally one from a set of ten, this magnificent scroll depicts a King of Hell presiding over his court. Another painting from the same set of *Ten Kings of Hell* is also in the Milwaukee Art Museum; three others from the set are now in the Arthur M. Sackler Museum, Harvard University. This painting can be attributed to the mid-sixteenth century by comparison with a painting of a god of the popular pantheon dated 1542, in The Metropolitan Museum of Art, New York.

Since at least the Tang dynasty (618–906), the Ten Kings of Hell have been venerated in China as judges of human fate. When an individual died, it was believed that his or her karma (the accumulated weight of one's thoughts and actions) would be assessed by the Kings of Hell and the individual would be reborn in a new life or condemned to Hell. This painting depicts the court of a King of Hell. Presiding at the central table like a judge, the king raises his brush before inscribing the fate of the three obsequious sinners in the foreground who beg for forgiveness. A blank scroll of paper awaits his judgment. The king wears a high crown and the robes of the underworld bureaucracy, and sits in front of a large screen painted with a dragon among waves; he is accompanied by scribes and guardians. The condemned sinners, one of whom wears a *cangue*, are guarded by two demons. To the left another demon prods at four snakes which tumble from a large bin of flames. STL

Chinese, Ming dynasty. *King of Hell with His Court*, sixteenth century. Hanging scroll; ink and colors on silk. 54 1/4 x 30 7/8 inches. Gift of Eliot Grant Fitch (M1956.84).

Chinese, Qing dynasty, Kangxi reign
Hexagonal Bowl, 1662-1772

One of the great accomplishments of the early Qing dynasty was the development of the *famille verte* palette in porcelains decorated with overglaze enamels. As its name suggests, the color scheme was dominated by several shades of green. This delicately painted bowl is decorated with a combination of green, and red, yellow, and brown enamels. The narrative scenes on the sides depict a variety of mythological and literary themes. Each scene is accompanied by a four-character phrase in Chinese, along with a seal. The scene on the right in this illustration depicts two lovers, the Weaving Maiden and the Ox Herder, who meet at the Double Seventh Festival every year by crossing a bridge of magpies across the Milky Way. The Weaving Maid (corresponding to the bright star Vega) is shown with her celestial loom, while the Ox Herder (corresponding to the star

Altair) rides on the back of a dragon. Other scenes depict the ancient goddess Nüwa smelting "five-colored" stones to patch the heavens, a sleeping young scholar dreaming of a successful career, a scholar traveling in a winter landscape, a young official watching clouds in the sky, and a meeting of two old friends. From the six narrative scenes painted on the sides of this bowl, it would appear that it was created for an audience with sophisticated literary taste.

The bowl's interior is decorated with an iron-red diaper band within the lip. On each side the diaper band is punctuated by a cartouche with a floral spray. At the bottom center a scholar is shown seated on a mat, drinking a cup of wine. STL

Chinese, Qing dynasty, Kangxi reign. *Hexagonal Bowl*, 1662–1772. Porcelain with overglaze *famille verte* enamels decoration. H. 3 7/8 inches; dia. 8 inches. Gift of the Margaret and Fred Loock Foundation (M1973.465).

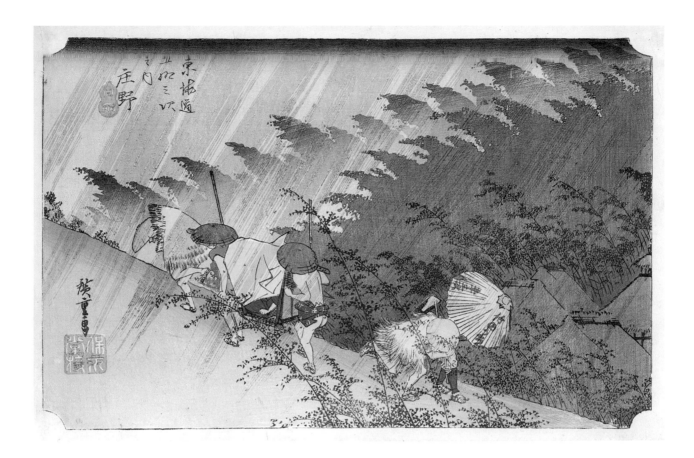

Andō Hiroshige
Sudden Shower at Shōno, 1833–34

The Tōkaidō, or Eastern Road, running along the coast of Japan, is one of the country's oldest and most important highways. During the rule of the Tokugawa samurai (1600–1868), it served as the major link between the imperial capital of Kyoto and Edo (now Tokyo), the commercial center of Japan and home of the ruling shōgun. The nearly three-hundred-mile journey took about two weeks by foot, horse, boat, or a hand-carried conveyance called a *kago*. It passed through diverse and scenic terrain, where one encountered muddy and dusty roads, exorbitant ferry rates, bandits, and other inconveniences and dangers, as well as the pleasures of interesting regional foods and festivals.

The Tōkaidō has been a favorite subject with writers and artists since the seventeenth century, but the most famous pictures of the highway are by the Edo woodblock artist Andō Hiroshige. Of the thirteen series on the Tōkaidō that

Hiroshige created, the first, entitled *Tōkaidō Go-ju-san-Tsugi* (*The Fifty-three Stages of the Eastern Road*), is the most celebrated. The fifty-five prints in the series depict the road's beginning, end, and major stopping places. Hiroshige based his views on sketches he made of people and sights he saw during the late summer and early fall of 1832 while accompanying the shōgun and his retinue on a trip to present a gift of horses to the emperor. The series represents the Japanese landscape during all seasons of the year, in various weather conditions, and at different times of day and night. In *Sudden Shower at Shōno* (stage 45), *kago* porters and other travelers scurry to find shelter from a sudden summer storm. As in the other works in the series, the power and beauty of this print lie in Hiroshige's mastery at portraying the lives of local people, the haphazards of travel, and surprising encounters with nature. TM

Andō Hiroshige (Japanese, 1797–1858). *Sudden Shower at Shōno.* From *The Fifty-three Stages of the Eastern Road*, 1833–34. Color woodcut. 9 1/2 x 14 1/2 inches. Gift of Mr. and Mrs. William D. Vogel (M1965.70.46).

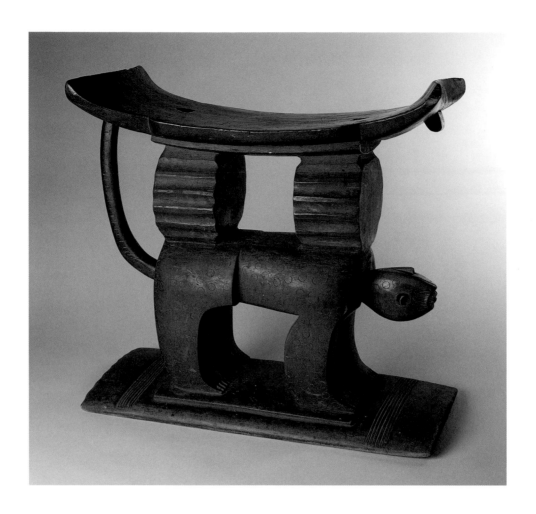

Asante; Ghana
Leopard Stool (Osebo Dwa), early twentieth century (probably 1920s)

Stools are among the most meaningful and important aesthetic objects within Asante culture. As personal possessions, they are closely associated with an individual's identity. One Asante proverb states, "There are no secrets between a man and his stool." The handsomely stylized leopard that supports the seat of this stool distinguishes it as the seat of a leader. For the Asante and other Akan-speaking people of Ghana and Ivory Coast, the fierce, independent, and dangerous leopard is a potent symbol of chieftancy. In the nineteenth century, when the power of the Asante kingdom was at its apex, leopard stools were restricted for use by the king. By the time this stool was made, in the early twentieth century, such strictures had loosened.

The artist who sculpted this stool was a master of subtle and playful imagery. For example, when seen from above, the leopard's snarling feline visage transforms into a human face. Similarly, the viewer's eye is teased to complete the arc of the cat's long tail, which is truncated where it meets the stool's seat, but reemerges in a brief tip on the opposite side. The elaborate form of this chief's stool expresses status, and its iconography delivers a message about public position and power. Today such stools continue to serve ceremonial functions. They are frequently displayed when a chief holds a formal audience and they are carried on the shoulders of royal servants, called stool-bearers, in public ceremonies that reiterate a chief's right to rule. KBB

Asante; Ghana. *Leopard Stool (Osebo Dwa)*, early twentieth century (probably 1920s). Wood. 22 x 22 x 12 inches. Gift of the African American Art Alliance (M2000.165).

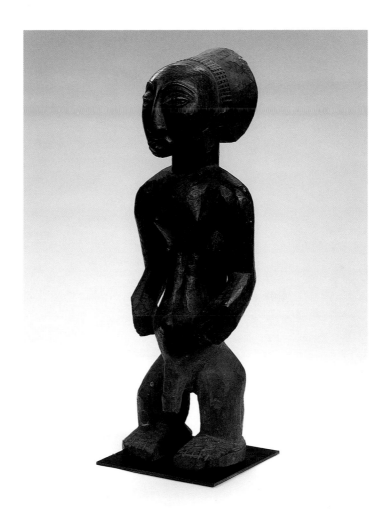

Hemba; Democratic Republic of Congo
Male Ancestor Figure, early to mid-twentieth century

The Hemba people live in what is today the Shaba province of the southwestern Democratic Republic of Congo. In the eighteenth and nineteenth centuries, many Hemba chiefdoms were incorporated into the far-reaching Luba kingdom, and some Hemba art bears a strong resemblance to that of the Luba. However, unlike the Luba, who have a tradition of sacred kingship and state building, Hemba political organization is based on smaller groupings of lineages and clans that can date back ten or more generations; leadership to a large extent is based on carefully guarded lineage claims to land. Sculpted figures portraying specific forbears were once critical in affirming ancestral connections and thus political power in Hemba society, though their use has all but ceased since the mid-twentieth century. Figures were kept by relatives in their homes and were used on a regular basis as a focus for honoring ancestors.

Though not a master craftsman, the artist who made this somewhat awkward figure was following in the Hemba sculptural tradition; he incorporated several of the significant gestures associated with Hemba ancestral characteristics. The figure's closed eyes suggest peaceful concentration and an ability to look inward or into another realm. The rounded belly and protruding navel, which are emphasized by the placement of the figure's hands, denote the connection between the ancestor and his living family. This figure is unusual in that it does not bear the ornate crossed hairstyle that graces most Hemba figures. The change of color at the figure's waist suggests it once wore a garment—probably a raffia cloth wrapper—that covered its legs. KBB

Hemba; Democratic Republic of Congo. *Male Ancestor Figure*, early to mid-twentieth century. Wood. 24 3/8 x 7 1/2 x 7 1/4 inches. Gift of Dr. Milton D. Ratner (M1974.24).

Early European Painting, Sculpture, and Decorative Arts

The Milwaukee Art Museum's collection of earlier European art was officially launched in 1957 when Director Edmund H. Dwight and the Board of Trustees made a commitment to enlarge the scope of the museum's permanent collections in conjunction with the grand opening of the new Milwaukee Art Center. One of the earliest works acquired for the new Saarinen galleries was Zurbaran's *St. Francis of Assisi in His Tomb*, which set a standard of excellence for the museum and provided

inspiration for future benefactors. Although 1957 was a relatively late date for an American museum to enter the expensive Old Master market, private collectors and donors rallied behind the museum's initiative with a number of major donations and gifts that have helped to forge a collection of international significance.

The Milwaukee Art Museum today boasts rich holdings of seventeenth-century Dutch painting, eighteenth-century French painting and Sèvres porcelain, and eighteenth-century English portraiture, thanks to the generous gifts of Dr. and Mrs. Alfred Bader, Leon and Marion Kaumheimer, Mr. and Mrs. Myron Laskin, Mrs. Catherine Jean Quirk, Mr. and Mrs. William D. Vogel, and the family of Mrs. Fred Vogel, Jr. The William Randolph Hearst Foundation provided a number of important late medieval and Renaissance works, most notably a sixteenth-century Flemish-Brabant tapestry. Acquisition funds, such as those established by the Laskins and by Marjorie Tiefenthaler, have recently enabled the museum to further enrich its galleries with such important works as the exquisite *Madonna and Child* by Nardo di Cione and an important Dutch Caravaggesque painting by Matthias Stom[er].

The 1991 donation of the Richard and Erna Flagg collection of European decorative arts and sculpture represents one of the most significant single donations of earlier European decorative arts to an American museum. Comprising more than 125 outstanding examples of Renaissance and Baroque decorative objects and German Renaissance clocks, the Flagg collection forms the core of the museum's Renaissance Treasury. Highlights include domestic and liturgical master-pieces; rare tablewares and vessels; table cabinets with exquisite inlays of ivory and precious stones; intricately tooled metalwork; and carved and polychromed wood sculptures and house altars. Their unique collection of German Renaissance clocks is considered the best in any North American museum. Publication of a scholarly catalogue in 1999 helped to establish the Flagg collection's significance and bring it to the attention of a wider public.

In 1986 the first curator of earlier European art was added to the staff. In 1987 the Fine Arts Society, a museum-sponsored support group, was formed to initiate fundraising and sponsor educational programming. These commitments to the field have greatly strengthened the area and offer much promise for future acquisitions, collections research, and exhibitions of earlier European art. LW

Nardo di Cione
Madonna and Child, ca. 1350

Nardo di Cione epitomizes the refined skill and conservatism of Florentine artists who came to maturity after the first outbreak in 1348 of the bubonic plague—the so-called Black Death, which may have killed as much as two-thirds of the city's population. Regarded as one of the leading artists of his day, Nardo and his two brothers (Andrea and Jacopo) responded to the subsequent devastation and religious fervor with a markedly conservative style of fresco and panel painting. The buoyant naturalism and humanity achieved at the dawn of the century in the works of Giotto and Duccio were replaced with a neomedievalism and an authority of religious doctrine. Nardo's own sudden illness and premature death in 1366 may explain why only a few rare panel paintings and frescoes can be firmly attributed to him.

The motif of the Madonna and Child is perhaps the most enduring image of the Italian Renaissance. In the Milwaukee panel, Nardo di Cione depicted the Madonna formally presenting Christ in a manner that emphasizes her rank as the Queen of Heaven and gently reminds the viewer of the fate of her son. Nardo maintained the traditional abstract gold background and figural stylizations adapted from earlier Italo-Byzantine models, yet softened his image with a distinctive taste for sumptuous surfaces, deeply saturated hues, and the ornamental rhythms of drapery folds and jeweled hemlines. The pronounced lyricism of his style creates a serenely meditative presence that enhances the contemplative aspect of the panel. Surviving fragments of the original framing elements suggest that this painting was once the main or central panel of a small-scale folding altarpiece used to aid private devotions. LW

Nardo di Cione (Italian [Florence], ca. 1320–ca. 1366). *Madonna and Child,* ca. 1350. Tempera on panel. 29 1/2 x 19 inches. Purchase, Myron and Elizabeth P. Laskin Fund, Marjorie Tiefenthaler Bequest, Friends of Art, Fine Arts Society; and funds from Helen Peter Love, Chapman Foundation, Mr. and Mrs. James K. Heller, Joseph Johnson Charitable Trust, the A. D. Robertson Family, Mr. and Mrs. Donald S. Buzard, the Frederick F. Hansen Family, Dr. and Mrs. Richard Fritz, and June Burke Hansen; with additional support from Dr. and Mrs. Alfred Bader, Dr. Warren Gilson, Mrs. Edward T. Tal, Mr. and Mrs. Richard B. Flagg, Mr. and Mrs. William D. Vogel, Mrs. William D. Kyle, Sr., L. B. Smith, Mrs. Malcolm K. Whyte, Bequest of Catherine Jean Quirk, Mrs. Charles E. Sorenson, Mr. William Stiefel, and Mrs. Adelaide Ott Hayes, by exchange (M1995.679).

Jan Swart (van Groningen)
Triptych with Moses and the Tablets of the Law and Josiah and the Book of the Law, ca. 1550

Netherlandish artists during the Renaissance took endless delight in depicting the world around them, down to the smallest particular. This penchant for unflinching realism and meticulously executed detail is evident in Jan Swart's large, brilliantly colored altar triptych of *Moses and the Tablets of the Law and Josiah and the Book of the Law*. Although none of the paintings gathered around Swart's name is signed or dated, each has an inner cohesion with a particularly strong flavor of Northern Mannerism. The Italianate figure types with elongated proportions and complex poses and the naturalistic landscapes are linked stylistically with Antwerp artists such as Dirk Vellert and Pieter Coecke van Aelst. Peculiar to Swart are the exotic hats and turbans worn by many of his figures and their long gesticulating hands which are used to organize and give focus to the composition.

Swart was a marvelous storyteller, capable of a rich and complex layering of continuous narratives that could captivate and engage the viewer in a sustained way. The interior of the altarpiece, reproduced here, depicts scenes related to Josiah, the King of Judah, and his religious purification of his corrupt kingdom following the discovery of the Book of Deuteronomy, thought to have been written by Moses himself (2 Kings 22:10–13; 23: 2-3, 5, 20). The exterior panels illustrate important precedents for Josiah's reform, showing scenes related to Moses and the Tablets of the Law, Aaron and the Golden Calf, and Aaron and the Children of Israel (Exodus 18; 31; 32: 4; 34: 4, 5, 30). It has been suggested that the Old Testament subjects depicted in this triptych reflect contemporary Reformation ideology in their emphasis on collapsing codes of behavior and their preoccupation with moral regeneration through established Judaic Law. LW

Jan Swart (van Groningen) (Dutch, ca. 1500–ca. 1560). *Triptych with Moses and the Tablets of the Law and Josiah and the Book of the Law*, ca. 1550. Oil on wood panel. Center panel: 48 x 33 x 2 inches; side panels: 48 x 18 1/8 x 2 inches each. Gift of Richard and Erna Flagg (M1972.229).

Flemish
Manius Curius Dentatus Refusing the Gifts of the Samnites, 1530–50

Used to decorate and insulate expansive interior spaces, tapestries have been prized for centuries in Europe by the gentry, the government, and the church. During the Renaissance, tapestry enjoyed a Golden Age in Northern Europe, especially in Flanders. Influenced by monumental Italian wall painting, sixteenth-century Flemish weavers used artists' cartoons as the basis of their designs. An expanded range of textile dyes allowed them to refine their technique, resulting in more realistic shading, modeling, and perspective. The intricate designs of these often immense, yet easily portable, textiles reflect social and regional influences as well as other art forms. While some tapestries were used for permanent display, others were stored and unfurled only for special occasions such as state visits or grand banquets.

This tapestry comes from a workshop in the great Renaissance center for Flemish tapestry Brabant-Brussels, as is indicated by its mark, a "B "on either side of a red shield, found in the lower left corner. The design features a typically Flemish elongated central figure, identified in the woven inscription as the third-century B.C. Roman general Manius Curius Dentatus. Clad in Roman-inspired ceremonial armor, he stares straight ahead, pleased with his army's defeat of the Samnites. The Samnite ambassadors, dressed in their finest garb, offer gifts which Dentatus, "satisfied by glory alone," resolutely dismisses. His refusal of these gifts earned Dentatus a reputation for incorruptibility and justice, characteristics that would have appealed to European Renaissance princes. In the distance, shepherds and shepherdesses dressed in provincial fashion shear their flock of sheep. Bordering these scenes is an elaborate array of mythological figures, fruits, and blossoms characteristic of Flemish tapestry in the second quarter of the sixteenth century. The Zodiac sign of Cancer, the crab, is centered in the upper border, indicating that this panel is part of a series representing the twelve months. JVC

Flemish (Brabant-Brussels). *Manius Curius Dentatus Refusing the Gifts of the Samnites*, 1530–50. Wool and silk weft, linen warp. 167 3/8 x 228 inches. Gift of the William R. Hearst Foundation (M1953.148).

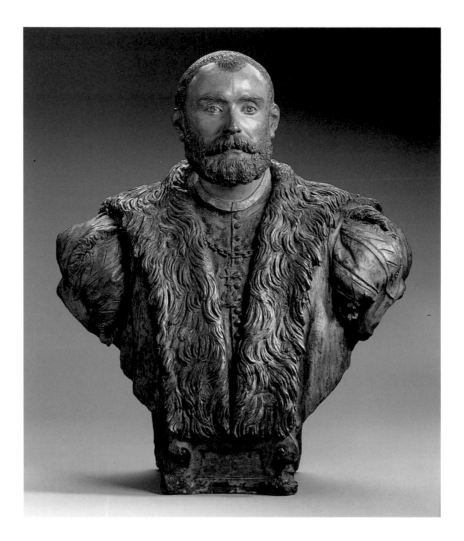

Italian
Bust of a Nobleman, 1556

North Italian artists took the art of portraiture to new levels of sophistication in the sixteenth century. Respect for the individual and pride in personal achievement led to a revival of portraiture and biography, forms of art and literature that had virtually disappeared with the fall of ancient Rome. Like Roman sculptors, Renaissance artists sought to capture not only physical likeness, but also the character and disposition of their subject. In this handsome *Bust of a Nobleman*, the artist has created an elegant and dignified persona. Choosing a bust form that includes most of the chest, he curved the truncation to echo the arch of the spreading shoulders and billowing sleeves, producing an effect of both harmony and imposing physical bulk. The close-cropped hair and beard show the nobleman to be pragmatic and decisive; his large, alert eyes reveal a lively self-confidence.

The identity of both the sitter and the author of this extraordinary portrait bust has long been a topic for scholarly discussion. The tour-de-force modeling of the fur stole and various textures suggests a sculptor of the highest caliber, but no artist's name has been put forward with any assurance. Initially it was attributed to the North Italian sculptor Alessandro Vittoria and then to Danese Cattaneo, but a growing consensus now favors a tentative attribution to the Paduan Francesco Segala, who produced busts analogous in their broad frontality and quiet conception. The sitter's physiognomy and the presence of the two Venetian orders suspended from his golden chain—the Cavaliere di San Marco and the Cavaliere di Doge—help to narrow the possible candidates for the sitter to Giovanni Girolamo Albani, a Bergamese nobleman, or Giovanni de Nores, Count of Tripoli. LW

Italian (Paduan or Venetian). *Bust of a Nobleman,* 1556. Polychromed terracotta. 30 x 24 3/4 x 11 1/2 inches. Gift of Richard and Erna Flagg, Mrs. Max Gottchalk, with Isabelle Miller, Mrs. Herman Weigell, and Mrs. S. S. Merrill by exchange (M1990.124).

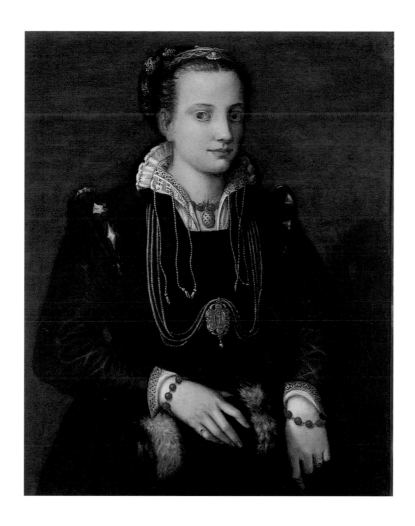

Sofonisba Anguissola
The Artist's Sister Minerva Anguissola, ca. 1564

The eldest of six highly educated and artistic daughters of a North Italian nobleman, Sofonisba Anguissola was the first woman artist of the Renaissance to establish a major international reputation for her sensitively rendered portraits. She was encouraged early on by such impressive figures as Giorgio Vasari and Michelangelo, and in 1559 she was invited to become court painter in Madrid to King Philip II, whom she served for over a decade. Anguissola was highly regarded throughout her lifetime—Anthony van Dyck visited her shortly before her death—and her success was an important inspiration to other women artists. While her commissioned portraits follow the formal conventions of the day, she was at her best in the more intimate paintings of her family, as in this charming portrait, *The Artist's Sister Minerva Anguissola*.

Once considered a self-portrait, this painting has been identified as a portrayal of Anguissola's younger sister Minerva, who died in 1564. The sitter resembles other portraits by Anguissola of Minerva, and she wears a medallion depicting an armed Minerva, the goddess of wisdom. This portrait may have been painted before Anguissola's departure for Spain in 1559, but more likely was done in 1564, the year of Minerva's death, as a remembrance of her sister. The latter date would better explain the drawings sent by Anguissola's sisters to inform her of the adult Minerva's appearance, as well as account for the statuesque rendering of the subject, which is more typical of Spanish custom than Italian. Minerva's elegantly posed hands, fur-trimmed muff, and the rich ornaments of her costume have affinities with Mannerist court portraiture, while the portrait's warmer, more direct and painterly approach is closer to the naturalism of North Italian and Spanish painting. LW

Sofonisba Anguissola (Italian, ca. 1532–1625). *The Artist's Sister Minerva Anguissola*, ca. 1564. Oil on canvas. 33 1/2 x 26 inches. Gift of the Family of Mrs. Fred Vogel, Jr. (L1952.1).

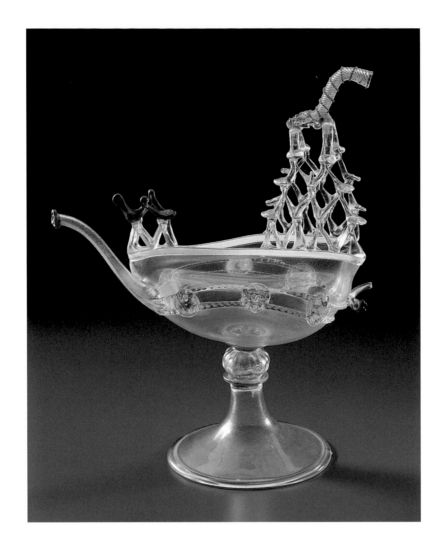

Italian, Murano
Nef Ewer, late sixteenth century

Venetian glass, by its very name, conjures up mystery and a certain exotic glamour, as well as being synonymous with quality. The invention of *cristallo* in the mid-fifteenth century revolutionized glassmaking on the Venetian island of Murano and throughout the glass centers of Europe. This type of glass—colorless and so free of impurities that it resembled rock crystal, after which it was named—could be blown and drawn out very thinly. This led to the manufacture of wine glasses and bowls in a seemingly endless variety of fantastic forms. Milwaukee's *Nef Ewer* in the shape of a sailing ship is a tour-de-force example of Venetian glassmaking, with its mold-blown hull, delicately tooled latticework sails, and applied and gilded ornamentation. Such ornate and fragile vessels were most likely made as diplomatic gifts or to be used as table ornaments at Renaissance banquets.

Although the date of the *Nef Ewer* has often been questioned, a recently discovered photograph dated 1868 shows the piece in the celebrated decorative arts collection of Karl Thewalt in Cologne, Germany. Many historicized versions of the ewer were made in the late nineteenth century, but this photograph, taken well before the production of such pieces, significantly reduces the likelihood that the Milwaukee ewer is anything but an exceptionally rare example of Venetian glassmaking, perhaps one of only three such ewers in the world. The other two examples that can be firmly identified as late sixteenth-century Venetian are located in the British Museum, London, and in the Museum of Applied Arts, Prague. LW

Italian, Murano. *Nef Ewer*, late sixteenth century. Colorless *cristallo* and blue glass with gilded ornamentation. 12 1/4 x 10 1/5 x 5 inches; dia. of foot 5 1/2 inches. Gift of Gabriele Flagg Pfeiffer (M1988.135).

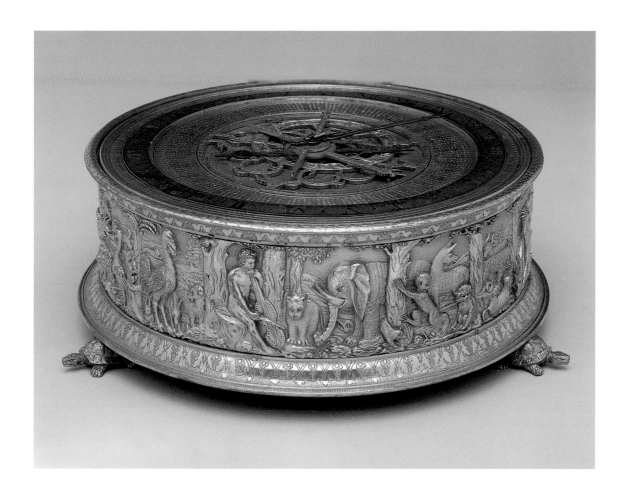

German, probably Nuremberg
Table Clock with Orpheus Frieze, ca. 1560–80

This spring-driven drum *Table Clock with Orpheus Frieze* is an excellent example of German Renaissance clock making. Clock making and the related metalwork arts flourished in the mineral-rich areas of southern Germany during the 100–year period between 1550 and 1650. This particular clock belongs to a well-known and widely published group of eleven examples, nine of drum form and two of square form, all with identical or nearly identical high-relief cast cases depicting the Greek myth of Orpheus and Eurydice. All of the clock cases are thought to have come from the same workshop during the third quarter of the sixteenth century. The original movement of this clock was replaced in the eighteenth century, as was often done when clocks were brought up to date.

Orpheus is the subject of a number of myths, two of which appear on the series of Orpheus clocks. The best-known myth is that of Orpheus' skill with the lyre, which was said to be so remarkable that birds and wild beasts would gather to listen and even trees and rocks would fall under his spell. The second myth recounts Orpheus' ill-fated descent into Hades to recover his wife, Eurydice, a wood nymph, who died of snakebite. The Milwaukee relief is distinguished among the eleven clocks for its depiction of Orpheus alone charming the animals with his bowed foot lyre. Neither Eurydice nor Pluto, the god of the underworld, is present, and there are no morbid undertones to spoil the harmony of Orpheus' spell over nature. The power of his music may be seen as a metaphor for the triumph of art over nature, and perhaps over time as well. LW

German, probably Nuremberg. *Table Clock with Orpheus Frieze*, ca. 1560–80 with later movement. Gilt brass, brass, steel, blued steel, silver, and blue enamel. 3 1/2 x 9 3/4 x 9 3/4 inches. Gift of Richard and Erna Flagg (M1991.84).

Christoph Leipzig
Leipzig Pokal, ca. 1635–45

Magnificently decorated, this soaring *pokal* or standing cup with cover is one of the most spectacular and characteristic examples of German Renaissance metalwork. An explicitly Germanic invention, these lavish vessels took on a wide variety of forms, ranging from the early Gothic cups of lobate shape to the more symmetrically balanced Renaissance *pokals* with classically inspired Italianate motifs. With its complex design of multiple levels and flamboyant surface ornamentation, the *Leipzig Pokal* is an outstanding example of later Mannerist cups. Exquisitely crafted, this partly sculptural and partly functional object was never intended for mass consumption or everyday use. Members of the nobility and city officials typically commissioned such precious objects as diplomatic gifts for visiting dignitaries and ambassadors or as status symbols to impress guests when used as table ornaments.

The importance of the *Leipzig Pokal* is enhanced by its historic distinction and noble pedigree. The maker's mark and the town assay mark punched on this vessel indicate that it was made by Christoph Leipzig, probably in 1639, and probably as a masterpiece (a qualifying piece) for admission into the goldsmiths' guild in Augsburg. Since guild membership was crucial to a goldsmith's career, submissions for master status were often virtuoso displays of metalworking. Expertly constructed from nine separate sections screwed and bolted together, this *pokal* is just such an example. The vessel is fluidly integrated and the entire surface is richly and diversely embellished with a variety of designs and motifs. As a further distinction, the Milwaukee *pokal* was once in the collection of the Dukes of Buckingham. LW

Christoph Leipzig (Augsburg, Germany, master 1639–1678). *Leipzig Pokal*, ca. 1635–45. Silver gilt. 24 x 8 x 8 inches. Gift of Richard and Erna Flagg (M1991.92).

Ludwig Hyrschöttel (Eirerschöttel)
Table Clock with Astronomical and Calendar Dials, ca. 1658

One of the most important German Renaissance clocks in North America, this spring-driven *Table Clock with Astronomical and Calendar Dials* is probably the masterpiece clock Ludwig Hyrschöttel submitted to the Augsburg clockmakers' guild in 1658. This monumental tower clock is an exceptionally rare example of a masterpiece submission. The Augsburg regulations governing clocks were strictly enforced and this clock adheres to all of the technical specifications for mastery. The movement is set between gilt brass train bars and has trains for timekeeping, hour-striking, quarter-hour-striking, and alarmwork. The twelve dials on the clock have indications for an annual calendar, the hours and quarter-hours, the days of the week, and the zodiac. As stipulated in the masterpiece specifications, this clock is able to chime both 1-12 twice, and 1-24.

The ornamental case for a masterpiece clock was not subject to the same rigid constraints as the mechanism. Here the clockmaker could demonstrate his individuality, although he often chose the tower form, which, mechanically and aesthetically, was ideally suited for enclosing a spring-driven movement and displaying its indications. Originally quite modest, the shape reflected the architectural influence of the towers and spires that dominated the townscapes of Renaissance Germany. By the mid-seventeenth century, clock cases exploded in grandeur and opulence, as demonstrated in the Hyrschöttel clock. Multiple-storied clocks with round, bell, or onion-shaped domes became common, as did an abundance of spires, cupolas, balustrades, and lathe-turned finials. Other forms also were used for clock cases, but the tower retained its popularity well into the eighteenth century. LW

Ludwig Hyrschöttel (Eirerschöttel) (Augsburg, Germany, master 1658). *Table Clock with Astronomical and Calendar Dials*, ca. 1658. Gilt brass, gilt copper, brass, iron, blued iron, bell metal, and silver. 25 1/2 x 16 x 16 inches. Gift of Richard and Erna Flagg (M1991.94).

Matthias Stom[er]
Christ Before the High Priest, ca. 1633

Born in Amersfoort, near Utrecht, Matthias Stom was among the dozens of seventeenth-century Northern artists who worked in Italy and were profoundly influenced by the revolutionary and realistic painting of Caravaggio. Following an apprenticeship with Gerrit von Honthorst in Utrecht, Stom is recorded as working in Rome in 1630–32 and soon thereafter in Naples, where he established himself as an accomplished painter of dramatically lit night scenes. The large and impressive painting *Christ Before the High Priest* belongs to Stom's early Neapolitan period and employs many of the hallmarks of the Caravaggesque vocabulary, such as sharp contrasts between light and dark, dramatic gestures, and heightened naturalism (evident in the tattered clothing of the high priest and the roguish appearance of the witnesses).

This painting depicts the moment when the high priest Caiaphas accuses Christ of blasphemy because of his refusal to deny that he was the Son of God (Matt. 26:57–68). Stom has captured beautifully the psychological drama of this decisive moment in Christ's Passion by contrasting an emphatic, gesticulating Caiaphas with a strangely serene and saddened Christ, whose countenance betrays his knowledge of future events. His quiet beauty contrasts with the gleeful snickers of the two false witnesses who lurk behind him. Intense candlelight casts an eerie, pale hue over the figures and further heightens the psychological tension of the confrontation. The three-quarter-length figures and their placement close to the picture plane transform the painting into a powerful and moving image that was meant to engage the viewer and inspire religious devotion. *Christ Before the High Priest* is one of Stom's finest paintings and was probably once part of an important Passion series for the Capuchin Church of St. Efremo, Naples. LW

Matthias Stom[er] (Dutch, ca. 1600–after 1652). *Christ Before the High Priest*, ca. 1633. Oil on canvas. 56 x 72 3/4 inches. Purchase, with funds from Friends of Art, Myron and Elizabeth P. Laskin Fund, and Marjorie Tiefenthaler Bequest (M2000.6).

 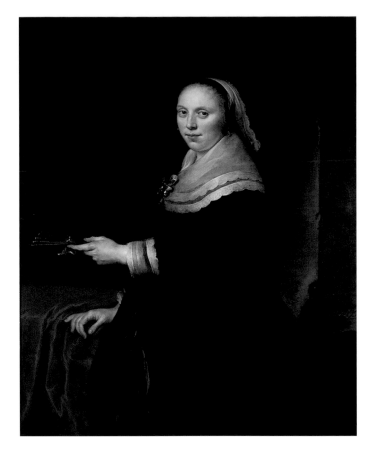

Govaert Flinck
Portrait of a Gentleman, 1648
Portrait of a Lady, 1648

In seventeenth-century Holland, the rise of prosperity, along with an increasingly materialistic outlook on life, led to the development of a self-made middle class concerned with hard work and moral diligence. The confidence and pride of this new burgher class are apparent in the large number of portrait commissions of all types, including paired likenesses of married couples such as these paintings by Govaert Flinck and on the opposite page by Jan Victors. Although many pendants were separated in the nineteenth and early twentieth centuries, the Milwaukee Art Museum is fortunate to have outstanding examples by two of Rembrandt van Rijn's most gifted followers. In his day, Flinck was admired even more than Rembrandt and most citizens of Amsterdam would have agreed that he had surpassed his master as a portrait painter. He was especially favored by wealthy merchants, who preferred his lighter palette and precise technique to the dark, brooding surfaces of Rembrandt's later work.

Flinck's *Portrait of a Gentleman* and *Portrait of a Lady* present a contented couple who appear to enjoy a comfortable life and the advantages of their position in society. The sitters are shown three-quarter-length and set close to the viewer. The intimate view reinforces the emphasis on their exact physical appearance, as do the diffuse background and surrounding space. Careful attention is paid to the elegant but discreet details of the costumes, including the bits of lace and ribbon that relieve the severity of their fashionable black garb. Juxtaposed, the sitters' affectionate gestures and the identical architectural settings create a psychological and visual bond that rhythmically joins the couple. Despite the rather conventional poses, Flinck's portraits convey a genuine human dignity and unaffected naturalism that would have appealed to Amsterdam's merchant class. LW

Govaert Flinck (Dutch, 1615–1660). *Portrait of a Gentleman*, 1648. *Portrait of a Lady*, 1648. Oil on canvas. 50 1/2 x 39 1/2 inches each. Gift of Dr. and Mrs. Alfred Bader (M1963.88, 89).

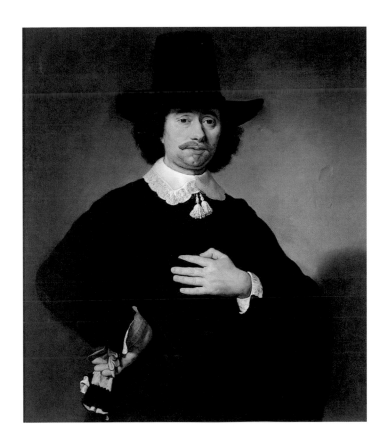 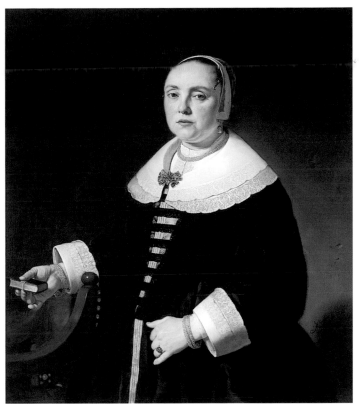

Jan Victors
Portrait of a Gentleman, 1650
Portrait of a Lady, 1650

The strength and vitality of the individuals who established the new Dutch Republic in the seventeenth century are nowhere better represented than in these superb paired *Portrait of a Gentleman* and *Portrait of a Lady* by Jan Victors. Self-made and proud, these Dutch burghers undoubtedly wanted their portraits to be frank and precise likenesses, with full attention to the finery and exquisite lace collars and cuffs that signify their affluence. The sitters make direct eye contact with the viewer, thereby lending the portraits a sense of engagement and immediacy. The uncompromisingly upright, immaculately attired woman rests her arm on a chair and carefully displays what is probably a small book of psalms, a sign of educated piety. Her sumptuous black costume is accented by a yellow damask stomacher and a dark aubergine underskirt. Contrasting with her somewhat rigid aspect, her companion's animated features and the unconstricted space he occupies suggest a more expansive personality. As in many paired portraits of the period, the man seems more spontaneous and mobile and is depicted more boldly than the woman.

The linear clarity and meticulous detail with which Victors treated the jewelry and lace of the costumes recall Rembrandt's society portraits of the 1630s. Although Victors's training is undocumented, he has long been associated with the circle of Rembrandt in Amsterdam. His paintings share many stylistic and thematic connections with Rembrandt and Rembrandt's documented pupils of the 1630s, such as Govaert Flinck, Ferdinand Bol, and Gerbrandt van den Eeckhout. After the mid–1650s, Victors became less prolific and suffered increasingly from financial difficulties. He eventually abandoned painting to become a *ziekentrooster* (comforter of the sick) in the service of the Dutch East India Company. He reportedly died in the East Indies in 1676 or shortly thereafter of unknown causes. LW

Jan Victors (Dutch, 1619–ca. 1676–77). *Portrait of a Gentleman*, 1650. *Portrait of a Lady*, 1650. Oil on canvas. 38 x 32 1/2 inches each. Gift of Mrs. William D. Vogel (M1979.1, 2).

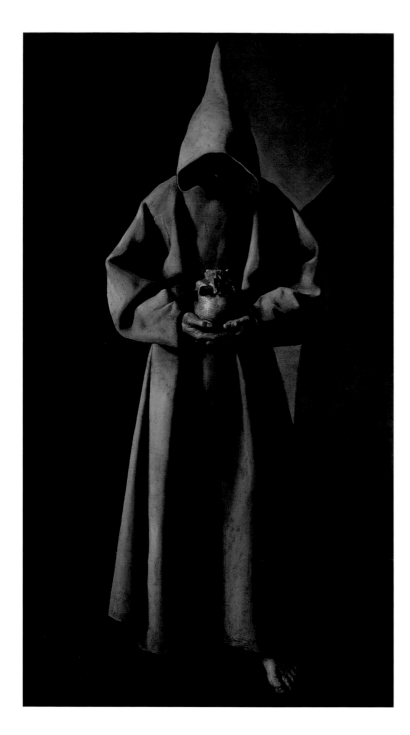

Francisco de Zurbarán
Saint Francis of Assisi in His Tomb, ca. 1630–34

Francisco de Zurbarán was one of the greatest painters of the Golden Age in Spain. He worked primarily for the monastic orders that flourished in Spain during the Counter-Reformation. His best-known paintings are of humble monks and saints dramatically lit against simple dark backgrounds, as in this hauntingly beautiful work *Saint Francis of Assisi in His Tomb*. As the founder of the Franciscan Order, the ascetic saint had a special resonance in Spain's monastic communities and with the reform movement of the Catholic Church. Zurbarán's many paintings of the subject are notable for their quiet evocation of monastic solitude and contemplation.

This strangely austere and somber Saint Francis was inspired by a legend that became popular in the seventeenth century. The uncorrupted, motionless body of the saint miraculously appeared above his coffin when Pope Nicholas V visited the burial crypt in the church at Assisi in 1449. Zurbarán's powerful portrayal concentrates solely on the single figure of the saint, who stands before us full-length, life-size, and dressed in the coarse wool garments worn by the Franciscan monks. A high, peaked cowl casts his face into darkness and focuses our attention on the saint's meditative state and on the golden skull he clutches to his chest—the object of his intense contemplation. A strong shaft of light pierces the darkness and imbues the figure with a mystical presence. His hands, feet, and chest exhibit the stigmata—the five wounds of Christ's Passion—symbolizing the hope of Resurrection. Few Baroque works so poignantly address the ultimate questions of reality and illusion, substance and shadow, life and death. LW

Francisco de Zurbarán (Spanish, 1598–1664). *Saint Francis of Assisi in His Tomb*, ca. 1630–34. Oil on canvas. 80 3/4 x 44 5/8 inches. Purchase (M1958.70).

Philippe de Champaigne
Moses Presenting the Tablets of the Law, 1648

Consummate skill of execution, attention to a literal truth, and an underlying sense of devout spirituality made Philippe de Champaigne one of the most important artists of the seventeenth century. Born and trained in Brussels, he moved to Paris at the age of nineteen and began a prolific, forty-year career. Dividing his efforts equally between portraiture and religious painting, Champaigne received important commissions from Cardinal Richelieu, Louis XIII, Anne of Austria, the Catholic Church, and numerous members of the administrative classes. Always disciplined and moral, Champaigne was drawn increasingly after 1642 towards Jansenism, a strict Catholic reform movement. The severe realism, restrained color, and austerity of his mature work have often been connected to its ascetic influence.

Moses Presenting the Tablets of the Law was commissioned in 1648 by Pompone II de Bellièvre, a French legislator, who went on to become Premier Président of the Parlement of Paris. He specified the subject of Moses transmitting God's code of law to the Israelites. It was painted during a time of political turmoil, and Champaigne emphasized the relevance of the law's message by presenting the Ten Commandments in French, the language of the people, rather than in the traditional Latin. With characteristic concern for accuracy, he arranged the commandments in the order recommended by contemporary theologians and on tablets whose rectangular shape was considered authentic. Champaigne's powerful naturalism, depicting each wrinkle and dirty fingernail as faithfully as the texture of velvet, conveys the humble fervor of the prophet. The juxtaposition of flesh and carved stone eloquently contrasts human frailty with sacred law in this poignant image of private devotion. LW

Philippe de Champaigne (French, 1602–1674). *Moses Presenting the Tablets of the Law*, 1648. Oil on canvas. 35 1/5 x 29 1/2 inches. Gift of Mr. and Mrs. Myron Laskin, Sr. (M1964.121).

Giovanni Benedetto Castiglione
Noah and the Animals Entering the Ark, ca. 1650

Born in the bustling port city of Genoa, Giovanni Benedetto Castiglione demonstrated his artistic talents at an early age. Studying in the studio of Giovanni Battista Paggi as early as 1626, he excelled at landscapes, animal paintings, and still lifes, which appear frequently in his work and reveal the influence of Northern European painters such as Jan Brueghel the Elder and Anthony van Dyck, who worked briefly in Genoa. Traveling throughout Italy, Castiglione developed an eclectic style that combined Northern European and Italian Baroque characteristics. He favored warm, atmospheric tones punctuated with vibrant blues, greens, reds, and white. In later works, evident for example in the background of *Noah and the Animals Entering the Ark*, his brush strokes became looser without compromising his trademark attention to detail.

Castiglione was drawn to uncommon secular and religious subjects, including the journeys of Old Testament patriarchs. In *Noah and the Animals Entering the Ark*, the emphasis is on the beginning of the journey: the ark all but disappears into the mountainous landscape, while a diverse array of creatures are featured in the foreground. Two-by-two, animals gather as they await sanctuary within the vessel, indicated by the outstretched hand of the figure on the left, presumably a son of Noah, the hunched figure on the right. Ranging from domestic cows and canines to more exotic parrots and guinea pigs, the creatures are painted with astounding accuracy, revealing Castiglione's encyclopedic knowledge and sheer delight in portraying the animal kingdom. Narrative cues characteristic of the Italian Baroque— the stormy sky, dramatic lighting, swirling lines, and tight composition—create an overall sense of foreboding. JVC

Giovanni Benedetto Castiglione (Italian, 1609–1665). *Noah and the Animals Entering the Ark*, ca. 1650. Oil on canvas. 47 1/2 x 111 inches. Centennial Gift of Friends of Art, Myron and Elizabeth P. Laskin Fund, Fine Arts Society, Friends of Art Board of Directors, Francis and Rose Mary Matusinec, Burton and Charlotte Zucker, and the Milwaukee Community (M1988.182).

Francesco Solimena
Madonna and Child with St. Januarius and St. Sebastian, ca. 1700

One of the greatest and most prolific painters of the Late Baroque age, Francesco Solimena dominated Neapolitan artistic life in the first half of the eighteenth century with a vast array of works ranging from frescoes and altarpieces to mythological paintings and portraits. His altarpiece *Madonna and Child with St. Januarius and St. Sebastian*, produced at the height of his career, is a superb example of the extravagance and splendor associated with Italian painting of this period. Solimena created a highly personal synthesis of naturalism and dramatic elegance that won him international attention. He was the most celebrated painter in Italy until the emergence of Giovanni Battista Tiepolo. Gifted also as a teacher, Solimena operated a large studio that attracted the best painters of the next generation.

Solimena's altarpiece is typical of the Late Baroque's emphasis on large-scale propaganda pieces that illustrate Roman Catholic subjects in grandiose, epic terms. Probably intended for a church in Naples, a city frequently smitten by plague epidemics, the altarpiece shows the nearly life-size saints Januarius (patron saint of Naples) and Sebastian (protector of the plague-stricken) pleading to the Madonna and Child for divine protection. The rhetorical gestures and the adoring glances of the saints create a sweeping, upward movement that culminates in the figures of the Madonna and Child and in the surrounding golden atmosphere. A languorous warmth pervades and slows the composition. Such grand and theatrical depictions were highly prized in an age when the purpose of religious art was to arouse wonder and intense devotion in the spectator. LW

Francesco Solimena (Italian, 1657–1747). *Madonna and Child with St. Januarius and St. Sebastian*, ca. 1700. Oil on canvas. 99 3/4 x 69 1/4 inches. Gift of Friends of Art (M1964.35).

Jean-Honoré Fragonard
The Shepherdess, ca. 1750–52

Jean-Honoré Fragonard was the quintessential artist of the Rococo. Over the course of four decades, he produced a variety of works, including highly acclaimed public history paintings, but he preferred to paint easel-sized pictures with light-hearted subjects for a private clientele. This captivating picture is a masterpiece of his early career, produced during a period when he painted in a style still in the spirit of his master, François Boucher. Although many of the hallmarks of Boucher's decorative pastoral style are present—a highly keyed color scheme, an oval composition revolving around a dominant figure, and (not least) a frivolously amorous subject—Fragonard's distinct personality has already emerged in the spontaneous brushwork and the uninhibited approach toward feminine beauty.

The Rococo taste for frivolity and gallantry is vividly illustrated in the subject of an alluring shepherdess shown awaiting her lover, a youthful shepherd who makes his way through the lush landscape with a lost lamb. The fertile bounties of nature are demonstrated by the basket of brightly colored flowers and the garland of roses the shepherdess holds in her right hand. The fecund pastoral setting would have been readily understood in the eighteenth century as the clandestine backdrop for the passions of youthful courtship. The unshod feet of the shepherdess and the birdcage beside her, both traditional symbols for lust in the emblematic literature of the period, further underscore the theme of an amorous encounter. The eroticized undercurrent that characterizes this picture and much genre painting of the mid-eighteenth century was well suited to the intimate domestic interiors of the Parisian aristocracy and sophisticated private collectors. LW

Jean-Honoré Fragonard (French, 1732–1806). *The Shepherdess*, ca. 1750–52. Oil on canvas. 46 3/4 x 63 5/8 inches. Bequest of Leon and Marion Kaumheimer (M1974.64).

Jan van Os
Flowers in a Terra-cotta Vase, after 1780

Flowers in a Terra-cotta Vase testifies to Jan van Os's stature as one of the most accomplished still-life painters of the eighteenth century. Over twenty types of flowers and a wide variety of insects have been brought together in a harmonious and opulent arrangement of colors and shapes. Despite the realistic depiction, this arrangement could never actually have existed, because the flowers depicted bloom at different times of the year. Like most still-life painters, van Os relied on a personal collection of watercolor drawings to use as models when particular plants were out of season. His consummate technique allowed him to portray a great variety of textures in a convincing manner. In keeping with Rococo decorative tastes, this bouquet is an expression of sheer ornamental delight with none of the dark, moralizing allusions to the transience of life and beauty commonly found in flower paintings of the previous century.

Van Os is best known for his large, asymmetrically composed still lifes in the manner of Jan van Huysum (1682–1749). The stone ledge, the lush arrangement in a terracotta vase, the pale green landscape background, and even the "carved" signature of the artist are common to both artists. Van Os ultimately distinguished his paintings by intensifying the floral spirals and employing a higher-keyed Rococo palette. He acquired an international reputation and exhibited regularly in London at the Society of Arts from 1773 to 1791. To meet the demands of his market, he varied his paintings little after 1770 and dated them only rarely, making it difficult to establish a proper chronology for his work. LW

Jan van Os (Dutch, 1744–1808). *Flowers in a Terra-cotta Vase*, after 1780. Oil on wood panel. 35 1/2 x 27 5/8 inches. Layton Art Collection, Gift of Frederick Layton (L111).

English, Staffordshire
Teapot, ca. 1745

Chinese porcelain and its first European imitation, tin-glazed earthenware or "delft," were available throughout England and the Continent by 1700. To remain competitive, Staffordshire's traditional potteries began developing a diverse range of thin, refined earthenwares and stonewares. Many of their most intriguing early products, like this agate-figured teapot, were extremely short-lived; by 1760 the move toward industrialization led by Josiah Wedgwood was well underway, and such labor-intensive wares were abandoned.

While agate-figured ware resembles pottery decorated with marbled slip—a Staffordshire tradition—the technique is more similar to making marbled paper. Batches of colored clay are partially combined, then thinly rolled out and pressed into multipart molds. This teapot dates from the first period after plaster molds were introduced, a development that encouraged eccentric forms and Baroque juxtapositions. Here a shell-shaped body, dolphin handle, and swan's neck spout are capped by a conventionalized, doglike lion derived from Chinese prototypes. The result is an exotic fantasy, evoking a mythical land whose inhabitants, surrounded by fabulous beasts, drink tea from shells. China itself was the locus of such fantasies for many eighteenth-century Europeans, who imagined Cathay as a tantalizing alien paradise. JC

English, Staffordshire. *Teapot*, ca. 1745. Lead-glazed earthenware. 5 7/8 x 7 x 3 5/8 inches. Given in memory of Elizabeth Mann Brown by her family and friends, in memory of Anita C. Kyle by her daughter, Ann Kyle Kuehn, and in memory of Mr. and Mrs. Dudley James Godfrey by Mr. and Mrs. Dudley James Godfrey, Jr. (M1989.114a,b).

Francis Cotes
Miss Frances Lee, 1769

Francis Cotes's fame as a portrait painter in eighteenth-century England was surpassed only by that of Sir Joshua Reynolds and Thomas Gainsborough. Working primarily in pastels until the end of the 1750s, he gradually turned to oils and by the 1760s was the most fashionable portrait painter in London. He was also instrumental in setting up the British Society of Artists and the Royal Academy in 1768. Although Cotes achieved his greatest success with polished society portraits that emphasize decorative detail and elaborate draperies, he was at his best in more intimate portraits like *Miss Frances Lee*. Particularly successful are his portraits of children, who appear relaxed and unaffected as they grasp a favorite toy or possession.

Frances Lee, the daughter of Robert Cooper Lee of London, kneels quietly but alertly on the seat of a chair, engaging the viewer with her direct, innocent gaze. In her right hand she holds a handkerchief tied in a knot to look like a rabbit. The blended harmonies of pinks, whites, and creams in her dress and skin tones evoke the sweetness of Frances and of all little girls her age. Cascading green drapery on the left provides a strong counterpoint of color and creates a dynamic yet balanced backdrop for the young subject. As recent conservation of this portrait has revealed, Cotes was not only a brilliant colorist, but was also capable of extraordinary, almost impressionistic brushwork, as seen in the contrasting textures and tonalities of the ornamental lace and the shimmering folds of the silk dress. The complete assurance in the handling of this portrait superbly captures the young sitter's forthright and lively character. LW

Francis Cotes (English, 1726–1770). *Miss Frances Lee*, 1769. Oil on canvas. 36 x 28 1/2 inches. Gift of Mr. and Mrs. William D. Vogel (M1964.5).

Nineteenth-Century European Painting, Sculpture, and Decorative Arts

The Milwaukee Art Museum's collection of nineteenth-century European painting and sculpture contains outstanding examples from almost every period and movement and is a major component in the museum's educational programming. The nucleus of the collection was created with the establishment of the Layton Art Gallery in 1888 and through subsequent gifts provided by the Layton Foundation in the early twentieth century. Arriving in Milwaukee as a poor immigrant in 1843, the

English-born Layton made his fortune in the meat packing and export trade, which required frequent trips abroad. There his interest in art and collecting was stimulated by his British agent, Samuel Page, whose home boasted a gallery of contemporary art. Page introduced Layton to the world of art museums, exhibitions, auctions, galleries, and dealers. In 1883, grateful for the prosperity he felt he owed to his adopted country, Layton crowned his reputation for philanthropy by promising Milwaukee an art gallery.

When the Layton Art Gallery opened in 1888, thirty-eight of the sixty-five paintings on view had been donated by Layton, the rest by his friends and associates. Included in his original gift and subsequent donations are such favorites as Bouguereau's *Homer and His Guide*, Jan van Os's *Flowers in a Terra-cotta Vase*, and Bastien-Lepage's *The Wood Gatherer*. Layton wished to give the public a representative range of contemporary European and American art, avoiding what he viewed as the more extravagant and controversial examples of Impressionism. Conforming on the whole to the standards of academic realism that dominated the art establishment of the 1880s, his collection reflects his preference for craftsmanship, for the beauties of natural landscape, and for human interest expressed in narrative and anecdotal paintings.

The Layton works were complemented in the 1950s and 1960s by an important Courbet and a small group of Impressionist works, including the outstanding Monet and Caillebotte, gifts respectively of Mrs. Albert T. Friedmann in 1950 and the Milwaukee Journal Company in 1965. Rodin's celebrated *Kiss* entered the museum in 1966, representing the kind of patronage that has also been an intrinsic part of the museum's development: a gift from an individual with a few fine works who decided to share them for posterity.

In 1976 René von Schleinitz significantly expanded the overall range of the nineteenth-century collection with his donation of over 100 paintings by such artists as Grützner, Spitzweg, and Waldmüller, making Milwaukee a world center for Munich School painting. His gift also included an outstanding collection of German beer steins, which he assembled as a memorial to the German cultural influence in his native Milwaukee. The René von Schleinitz Memorial Fund has continued to provide funds for the acquisition of nineteenth-century German artwork; it is hoped that one day the Milwaukee Art Museum will become a world center not only for Munich School painting, but for all nineteenth- and early twentieth-century German art. LW

Edwin Landseer
Portrait of a Terrier, The Property of Owen Williams, ESQ., M.P. (Jocko with a Hedgehog), 1828

Sir Edwin Landseer was the most popular animal and sporting painter of the nineteenth century. Precociously gifted, he achieved instant professional success in his teens and was a full Academician before he was thirty. Much of Landseer's fame rested on his ability to invest his animals with anthropomorphic qualities—a characteristic that went beyond traditional animal painting and appealed enormously to English sentimental taste. His charming good looks enhanced his popularity and contributed to his favor with such preeminent patrons as Charles Dickens, Prince Albert, and Queen Victoria. Landseer preferred dogs as subjects and often depicted them in animated scenes of devotion and heroism. His many dog paintings of the late 1820s and 1830s constitute one of the high points of his career and form a coherent group of work by virtue of their subject matter and narrative invention.

Commissioned by Owen Williams, of Temple House, Bucks, a landowner and member of Parliament, *Jocko with a Hedgehog* ranks among Landseer's finest portraits. Landseer consciously posed the fox terrier Jocko, eagerly assessing the bristling hedgehog and wisely waiting for his moment of attack, as a way of revealing the dog's judicious and controlled personality. His gleaming white body stands out against the grayish-brown rocks and further establishes his commanding presence in the picture. The threatening landscape beyond may represent Loch Laggan, Scotland, a favorite retreat of the artist that appears frequently in his landscapes after the mid–1820s. The vibrant color contrasts and heightened drama of the encounter pitch the work in a high key characteristic of the Romantic period. LW

Edwin Landseer (English, 1802–1873). *Portrait of a Terrier, The Property of Owen Williams, ESQ., M.P. (Jocko with a Hedgehog)*, 1828. Oil on canvas. 39 5/16 x 49 3/16 inches. Gift of Erwin C. Uihlein (M1967.79).

Christopher Dresser
"Crow's Foot" Claret Jug, designed 1878

At a time when many viewed industry as a threat to art and craftsmanship, Christopher Dresser was a passionate advocate of art applied to mass production. Dresser was Britain's leading industrial designer by the 1860s, and while his designs were inspired by nature and the art of the past, he saw machine production as a tool for improving ordinary people's lives. Calling himself an "art workman," he embraced inexpensive materials like cast iron, silver-plate, and wallpaper.

Dresser's graphic style, with its subtle color harmonies and rigorously structured ornament, was immensely influential. But he was also celebrated for eccentric designs like this claret jug, a complex formal essay enhanced by bright,

undecorated surfaces. This startling vessel combines historicist references with Dresser's droll zoomorphism and gift for organic form. The jug's birdlike feet and amphora shape are drawn from ancient Egyptian ceramics and glass; the flat lid, compact spout, emphatic rivets, and belt come from early Japanese metalwork. In its clarity and economy, however, Dresser's design seems strikingly modern. Furthermore, he concerned himself with use as much as beauty. The jug's handle is well balanced, the feet offer stability, the wide mouth facilitates refilling and cleaning. Even the peculiar suspended form has a kind of function: by hanging clear glass in mid-air, Dresser allowed as much light as possible to shine through a good red claret. JC

Christopher Dresser (English, 1834–1904). *"Crow's Foot" Claret Jug*, designed 1878. Produced by Hukin & Heath, Birmingham, England. Silver-plate and glass. 9 5/16 x 6 1/2 x 4 1/4 inches. Purchase, by exchange (M1998.75).

Joseph Anton Koch
Landscape with Ruth and Boaz, ca. 1823–25

Joseph Anton Koch was one of the great landscape painters of the nineteenth century and a key figure in the revitalization of German art. While he worked in the Neoclassical tradition inspired by the ordered, idealized landscapes of the French painters Claude Lorrain and Nicolas Poussin, his art also reveals a sympathy for the emerging Romantic movement. Familiar with the writings of the German philosophers Immanuel Kant and Friedrich Schiller, Koch adapted the concept of the sublime and his own interest in empiricism to a "heroic" style of landscape painting that placed human figures in a vast, majestic landscape. His work influenced the subsequent generation of German artists who came to Rome and derived enlightenment from his inspiring paintings.

Koch came in 1795 to Rome where he remained for most of his life. There the painter Jakob Astens Carstens encouraged him to study the human form and classical and biblical liter-ature, including the story of Ruth and Boaz, a tale of love and family devotion (Ruth 1:4–4:13). Upon her husband's death, Ruth remained with her mother-in-law, Naomi, who returned to her homeland, Bethlehem. There, while glean-ing barley and wheat in his fields, Ruth met Naomi's kins-man Boaz, whom she would later marry.

Inspired by Poussin's *Ruth and Boaz*, also called *Summer*, Koch first painted the Old Testament subject in 1803, revisiting it numerous times and producing four oils and nearly a dozen drawings and watercolors. The Milwaukee painting is based on the 1803 composition and shows a humble Ruth on her knees before Boaz while other workers continue their activi-ties. Koch's attention to minute detail, such as the individ-ual grains of wheat, the varied and well-articulated vegeta-tion, and the texture of human and animal hair, all work together to create a rich and beautiful version of this theme. JVC

Joseph Anton Koch (Austrian, 1768–1839). *Landscape with Ruth and Boaz*, ca. 1823–25. Oil on canvas. 33 1/4 x 43 1/4 inches.
Purchase, René von Schleinitz Memorial Fund, by exchange (M1999.117).

Carl Spitzweg
Scholar of Natural Sciences, ca. 1865–70

The *Scholar of Natural Sciences* is one of the finest and most important works by the German genre painter Carl Spitzweg. Initially trained as a pharmacist in Munich, Spitzweg decided to become a painter after receiving a large legacy that guaranteed his financial security. With no professional training as a painter and perhaps feeling that he was too old to begin formal instruction, he resolved to teach himself by studying the Dutch Old Masters. At first neglected and ridiculed by the art community, he gradually achieved both financial and critical success, becoming one of the foremost painters of the Munich School. Spitzweg's works were admired for their mildly ironic and humorous themes that echo contemporary middle-class values, their mastery of light effects, and their diminutive scale—often no bigger than the tops of the cigar boxes he occasionally used as painting surfaces.

The subject of this painting evokes a harmonious, fairytale world that has eluded precise interpretation. Bizarre and unusual objects draw the viewer into the narrative and suggest multiple layers of possible meaning. One interpretation has connected the objects to the various branches of learning and research, such as botany (the exotic palms), geography (the globe), anthropology (the skeletons), ornithology (the eagle), history (the mummy coffin), zoology (the crocodile), and so on throughout the picture. The painting may also be self-referential. As a pharmacist, Spitzweg knew that at one time apothecaries used both mummies and crocodiles for curative powders and that mummy coffins and stuffed crocodile skins were often displayed in apothecary shops to awe and mystify patrons. Spitzweg made about twenty such pictures, an interest that may mirror the larger, emerging popular fascination with the sciences. LW

Carl Spitzweg (German, 1808–1885). *Scholar of Natural Sciences*, ca. 1865–70. Oil on paper mounted on canvas. 22 1/2 x 13 1/2 inches. Gift of the René von Schleinitz Foundation (M1962.136).

Gustave Courbet
Clément Laurier, 1855

"Show me an angel and I'll paint one." With statements such as this, Gustave Courbet became the spokesman for the French Realists, a radical group of artists and writers—including Daumier, Millet, Balzac, and Flaubert—that emerged at mid-century. Championing the ordinary and the real, Courbet rejected mythological, religious, and historical themes in favor of subjects drawn from contemporary life, including those usually considered ugly or vulgar. His paintings often focused on the people and places around his native Ornans in southwestern France, and included such harsh themes as peasants, family funerals, and the rocky terrain of the Jura Mountains. Courbet's outspoken rejection of academicism and the state patronage system made him one of the century's most influential figures in the development of Modernism.

The portrait *Clément Laurier* displays all the stylistic forthrightness typically associated with Courbet's mature paintings. Dated 1855, the portrait is dedicated with an inscription: "A mon ami Laurier, Gustave Courbet" and depicts the young attorney Laurier at the age of twenty-four. Laurier was a specialist in public finance, a Republican, and a socialist sympathizer, which put him in the middle of the artist's politically active milieu. Courbet posed the jurist in front of a loosely brushed dark landscape that evokes a rocky terrain beneath a dramatic sky, the bleak setting heightening the sitter's somber attitude. His broad forehead, deep-set eyes, and vulpine features convey a certain intransigence, which is reinforced by the gesture of the gloved hand thrust into his pocket. Laurier held a number of public offices in later life, and was frequently accused of shifting his loyalties and ideological positions; one critic labeled him the "Machiavelli of our time." LW

Gustave Courbet (French, 1819–1877). *Clément Laurier*, 1855. Oil on canvas. 39 3/4 x 31 3/4 inches. Gift of Friends of Art (M1968.31).

Jules Bastien-Lepage
Le Père Jacques (Woodgatherer), 1881

Not long before his death, Jules Bastien-Lepage stated his ambition to an English journalist: "I wish to represent genuine country life in all its phases," he declared. "The public in Paris are accustomed to an opera comique representation of it." The desire to paint a comprehensive record of life in the countryside originated in 1876 when, after his second failed attempt at the Prix de Rome, he decided to concentrate on the life of the peasant farmers in his native village of Damvillers in the Meuse. In doing so, he transformed the harsh, politicized themes of Courbet and Millet into large-scale peasant pictures of intense naturalism, occupied with the factual rendering of outdoor light and detail. By the early 1880s, Bastien-Lepage had become the leader of the Naturalist school, and many of his contemporaries believed that he would one day succeed Manet as the leader of modern painting.

The Wood Gatherer, painted for the Salon of 1882, is one of Bastien-Lepage's most important works. The old woodsman, a family friend, and his granddaughter represent the innocence of youth and the heavy weariness of old age, as well as the passage of time. The remarkable color and handling of paint reflect Bastien-Lepage's unique ability to blend the greater luminosity and atmosphere of the Impressionists with the more conservative, precisionist technique of the Academicians. The single, dominant figure surrounded by a graceful layering of forms and the subtle gradations of texture are typical of Bastien-Lepage's compositions and his larger concern for creating convincing spatial recession. LW

Jules Bastien-Lepage (French 1848–1884). *Le Père Jacques (Woodgatherer)*, 1881. Oil on canvas. 77 1/2 x 71 1/2 inches. Layton Art Collection, Gift of Mrs. E.P. Allis and her Daughters in Memory of Edward Phelps Allis (L102).

William-Adolphe Bouguereau
Homer and His Guide, 1874

This outstanding painting, *Homer and His Guide*, illustrates why William-Adolphe Bouguereau was the most famous French academic painter of the later nineteenth century. Trained in the tradition of David and Ingres, he perpetuated with slight modification the Neoclassicism of his predecessors and became one of the century's leading proponents of French academic teaching. Best remembered today for his sentimental, often eroticized scenes of women and children, Bouguereau began his career as a painter of religious and mythological subjects and many of his most important and successful works are in these genres. His emphasis on high technical finish, lofty narrative content, and a reliance on tradition made his work extremely popular with the bourgeoisie and conservative critics. He was one of the wealthiest and most sought-after artists of his time.

The subject of this painting is based on a poem by André Chénier in which the blind Homer's desperate prayer for a guide is overheard by three shepherds who come to his rescue. As a staunch supporter of academic painting at a time when it was increasingly challenged by adherents of more progressive painting, Bouguereau may have identified with Chénier's own reliance on the ancients as models of integrity. The greatest French poet of the eighteenth century, Chénier is credited with the revitalization of French poetry through his knowledge of the Greek lyric poets. Viewed in this context, the noble solemnity of the aged Homer and the stately drama of the encounter constitute a moving tribute to the most celebrated poet of antiquity and an ideological demonstration of academicism. *Homer and His Guide* was exhibited at the Salon of 1874, just one year after the Impressionists made their independent debut at the *Salon des Refusés*. LW

William-Adolphe Bouguereau (French, 1825–1905). *Homer and His Guide*, 1874. Oil on canvas. 82 1/2 x 56 1/4 inches. Layton Art Collection, Gift of Frederick Layton (L1888.5).

Jean-Léon Gérôme
The Two Majesties (Les Deux Majestés), ca. 1882–83

A highly esteemed Salon painter and respected professor at the Ecole des Beaux-Arts, Jean-Léon Gérôme embodied the artistic establishment of late nineteenth-century Paris. He began his long career as a successful master of the Néo-Grec school of classicism, but soon expanded his range to include traditional history paintings, sculpture, and, as a result of his extensive travels, Orientalist subjects. Following Napoleon's invasion of Egypt in 1798, the seemingly exotic cultures of North Africa and the Near East became a source of inspiration for European writers and artists throughout the following century. Like Delacroix and Chassériau before him, Gérôme recorded with the zeal of an ethnographer the daily life and customs of the people and places he saw on his many travels. By the early 1870s he had become the leading Orientalist painter of his generation.

Identified as "the epitome of Gérôme's lion heroes," *The Two Majesties* is one in a series of lion paintings done late in the artist's career after he had traveled extensively in the Egyptian desert. Gérôme demonstrated a special affinity for animals from the beginning of his career, but most of his cat paintings date from the 1880s when he focused on lions— usually heroic single males stalking, hunting, resting, and occasionally playing. *The Two Majesties* is remarkable for its quiet solemnity. A huge, solitary lion, the king of the beasts, gazes across the seemingly endless desert terrain at the majestic setting sun, thus explaining the romantic title. The eerie grandeur is dramatized by the single vertical element of the lion's profile against the horizontal planes of the desert. Characteristic of Gérôme's fidelity to academic principles is a precision of detail and a meticulous smoothness of surface. LW

Jean-Léon Gérôme (French, 1824–1904). *The Two Majesties (Les Deux Majestés)*, ca. 1882–83. Oil on canvas. 27 1/4 x 50 3/4 inches.
Layton Art Collection, Gift of Louis Allis (L1968.82).

Gustave Caillebotte
Boating on the Yerres (Périssoires sur l'Yerres), 1877

The French Impressionists were a diverse group of artists who regarded themselves as the ultimate realists of the nineteenth century. They chose subjects from contemporary life and painted them with a special attention to the ephemeral effects of light and atmosphere. As an art student, Gustave Caillebotte became associated with Monet and Degas, and from the mid–1870s onwards he became one of the most steadfast, inventive, and supportive adherents of the Impressionist movement, exhibiting regularly with them thereafter. Among his most impressive paintings are a series of seven boating scenes painted in 1877 and 1878 at his family estate along the Yerres River. Caillebotte's subject matter surely reflects the influence of Manet, Monet, and Renoir, but he also maintained a lifelong personal passion for boating, and in the 1880s he designed, built, and raced his own vessels.

Boating on the Yerres is one of the earliest and largest of Caillebotte's boating scenes. It depicts a group of sleek, one-man skiffs, known as *périssoires*, gliding through the quiet waters of the Yerres River. Almost two-thirds of the canvas is given over to the water, which is painted in a broad pattern of brightly colored horizontal brush strokes. The verticals of the three trees and their reflections help to stabilize the horizontal thrust of the composition and to create an intellectually adjusted network of horizontals, verticals, and diagonals. The viewer's perception of the scene thus alternates between a broadly rectilinear surface pattern and the illusion of a fairly deep space receding along the shoreline. This kind of subtly calculated interplay between surface and depth is characteristic of Caillebotte's finest paintings. *Boating on the Yerres* has been featured in every major exhibition on the artist since the late nineteenth century. LW

Gustave Caillebotte (French, 1848–1894). *Boating on the Yerres (Périssoires sur l'Yerres)*, 1877. Oil on canvas. 40 3/4 x 61 3/8 inches. Gift of the Milwaukee Journal Company in Honor of Miss Faye McBeath (M1965.25).

Auguste Rodin
The Kiss (Paolo and Francesca), 1886

One of the greatest sculptors of all times, Auguste Rodin was born in Paris in 1840. His most productive period, 1880–1900, coincided with Impressionism and Post-Impressionism in painting—avant-garde styles and aesthetic attitudes that dramatically impacted his own art, often considered a brilliant translation of the direct observation and spontaneity of Impressionist painting into three dimensions. Like Renoir and Monet, Rodin worked from life, not from plaster casts or stationary models, as did the academic sculptors. He preferred the natural poses of untrained models and the rough surfaces of "hollows and lumps" that allowed him to capture the pulsating effects of light. Often compared to Michelangelo, Rodin demonstrated a virtuoso ability to create expression beyond formal perfection.

The Kiss illustrates the story of Francesca da Rimini and her husband's brother, Paolo Malatesta, two star-crossed lovers condemned to Dante's hell for their forbidden passion. The sculpture suggests the gentle tentativeness of a first kiss, as well as exploring the solids and voids created by the spiraling embrace of the nude bodies. The subject of *The Kiss* emerged from Rodin's most ambitious project, *The Gates of Hell*, which was commissioned in 1880 by the French government to serve as the entrance to a proposed museum of decorative arts. Inspired by Dante's *Inferno*, Rodin planned the monumental bronze portal as an image of humanity fated to exist throughout eternity without hope and forever enslaved to passion. The project—cast only posthumously—provided Rodin with the genesis for many of his most famous independent sculptures: *The Kiss, The Thinker, The Three Shades,* and *The Crouching Woman.* LW

Auguste Rodin (French, 1840–1917). *The Kiss (Paolo and Francesca),* 1886. Painted plaster, cast from clay original. 34 x 20 1/2 x 23 1/4 inches. Gift of Mrs. Will Ross in Memory of Her Husband (M1966.117).

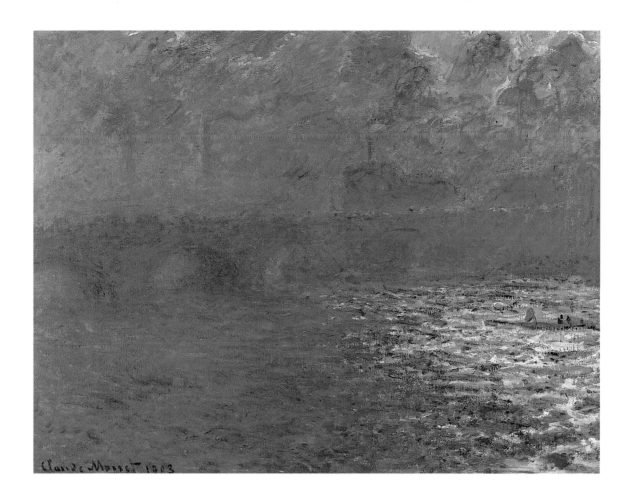

Claude Monet
Waterloo Bridge, Sunlight Effect (Waterloo Bridge, Effet de Soleil), ca. 1900

Claude Monet, regarded as the leader of the Impressionist movement, was the most original and influential painter of the late nineteenth century. He produced a variety of landscapes and outdoor scenes that explore the transitory effects of light and color under varying atmospheric and diurnal conditions. The magnificent *Waterloo Bridge, Sunlight Effect* belongs to Monet's later career, when he focused increasingly on series of canvases devoted to a single motif. These so-called serial paintings—*The Grainstacks, Poplars on the Epte, Rouen Cathedral, Views of the Thames,* among others—allowed Monet to study the ways in which light, air, and weather transform visual appearance. Monet himself commented in 1895: "The motif is insignificant for me: what I want to reproduce is what lies between the motif and me."

For his *Views of the Thames,* Monet painted an amazing ninety-five canvases during the winter months in London between 1899 and 1901. He concentrated his efforts on three separate motifs—Waterloo Bridge, Charing Cross Bridge, and the Houses of Parliament—but his subject was not, strictly speaking, the river or the bridges, but the intangible effects created by the dense fog as it mingled with plumes of smoke from the nearby industrial furnaces. Painting from the balcony of his room at the Savoy Hotel, Monet worked rapidly and at times with great frustration as he attempted to transcribe the constantly shifting effects of light and atmosphere that appeared before him. Although the paintings are similar in size and composition, the Milwaukee picture is distinguished by its bold contrasts of illumination and tonality and by its variegated skin of colored layers and forceful, broken brushwork. This painting was among thirty-seven canvases Monet selected for special exhibition at the Durand-Ruel gallery in Paris in 1904; it was signed and dated 1903 in anticipation of that event. LW

Claude Monet (French, 1840–1926). *Waterloo Bridge, Sunlight Effect (Waterloo Bridge, Effet de Soleil),* ca. 1900 (dated 1903). Oil on canvas. 29 1/16 x 36 5/8 inches. Bequest of Mrs. Albert T. Friedmann (M1950.3).

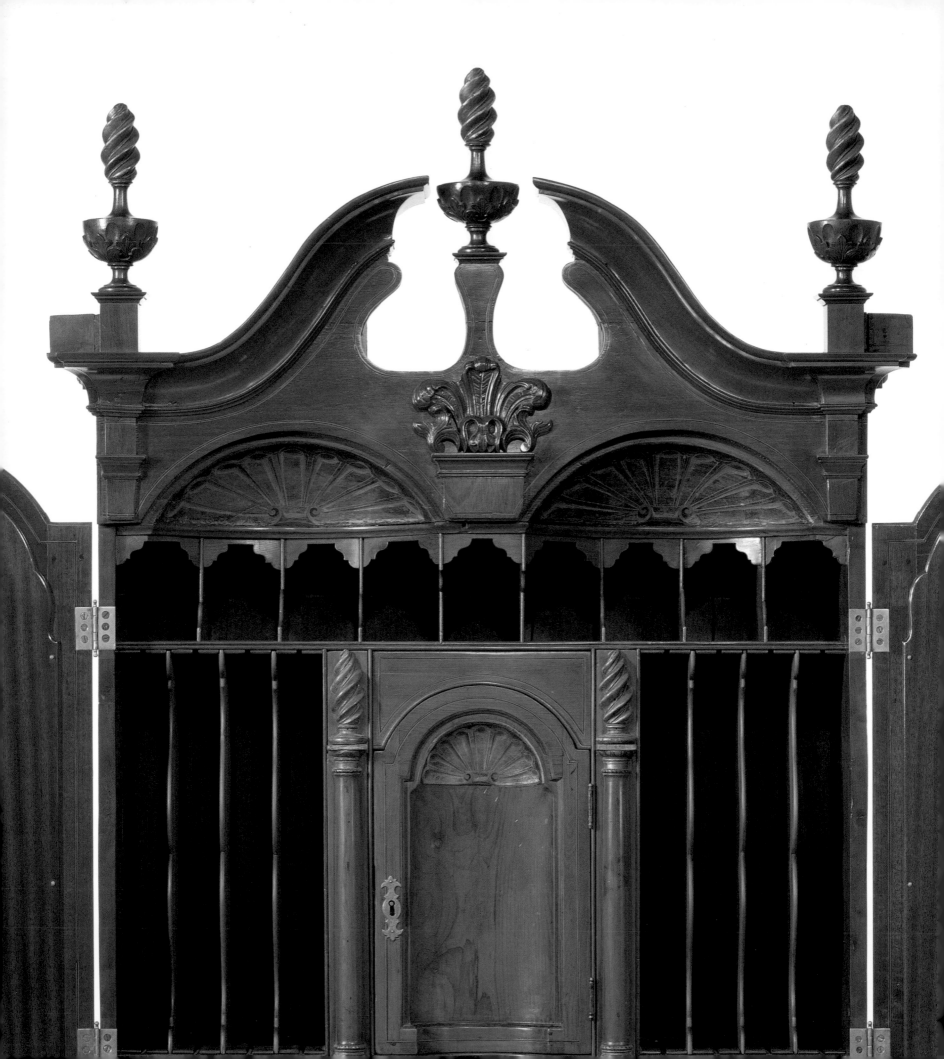

Eighteenth- and Nineteenth-Century American Painting, Sculpture, and Decorative Arts

The American art collection has its roots in the Layton Art Gallery, one of the museum's founding institutions. Eastman Johnson's portrait of Frederick Layton himself is among the highlights of the collection, and Layton's acquisition of works by Homer, Church, Durand, and Kensett in the 1880s encouraged important early gifts of paintings by Vedder, Tarbell, and Abbott Thayer. Since 1957, when the Layton Art Gallery became part of the Milwaukee Art Center, the Layton trustees have

purchased landscapes and genre scenes by Cole, Johnson, Allston, and others, as well as an impressive group of colonial portraits. Over the years generous individual gifts to the museum have matched the Layton trustees' efforts, adding works by Inness, Moran, Chase, Blakelock, and Saint-Gaudens, among others.

The Collector's Corner, a support group for American decorative arts founded in 1948 at the Milwaukee Art Institute, continues to acquire objects for the museum. Their first purchase was a pastel attributed to Copley; subsequent gifts of furniture, silver, ceramics, and textiles include the museum's best examples of export porcelain and schoolgirl needlework. In 1967 Mrs. John J. Curtis donated her home, the Villa Terrace, and it became the museum's decorative arts branch. A committee led by Dudley Godfrey, Jr., furnished it with period rooms representing American design from 1650 to 1810. Through the 1970s, development of the collection was spurred by a small but enthusiastic and knowledgeable group of supporters, including Constance and Dudley Godfrey, Jr.; Anne and Frederick Vogel III; and Virginia and the late Robert V. Krikorian. Among the most significant recent gifts are Warren Gilson's substantial collections of silver and silver overlay.

In 1972 the Layton Art Collection made a major shift in emphasis from American paintings to decorative arts. The museum's 1975 expansion provided significant space for the American decorative arts collection, shifting attention from Villa Terrace. With the American collection's new prominence, gifts and purchases accelerated steadily. In 1979 the museum hired its first full-time curator of decorative arts and established an endowed American Heritage Fund for acquisitions of art from the colonial period through 1900. The museum's newest support group, the American Heritage Society, was established in 1992 and sponsors public programming as well as acquisitions. Through a new collaboration with Milwaukee's Chipstone Foundation, which supports decorative arts scholarship and education, the museum now has the benefit of Chipstone collections and staff.

Their extraordinary growth and quality have earned the American collections a national reputation. New audiences and fresh interpretations of these objects challenge the museum to show them in a manner that is both accessible and provocative, incorporating current scholarship within the galleries and pursuing acquisitions that expand its presentation of American art and culture. JC

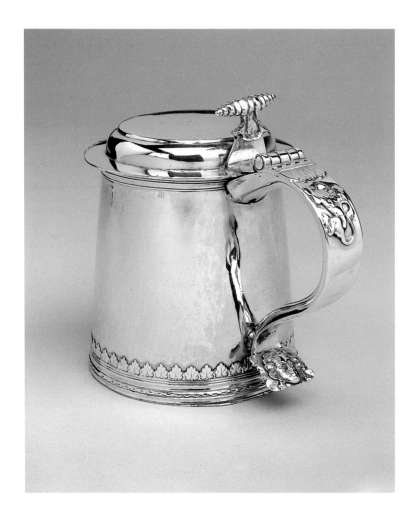

Cornelius Kierstede
Tankard, 1695–1705

A medieval form frequently engraved with a coat of arms, by the seventeenth century silver tankards had acquired a special luster as heirlooms. Tankards were used for ceremonial toasting in Northern Europe and, since traditionally they were communal vessels, intimated fellowship and trust. Among Protestants, they were often displayed with communion silver, lending the form an air of religiosity. The combined weight of these associations made silver tankards especially popular as wedding gifts. The engraved pomegranates on this example—symbols of fecundity and prosperity—would have been most appropriate for a marriage celebration.

One of the most gifted silversmiths in early New York, Cornelius Kierstede made tankards a mainstay of his production. Of Dutch heritage, he worked in both Dutch and English styles, presumably in response to his clients' taste. This tankard is a brilliant synthesis of the two. It is essentially an English form—straight-sided, with a scrolled handle, corkscrew thumbpiece, and flat, stepped lid—to which Kierstede has added Dutch ornament: an undulating wire and a row of upturned leaves at the base, a stylized lion on the handle, and lavish heraldic engraving festooned with foliage, ribbons, and pomegranates. Kierstede's great mastery is revealed in the subtle interplay between the weighty body and handle, the blunt edges of the cut lip and applied decoration, and the delicate, flowing engraved line. JC

Cornelius Kierstede (American, 1674–1757). *Tankard,* 1695–1705. Silver. H. 6 5/8 inches; dia. 4 13/16 inches. Gift of Friends of Art (M1977.11).

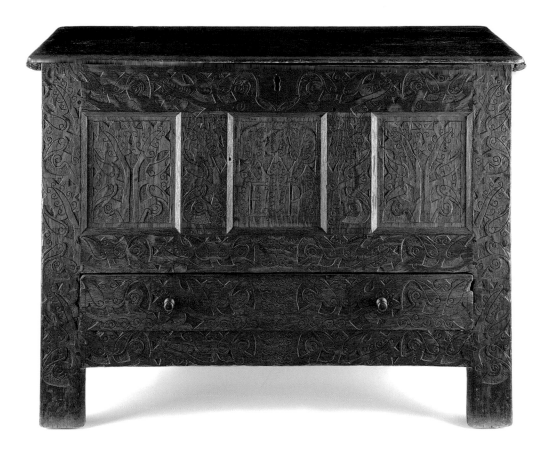

Deerfield or Hatfield, Massachusetts
Chest with Drawer, 1700–1720

The distinctive tulip, leaf, and scroll motif on this carved chest relates it to a group of over a hundred known pieces from the upper Connecticut River valley. Dubbed "Hadley chests" by a collector who purchased one in Hadley, Massachusetts, they were made by a network of craftsmen who developed a striking regional style based on this motif. Similar tulip-and-leaf carving on furniture of this period from Lancashire and Yorkshire suggests that one or more woodworkers making these Connecticut River valley chests learned his craft in northern England.

Hadley chests carry the same basic ornament, but their design varies substantially. This particular type, in which the flat, carved motif is repeated across the entire façade, is both the most abstract and the furthest removed from English examples. Thin gouged scrolls fill the interstices between each templated tulip-and-leaf, further unifying the surface. This design solution creates a weblike pattern that resembles textile ornament—lace, embroidery, or cut pile fabric—more than traditional carving. Although this chest has been stripped of its paint, related examples suggest that the drawer and three central panels were originally painted red, and the framing boards black. Paint was applied before carving, so that the recessed and gouged areas reveal unfinished oak.

The identity of E.P., whose initials are carved in the chest, is unknown, but other, well-documented Hadley chests suggest that the initials belonged to a woman. This was probably her dower chest, made to be brought to her husband's home. Generally chests and their contents represented women's only personal wealth within marriage, and the use of maiden names or initials was a significant way to acknowledge their family connections. While the exotic tulip decoration on this chest reflected current fashion, it may also have been—like much floral ornament—a subtle fertility charm. JC

Deerfield or Hatfield, Massachusetts. *Chest with Drawer*, 1700–1720. Carved with the initials "E P." Oak and pine, with iron hardware. 33 3/4 x 45 3/4 x 18 3/4 inches. Gift of Mr. and Mrs. Benjamin Ginsburg (M1992.106).

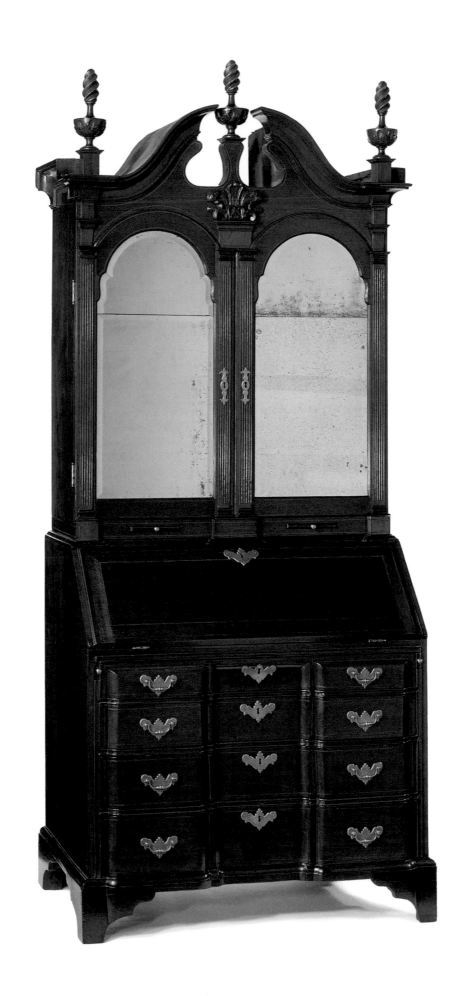

Attributed to William Price
Desk and Bookcase, 1735–40

Pre-Revolutionary Boston's merchant elite controlled much of the Atlantic coastal trade, and their demand for fashionable goods made the city the center of American furniture making until about 1750. This desk and bookcase demonstrates the sophisticated taste and specialized craftsmanship found in Boston's best workshops, and ranks among the most complex and innovative furniture produced in the New England colonies. Elaborately detailed architectonic design, urban British construction details, and an unusual choice of woods set this piece apart. Its designer—who appears to have been British-trained—combined elements of the late Baroque style, Palladian classicism, and regional shop traditions in a seamless expression that influenced Boston furniture production through the 1780s. In particular, the blocked desk façade, the richly articulated interior, and the thoughtful use of architectural elements were quickly assimilated by competing cabinet shops and became part of the local vocabulary.

In urban centers substantial furniture was produced by teams of specialists, rather than individual cabinetmakers. In this case the designer required the collaboration of a joiner, a turner, a carver, and a japanner (who gilded portions of the interior). Unfortunately most early American furniture is undocumented; the design of this piece is speculatively attributed to the cabinetmaker and architectural designer William Price, based on his background, financial resources, and social connections. JC

Attributed to William Price (English, 1684–1771, active in Boston after 1714). *Desk and Bookcase*, 1735–40. Courbaril, red cedar, cherry, white pine, oak, and silver gilding, with replaced glass and brass hardware. 97 x 40 5/16 x 24 1/8 inches. Purchase, through the bequest of Mary Jane Rayniak in memory of Mr. and Mrs. Joseph Rayniak (M1983.378).

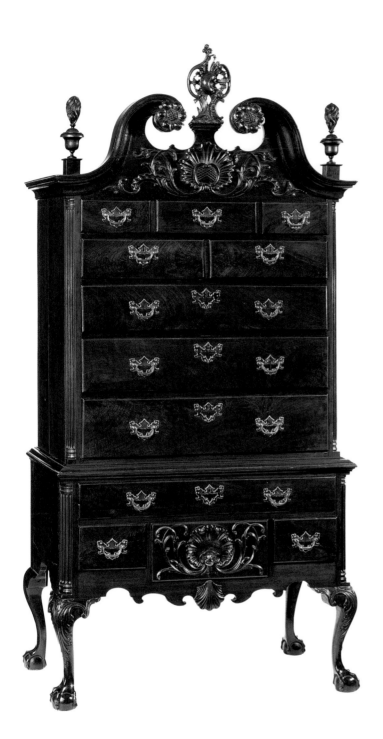

Philadelphia
High Chest of Drawers, 1760–75

Philadelphia experienced tremendous growth during the 1760s and 1770s, and demand for new homes and furnishings encouraged many immigrant craftsmen to seek work there. As a result, Philadelphia design from this period largely kept pace with British fashion, particularly in the use of Rococo carving. Ironically, while the Philadelphia high chest has become emblematic of fine late colonial furniture, in London this Baroque form was outmoded by 1730. American cabinetmakers, by contrast, refined the high chest over sixty years, developing complex scrolled pediments, thoughtfully positioned drawers, and—especially in Philadelphia—open expanses to showcase exquisite carving.

This high chest, like much furniture of its period, remains unattributed. Its essentially rectilinear structure is held in tension by dramatic carved outbursts around the pediment and the skirt, and the rhythmic placement of its brasses. While the fluid, naturalistic shells, scrolls, and foliage lighten the form considerably, its overall effect is massive and architectural. This is furniture of weight and consequence, intended to dominate a room and, in grander homes, complement elaborate interior woodwork. Yet for all their bulk, most high chests have a surprisingly intimate character, which stems, perhaps, from their function—storing linens and clothing—and their peculiarly anthropomorphic design. The legless chest-on-chests that superceded this form lack its endearing, almost human, quality. JC

Philadelphia. *High Chest of Drawers*, 1760–75. Black walnut, yellow poplar, and Atlantic white cedar, with replaced brass hardware. 94 1/2 x 46 3/4 x 23 3/4 inches. Purchase, Virginia Booth Vogel Acquisition Fund (M1984.120).

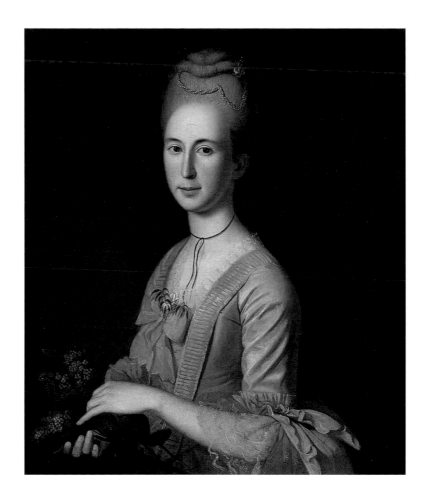

Charles Willson Peale
Elizabeth McClure or Mrs. Mordecai Gist (Cecil Carnan), 1774–75

Raised in genteel poverty, Charles Willson Peale worked as a saddler before he began to paint. Portraits were in such demand among the colonial gentry that when the young Peale showed promise, his Maryland patrons funded two years of study in London with the painter Benjamin West. A practical man, Peale focused on portraiture in London despite West's reputation for historical subjects and the emerging fashion for landscape. Upon his return in 1769, Peale became Annapolis's premier portraitist; after the Revolution, he flourished in Philadelphia as a painter, educator, and founder of "Peale's Museum," a showcase for art and natural science.

Even if their politics were revolutionary, most early Americans wished to be portrayed as cultivated aristocrats in the conservative British style. This sitter's moderate smile, erect spine, and composed, elegant hands give her an air of easy confidence; her perfectly oval face and long neck were considered marks of beauty. Flowers in colonial women's portraits imply gardening, a metaphor for mother-hood. Although this painting descended with one of Peale's two portraits of Mordecai Gist, there is no record of Mrs. Gist in the artist's papers, and Gist was a widower in 1774. The painting may well be the unlocated portrait of Elizabeth McClure, which Peale described cleaning (along with those of Gist) in 1788. McClure was a maternal aunt of Gist's second wife. JC

Charles Willson Peale (American, 1741–1827). *Elizabeth McClure* or *Mrs. Mordecai Gist (Cecil Carnan)*, 1774–75. Oil on canvas. 30 x 25 inches. Purchase, Layton Art Collection (L1958.1).

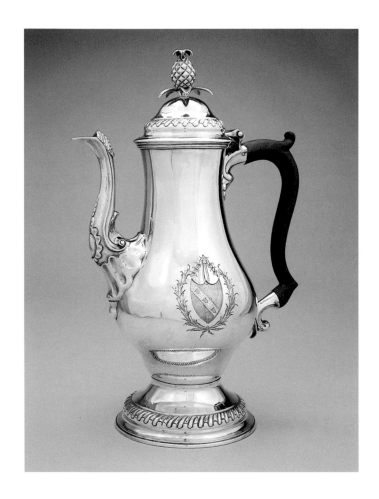

Thomas Shields
Coffeepot, 1765–90

Restrained, elegant, and subtly proportioned, this coffeepot is considered among the best examples of Philadelphia silversmith Thomas Shields's work. Tea- and coffeepots with this "double-bellied" form were common in England by the mid-eighteenth century, but rarely produced in America. While elements of this piece are clearly Rococo in design—the fluid, serpentine form, the softly curving shells and scrolls on the spout and handle—in spirit Shields's coffeepot reflects conservative British and American taste. Its plain, polished body, embellished with simple moldings and gadrooning, manifests a sense of monumentality and repose.

The engraving, while similarly restrained, is in the Neoclassical style current in America by 1780. This combination of styles is not unusual: old silver was often modified to keep it in fashion. But as this type of coffeepot remained in favor in America until about 1790 (by which time it was hopelessly out of date in Britain), this piece may have been made and engraved late in Shields's career. The coat of arms—three shields within a shield—refers to his own family, although the patron is unknown. Tea boycotts during the 1760s and 1770s elevated coffee's status among patriotic Americans, and like tea, coffee retained an aura of wealth and leisure. The extravagant pineapple finial on this pot has a similar connotation: as expensive imports, pineapples symbolized hospitality and elaborate entertaining. JC

Thomas Shields (American, active 1765–1794). *Coffeepot*, 1765–90. Silver, with replaced fruitwood handle. H. 13 1/2 inches; dia. 5 1/4 inches. Gift of Friends of Art (M1981.5).

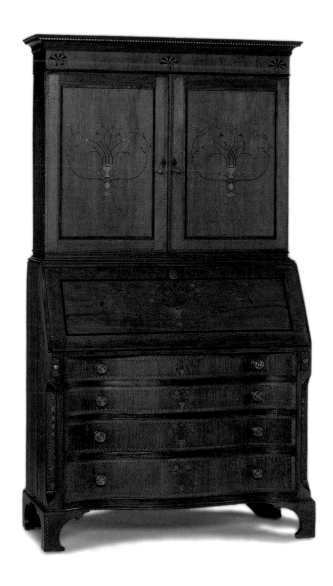

Nathan Lombard
Desk and Bookcase, 1800–1805

Sophisticated rural furniture that does not conform to urban fashion challenges the assumptions typically made about country craftsmanship. In the case of Nathan Lombard, a skilled and innovative cabinetmaker from the prosperous inland town of Sutton, Massachusetts, rural patronage did not limit him to rustic pieces. Nor does the distinctive style of his furniture—the delicate, precisely scaled inlay and carving, the unusual placement of stringing and cockbeading, curious details like the desk's concave corners, and a preference for cherry—mark him as a provincial eccentric. Lombard's work is certainly singular: before a signed chest of drawers was discovered, even a broad regional attribution

for his furniture remained elusive. But his designs also demonstrate a keen awareness of Neoclassical style and a facility with coastal New England woodworking conventions. Lombard and his clients were confident enough in their taste not to require imitations of Boston or Providence furniture.

This desk and bookcase succeeds visually in its present state, but a groove in the top suggests that it originally had a thin pediment. One of Lombard's surviving desks and bookcases retains such a scrolled pediment, with a delicately pierced tympanum and central urn finial. JC

Nathan Lombard (American, 1777–1847). *Desk and Bookcase,* 1800–1805. Inlaid with the initials "E T." Cherry, pine, and inlay of mahogany and other woods, with original brass hardware. 80 fi x 43 x 18 3/4 inches. Purchase, Virginia Booth Vogel Acquisition Fund and Layton Art Collection (L1996.1a-c).

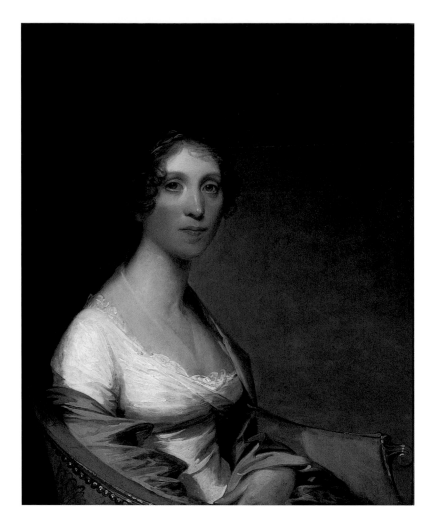

Gilbert Stuart
Portrait of Mrs. Josiah Quincy, 1809

Reared in Newport, Rhode Island, and trained in London by Benjamin West, a painter who emigrated from Boston and became head of the Royal Academy, Gilbert Stuart decided early on to focus on portraiture rather than the historical subjects favored by West. Perhaps his choice was forced, for returning to New York in 1793, he found America seemed to have little place for historical or even biblical subjects, but a ready market existed for portraiture among the prosperous citizens of the young and developing country. Known for his likenesses of George Washington, he came to be regarded as America's foremost portraitist.

Mrs. Josiah Quincy, née Eliza Susan Morton, of New York, was the wife of a prominent Massachusetts leader. Josiah Quincy was a state senator, Mayor of Boston, and president of Harvard University. This portrait was painted in 1809 as a pair with that of her husband, now in the San Francisco Museum of Fine Arts. Mrs. Quincy, wearing the elegant Empire clothing and hairstyle of the time, is shown seated in a delicately detailed Empire chair. Her long neck, gracefully sloping shoulders, and silk wrap contribute to the sense of elegance, but it is finally Stuart's typically high-colored complexion and limpid eyes that provide the portrait's focal center. Mrs. Quincy's direct gaze conveys strength as well as delicacy and suggests her contributions to her husband's career. The portrait remained in the Quincy family for many years and was included in the memorial exhibition of Stuart's portraits in Boston in 1828 and the centennial exhibition of Washington's inauguration in 1892. RB

Gilbert Stuart (American, 1755–1828). *Portrait of Mrs. Josiah Quincy*, 1809. Oil on panel. 30 7/8 x 24 3/4 inches. Layton Art Collection (L1990.9).

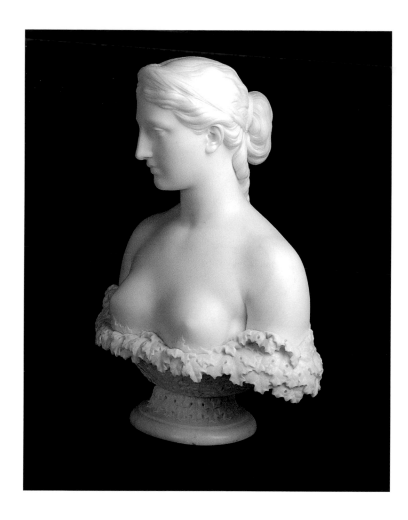

Hiram Powers
Proserpine, designed 1844

With limited training, Hiram Powers began his career sculpting portrait busts of friends in Cincinnati, Ohio. These works caught the attention of millionaire and fellow Cincinnatian Nicholas Longworth, who financed the young artist's travels to New York in 1829 and Washington, D.C., in 1834. With Longworth's letters of introduction in hand, Powers secured commissions from such illustrious figures as presidents Andrew Jackson and Martin van Buren and Justice John Marshall. Desiring to study the work of the Italian masters, Powers moved his family to Florence by way of Paris in 1837.

Turning to ancient history and mythology for inspiration, Powers distinguished himself with idealized Neoclassical figures such as *Proserpine*, while continuing to support his family with portraiture. Based on the ancient Roman bust *Clytie*, now in the British Museum, *Proserpine* quickly became one of Powers's most popular works, reproduced over 100 times by his studio. In Roman myth Proserpine, the beautiful daughter of Ceres, goddess of agriculture, was kidnapped and wed by Pluto, ruler of the underworld. Ceres was able to procure her daughter's release, but only during the spring and summer months, during which time, in her happiness, she caused the earth to bloom. Powers described this second of three versions of this mythological figure as appearing "in the bust with a wreath of wheat in bloom on her head [representing summer] and rising out of an acanthus (emblem of immortality) around her waist." Carved from white Italian marble, she is a noble, yet unassuming figure with a fixed, slightly downcast gaze. Her flawless complexion, elegant features, and reserved countenance emphasize her purity and innocence. JVC

Hiram Powers (American, 1805–1873). *Proserpine*, designed 1844. Marble. 24 15/16 x 19 1/4 x 10 inches. Layton Art Collection (L1897.1).

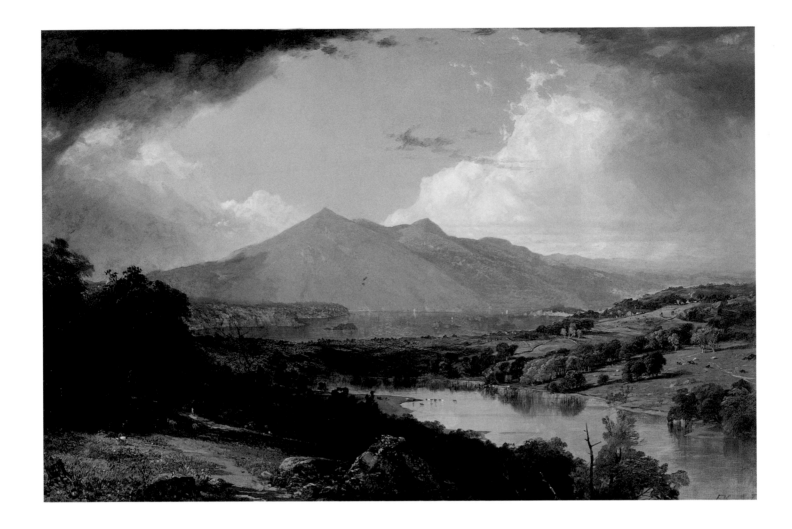

John Frederick Kensett
Lakes of Killarney, 1857

Often described as the most influential member of the second generation of the Hudson River School, John Frederick Kensett began his career as a commercial engraver, studying landscape painting in his spare time. He went abroad to study in 1840 and after his return to New York in late 1847, his career as a landscape painter quickly flourished. In contrast to contemporaries such as Albert Bierstadt and Frederic E. Church, Kensett avoided grandly scaled dramatic vistas, concentrating instead on modest views of nature faithfully rendered in every detail.

Lakes of Killarney, one of two paintings of this picturesque scene based on sketches Kensett made in Ireland during the summer of 1856, illustrates his favored method of construct-ing a composition by juxtaposing solid forms with voids to emphasize light and openness. The composition is also based on classical seventeenth-century French landscape painting, especially the work of Claude Lorrain, an artist much admired by the Hudson River School painters. Trees massed to one side and the dissipation of forms in an aerial perspective of hazy atmospheric light are typical Claudian devices. *Lakes of Killarney* is a relatively early work that also retains the influence of Kensett's friend Asher B. Durand in the dark woodland interior of the foreground as well as in its delicate finish and reserved palette of browns and greens. The open vista to the right suggests the direction Kensett's work would take by the late 1860s toward wider and far-reaching views. JO

John Frederick Kensett (American, 1816–1872). *Lakes of Killarney*, 1857. Oil on canvas. 24 x 34 inches. Purchase, Layton Art Collection (L106).

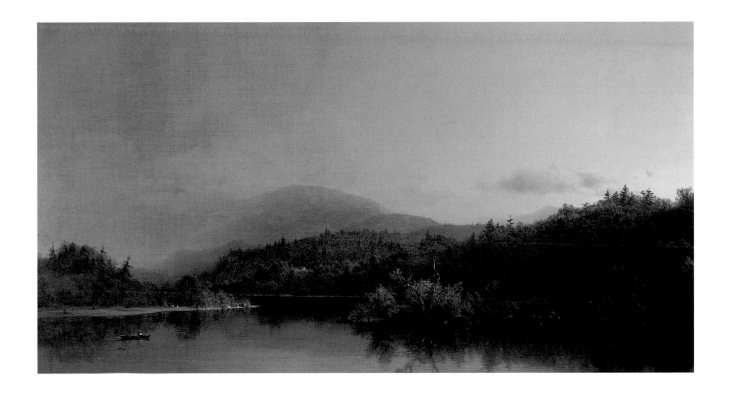

Frederic Edwin Church
A Passing Shower, 1860

Frederic Church was a religious man for whom landscape painting was an act of devotion. He was also a student of natural science, fascinated by physical geography and the diversity of nature. Inspired by the naturalist Alexander von Humboldt, Church traveled to wilderness areas in South America, the Caribbean, and the Arctic, producing detailed sketches from which he later composed finished paintings. Yet throughout his career he continued to paint the familiar landscape of New York and New England, where he trained with Thomas Cole, the first of the Hudson River School artists.

In the 1860s Church focused on dramatic, heroically scaled landscapes, and his heavily publicized single-picture exhibi-tions drew huge crowds. *A Passing Shower*, an East Coast scene, is one of the few small canvases he completed during this period. Soft, tinted mist clings to the mountains, heralding rain which may briefly disturb the lake's calm. While each leaf and ripple are precisely rendered, Church's attention to detail does not interrupt the atmosphere of harmony and repose. The tiny homestead and fishing boat, as integral to the landscape as the trees, present his ideal: humble Christian pioneers settling a benevolent wilderness. This peaceful scene may have had particular resonance for Church, who married and purchased his own land in the Catskills in 1860. JC

Frederic Edwin Church (American, 1826–1900). *A Passing Shower*, 1860. Oil on canvas. 16 13/16 x 30 9/16 inches. Layton Art Collection (L107).

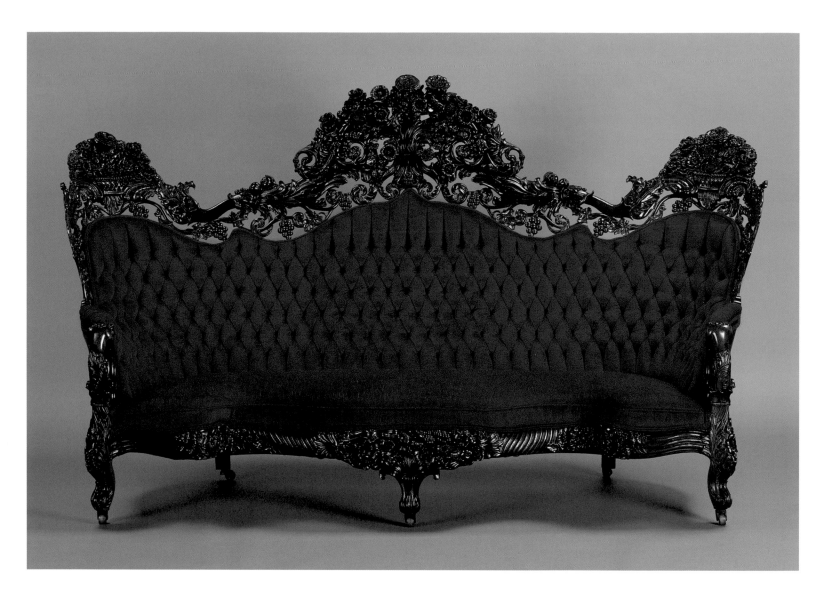

Attributed to John Henry Belter
Sofa, 1850–60

Apprenticed as a carver and cabinetmaker in Württemberg, Germany, by the late 1840s John Henry Belter was one of New York's most fashionable furniture makers. He employed over forty craftsmen—most German immigrants like himself—and although his factory used steam-powered machinery and newly patented techniques, most of the work was done by hand. Dense, virtuoso carving and voluptuous, compound curves are the hallmarks of Belter's idiosyncratic style. Innovative methods for bending and carving laminated wood—for which Belter held four patents—gave his massive forms both strength and lightness. His best work is sensuous and dramatic, suggesting a luxurious domesticity.

A revived fashion for the French Rococo was current in Europe as early as the 1820s, and the Rococo Revival maintained its status through mid-century as the most appropriate style for very grand homes and hotels. It combined elements of Rococo design—naturalistic flowers and foliage, S- and C-curves, controlled asymmetry, and a certain whimsy—with newly muscular proportions and a picturesque exuberance. Popular interest in horticulture and the natural sciences fueled a taste for botanical art, and the full-blown roses and grapes on this sofa echo the opulent bouquets that bedecked textiles, wallpapers, porcelains, and silver through the 1850s. JC

Attributed to John Henry Belter (American, b. Germany, 1804–1863). *Sofa*, 1850–60. Rosewood laminate and rosewood, with modern velvet upholstery. 54 x 93 1/2 x 40 inches. Purchase, through the bequest of Mary Jane Rayniak in memory of Mr. and Mrs. Joseph G. Rayniak (M1987.16).

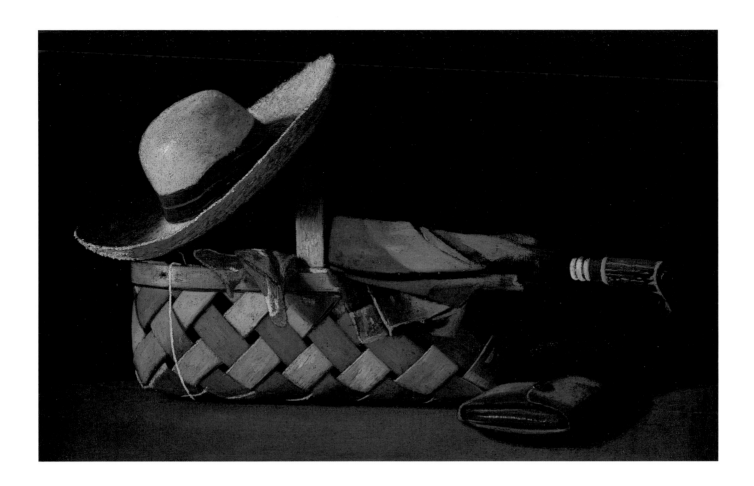

John Frederick Peto
Market Basket, Hat and Umbrella, after 1890

Born in Philadelphia, the still-life painter John Frederick Peto enrolled in 1878 at the Pennsylvania Academy of the Fine Arts, where he exhibited between 1879 and 1888. There he met and befriended William Harnett, whose trompe l'oeil still lifes had a decisive influence on his career. In fact, for many years Peto remained in the shadow of his better-known colleague to whom many of his pictures were wrongly attributed. With the advent of further research on American still-life painting, Peto gradually emerged as a distinct artistic personality whose work could be differentiated from Harnett's.

Market Basket, Hat and Umbrella demonstrates Peto's looser brushwork, warm tonality, and signature aura of subtle melancholy created by his tendency to represent humble objects. The horizontal view of a tabletop was one of Peto's favored still-life arrangements during the 1890s and one he explored frequently. In this work the textures and colors of the basket, hat, and umbrella, are carefully rendered, but the feeling for paint is more pronounced than the illusion of reality. Peto carefully repeated the diagonal weaves of the basket in the shadow of the umbrella and the brim of the hat. By eliminating extraneous objects and focusing his efforts on the thoughtful composing of forms, Peto imbued his painting with a strong visual impact and even an abstract power. JO

John Frederick Peto (American, 1854–1907). *Market Basket, Hat and Umbrella*, after 1890. Oil on canvas. 13 x 18 inches. Purchase, Layton Art Collection (L1964.5).

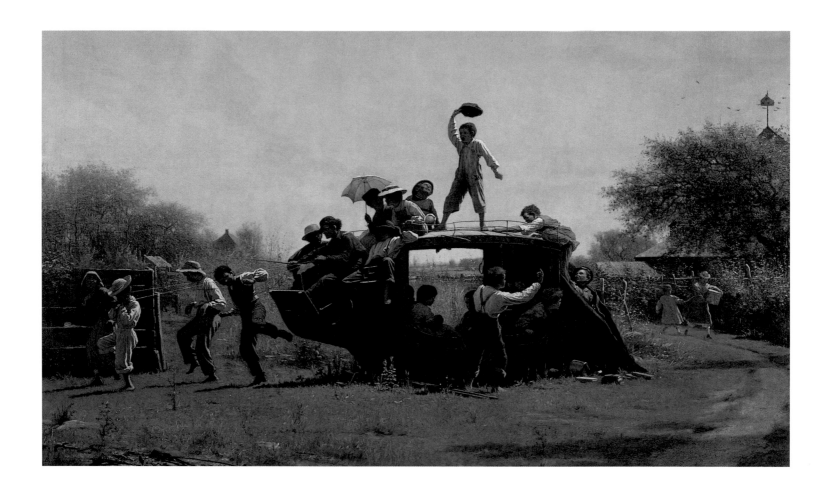

Jonathan Eastman Johnson
The Old Stagecoach, 1871

In the 1870s Eastman Johnson was at the height of his career as a genre painter. His scenes of rustic youth, quaint elders, and picturesque rural laborers were immensely popular, and contemporary critics described Johnson's paintings in wistful and nostalgic terms. In the wake of the Civil War, his sentimental images of children offered the promise of a new and unspoiled generation. In particular, Johnson's depictions of idealized, wholesome country childhood responded to popular anxiety about industrialization and urban life in an era when child labor, child poverty, and homelessness were beginning to prick the national conscience.

The Old Stagecoach was painted on Nantucket, a quiet island whose old-fashioned New England character inspired Johnson to establish a summer studio. He based the stagecoach itself on a derelict vehicle he had sketched in the Catskills, and posed local children on a carefully measured platform. Schoolbooks and lunch pails cast aside, the children seem fully engaged in an innocent game of organized fantasy. Despite its complexity the vigor of Johnson's composition and the energetic, individual gestures of each child create a convincing and endearing image of spontaneous play. Johnson added a moral theme by giving the stagecoach the evocative name "Mayflower." Our children's essential goodness will revive the wreckage of the colonial past, his picture asserts, and vanquish the evils of a changing world. JC

Jonathan Eastman Johnson (American, 1824–1906). *The Old Stagecoach*, 1871. Oil on canvas. 36 1/4 x 60 1/8 inches. Layton Art Collection, Gift of Frederick Layton (L1888.22).

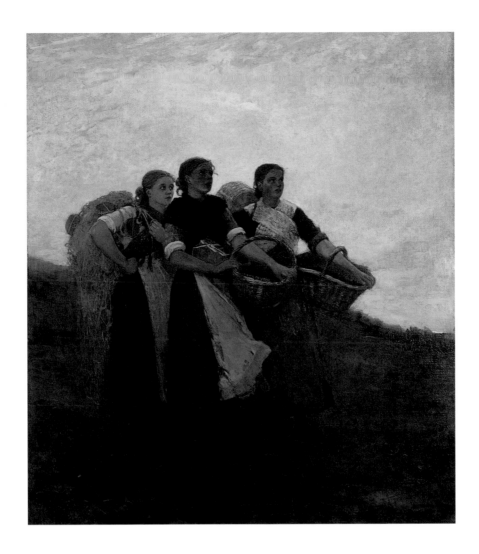

Winslow Homer
Hark! the Lark, 1882

In his mid-forties and well established as a painter of American subjects, Winslow Homer sought new inspiration in the English village of Cullercoats on the North Sea. He focused on the fisherwomen who marketed the catch, mended nets, gathered bait, and awaited the boats' return. Homer had often painted beach scenes, and his early career as an illustrator occasioned many images of picturesque bathers and tragic drownings. The Cullercoats paintings, however, have a gravity and monumentality that mark a turning point in his work.

Homer considered *Hark! the Lark* his most important picture from this series. As an image of rural workers, it relates to the romantic peasants painted by Jean-François Millet and the Barbizon School, yet it is invested with the dark tension that pervades Homer's late painting. While the title suggests that the women have paused to listen to a bird, their postures imply the wary optimism of fisherwomen looking out to sea. Homer annotated a sketch for this painting with a line from Shakespeare's *Cymbeline*: "Hark, hark! the lark at heaven's gate sings/And Phoebus 'gins arise" (Phoebus is the sun, rising as the boats start out in early morning). The direct, sculptural composition and the weighty silhouette against the bright sky create an aura of quiet heroism. Although these women remain on shore, they too are at the mercy of the sea, and Homer paid tribute to their sturdy, resolute courage. JC

Winslow Homer (American, 1836–1910). *Hark! the Lark*, 1882. Oil on canvas. 36 3/8 x 31 3/8 inches. Layton Art Collection, Gift of Frederick Layton (L99).

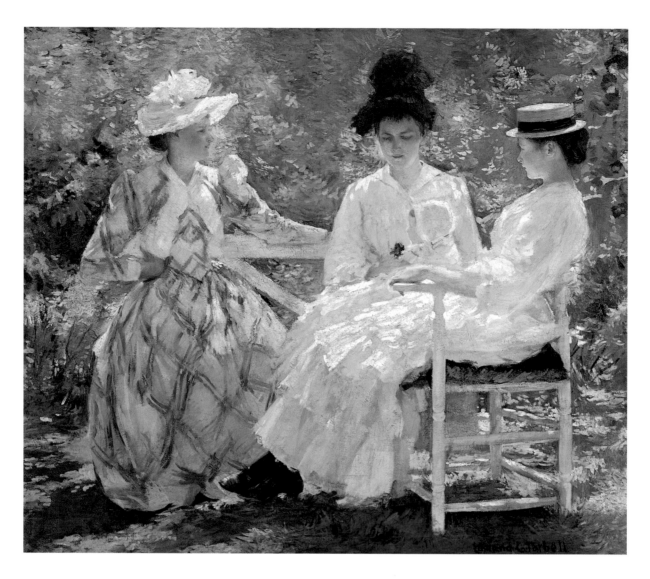

Edmund C. Tarbell
Three Sisters—A Study in June Sunlight, 1890

Edmund Tarbell studied in Paris in the mid–1880s, just as the work of the French Impressionist painters was gaining critical acceptance. American artists embraced the new style rather late, and this painting—Tarbell's first important Impressionist work—caused a small sensation when it was exhibited in his native Boston. The brilliant fabrics and leaves shimmering in dappled sunlight, the strong reds, greens, and blues against white, and the short, rapid brush strokes are entirely in keeping with the French painters' focus on transient light and undiluted color. The serene women are more solidly drawn: Tarbell's figures never quite dissolve into the patterns of light around them, yet their passivity surrenders the stage to the warm, sweet atmosphere and the lavish effect of sun on their dresses.

Tarbell's models for this picture were his wife, Emeline, their baby daughter, and Emeline's sisters, all informally but fashionably dressed. Although he portrayed them as individuals, these are not probing likenesses. Instead the three sisters and the garden represent a way of life: affluent women and children whiling away the summer in quiet retreat, far from the hot and clamorous cities where their husbands do business. The painted roundabout chair—a colonial antique—implies their New England heritage, a subtle point that would have appealed to Tarbell's Boston patrons. JC

Edmund C. Tarbell (American, 1862–1938). *Three Sisters—A Study in June Sunlight,* 1890. Oil on canvas. 35 1/8 x 40 1/8 inches. Gift of Mrs. J. Montgomery Sears (M1925.1).

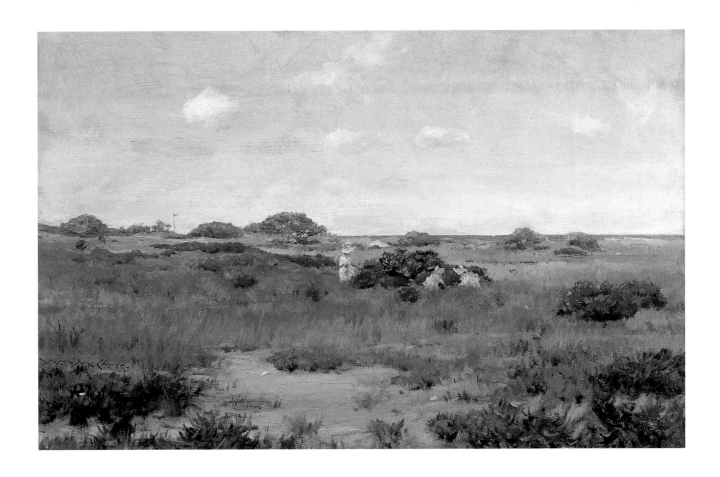

William Merritt Chase
Gathering Wild Flowers, ca. 1895

Trained at the National Academy of Design in New York, William Merritt Chase went on in 1872 to study at the Royal Academy of Munich. Although his early style relied heavily on the influence of European Old Masters and the dark manner of the Munich School, he soon became enamored with painting by Americans working abroad, the aestheticism of J. A. M. Whistler and the bravura painterliness of John Singer Sargent. By the 1880s Chase had taken up the plein-air approach of the French Impressionists along with their frequent subjects of bourgeois leisure entertainments and suburban landscape. His experiments in Impressionist style, more the fluid naturalism of François Boudin than the brilliant, divided strokes of Claude Monet, were probably the most advanced of American artists of the time.

Certainly the most complete of Chase's Impressionist works are the Shinnecock landscapes of the 1890s. From 1891 to 1902, Chase headed the first American art school to teach painting out-of-doors. Set at his summer home at Shinnecock on the eastern end of Long Island, the school brought Impressionist ideas to a number of American artists. *Gathering Wild Flowers* is typical of Chase's paintings of the environs of his house and school set in a broad expanse of dunes and sky under a brilliant summer sun. His lively brushwork captures the dazzling colors of sand, shore vegetation, and cloud-blown sky with a vivacity that is enhanced by the touches of color in the dresses of his three daughters. Embodying the spontaneity central to his teaching philosophy, *Gathering Wild Flowers* is an affectionate homage to family life and a simple but inspiring landscape. RB

William Merritt Chase (American, 1849–1916). *Gathering Wild Flowers*, ca. 1895. Oil on canvas. 16 x 24 inches. Gift of Mr. and Mrs. George M. Chester, Mr. and Mrs. William M. Chester, Jr., Mr. John Chapman Chester, and Mr. and Mrs. Verne R. Read (M1991.307).

Early Twentieth-Century European
Painting, Sculpture, and Decorative Arts

The early twentieth-century European collections at the Milwaukee Art Museum grew out of an intense interest in European Modernism during the first half of this century. As with the Layton Art Gallery collection, which focused primarily on the art of its time, the Milwaukee Art Association (later the Milwaukee Art Institute), was committed to showing the latest in modern art, often extending its vision across the ocean to the most progressive European art and artists of the day.

With exhibitions such as "The Modern Spirit," a show of European and American Cubist and Synchromist paintings and sculpture mounted in 1914, Milwaukee put itself on the map, daring to present the most challenging art directly in the wake of the famous Armory Show of 1913. Later, in the 1930s and 1940s, the Milwaukee Art Institute began an association with the newly established Museum of Modern Art in New York, which sent to Milwaukee ground-breaking exhibitions such as "Fantastic Art, Dada and Surrealism."

Through initiatives such as these, the Milwaukee Art Institute and its patrons became accustomed to seeing the best of modern art, thus providing the groundwork for the acquisition of key Modernist paintings, sculpture, and decorative arts. Fernand Léger's 1911 painting *Study for Three Portraits* entered the collection as a direct result of Milwaukee's early introduction to Cubism, while Lovis Corinth's *Portrait of Doctor Schwartz* was given in 1953 by the artist's son, who recalled an important exhibition of his father's paintings at the Milwaukee Art Institute in 1938. Through the generosity of other seminal patrons, such as Mr. and Mrs. William D. Vogel, Mr. and Mrs. Charles Zadok, Mr. and Mrs. Maurice W. Berger, and the Virginia Booth Vogel Acquisition Fund, established in 1976,

additional paintings by major European Modernists entered the permanent collection.

But it was ultimately the immense generosity and vision of Mrs. Harry Lynde Bradley that established the Milwaukee Art Museum as a leader in the United States of late nineteenth- and twentieth-century European art. Begun in 1950, the Bradley collection represented the epitome of classic Modernism, from 1906 Fauve paintings by Georges Braque and Maurice Vlaminck to seminal Expressionist paintings by such masters as Ernst Ludwig Kirchner and Wassily Kandinsky. Magnificent works by Pablo Picasso and Alberto Giacometti represent some of the highpoints of European art at mid-century. Indeed, from the early 1950s to the gift of Mrs. Bradley's entire collection in 1977–78, the number of extraordinary donations from the Bradley collection doubled the twentieth-century holdings of the museum and paved the way for the 1975 addition, funded in part through a challenge grant by Mrs. Bradley and the Allen-Bradley Foundation. The recent Friends of Art purchase of an important reclining chair by the Modernist architect and designer Marcel Breuer demonstrates the Milwaukee Art Museum's ongoing commitment to strengthen the decorative arts and design portion of its twentieth-century European collections. KM

Georges Braque
Seated Nude (Femme assise), 1906

Before he and Picasso invented Cubism, Georges Braque experimented with other artistic styles. *Seated Nude,* painted during a short-lived experimentation with Fauvism, offers a revealing glimpse into Braque's stylistic development while he was still under the influence of Matisse, but before he had discovered Cézanne. Braque abandoned Fauvism early in his career, but his personal interpretation of the movement can be seen in works such as *Seated Nude.*

The Fauve approach to using color for its own expressive qualities is evident in this painting. Instead of choosing hues that correspond to reality, Braque selected seemingly arbitrary and vibrant colors to define both figure and space. He used green to model the back of the nude and bold purples and reds to create the background. Although these choices are unusual, Braque managed to achieve balance and order in his painting by employing a color scheme of paired opposites, red and green, violet and yellow. By creating a classical pyramidal composition with subtle repetitions of diagonal lines and triangular forms, Braque further reinforced the underlying structure of the painting. The slightly tilted perspective of the picture plane hints at his future experiments with Cubist form and space. JO

Georges Braque (French, 1882–1963). *Seated Nude (Femme assise),* 1906. Oil on canvas. 24 1/8 x 19 13/16 inches. Gift of Harry Lynde Bradley (M1953.13).

Maurice Vlaminck
The Wheat Field, ca. 1906

A leading figure of the Fauve movement in early twentieth-century France, Maurice Vlaminck was a self-taught artist who began painting purely for pleasure, while supporting himself financially by playing the violin. Inspired by the French countryside surrounding Chatou on the Seine River, where he shared a studio with his friend and fellow Fauve painter André Derain, Vlaminck used powerful, gestural strokes of high-keyed color to capture the landscape. This dramatic approach became more pronounced after Vlaminck viewed the emotionally charged works in the 1901 van Gogh retrospective held at the Bernheim-Jeune gallery in Paris. Vlaminck was further encouraged by Henri Matisse, who advocated using bold, often unnatural, color for purely emotive effects.

Convinced that Vlaminck was sympathetic to his point of view, Matisse invited him to show his work with a group of independent artists at the 1905 Salon d'Automne in Paris, where critic Louis Vauxcelles disparagingly dubbed the group *Fauves*, or "wild beasts." Painted a year after the exhibition, *The Wheat Field* is a continuation of Vlaminck's use of expressive, clashing colors. His brush strokes are uncharacteristically long and curved for this period, but their spontaneity typically indicates the artist's passionate state of mind and his fascination with the movement of the wind-blown stalks. Vlaminck returned to this subject throughout his career, writing, "The sight of a wheat field always moves me deeply." His life-long interest in this theme, which he rendered with wildly animated brush strokes, testifies to the extraordinary impact of van Gogh's painting on Vlaminck's art. JVC

Maurice Vlaminck (French, 1876–1958). *The Wheat Field*, ca. 1906. Oil on canvas. 25 x 32 inches. Gift of Mrs. Harry Lynde Bradley (M1953.12).

Fernand Léger
Essai pour trois portraits (Study for Three Portraits), 1910–11

Study for Three Portraits is one of Fernand Léger's most significant early Cubist paintings. Following the lead of trailblazers such as Pablo Picasso and Georges Braque, who first developed the volumetric and spatial complexities of the Cubist aesthetic around 1909, Léger worked with a group of artists known as the Puteaux Cubists (Jean Metzinger, Albert Gleizes, Robert Delaunay, and others) in exploring new ways in which Cubism could engage modern life and experience. In this painting three figures emerge from a setting dominated by cylindrical fragments, shifting planes, and a distinctly monochromatic palette. A table with a potted plant, a still life with a bowl of fruit, and an open window occupy the spaces between the figures, who appear to gaze off into the distance. *Study for Three Portraits* goes beyond the multiple viewpoints and planar faceting of Cubism to engage in a more dynamic sense of movement and simultaneity influenced by Italian Futurism. Léger's emphasis on cylindrical and tubular forms, used prominently for the limbs and bodies of the figures, evidences the strong interest in mechanization that would mark his work from the 1920s onward.

Léger's status as one of the leaders of European Modernism was acknowledged when representatives of Milwaukee's Gimbel Brothers department store traveled to Paris in 1913 to locate the best of the new Cubist painting. Bolstered by the success and infamy of the Armory Show in New York in 1913, they assembled an important exhibition of Cubist paintings in Milwaukee, which included this work as well as others by Gleizes, Metzinger, and Jacques Villon. The exhibition, which traveled to several department stores throughout the United States, was influential in introducing the American public to some of the most progressive European art of the new century. KM

Fernand Léger (French, 1881–1955). *Essai pour trois portraits (Study for Three Portraits)*, 1910–11. Oil on canvas. 76 3/4 x 45 7/8 inches. Anonymous gift (MX.5).

Gabriele Münter
Boating, 1910

When Gabriele Münter met the Russian artist Wassily Kandinsky at the Phalanx School in Munich in 1902, they embarked on a relationship that would last well over a decade. Both artists became influential in the avant-garde circles in Munich in the early part of the century, founding the Neue Künstlervereinigung München in 1909 and Der Blaue Reiter group in 1911. Their close artistic correspondences developed most fully in Murnau, a town outside of Munich, where they sojourned along with artist-friends such as Alexei Jawlensky and Marianne von Werefkin from 1908 to 1914.

It was here during the summer of 1910 that Münter painted *Boating*, a depiction of an outing on the Staffelsee with Kandinsky, Werefkin, Jawlensky's son, Andreas, and Münter herself seated with her back to the viewer. Looking squarely out at us with uncanny blue eyes, Kandinsky is the focal point of the picture, the axis around which not only the composition, but also the theoretical ideas of the Munich avant-garde, revolved. His almost visionary gaze matches the intense ultramarine of the mountains in the distance, just one of the bands of pure color and flattened form that showcase Münter's total commitment to the color-saturated Modernist painting of her time.

But ironically, if Kandinsky is the center of the composition, Münter is the one who maintains its equilibrium, holding the group in a perfect symmetry threatened by the approaching storm and the eagerness of the black dog at her side. Münter's image of herself as the stabilizing force, the support, for the creative journey of her male companion is common with women artists of this period. It is a testament to Münter's astonishing artistry that she should create such a powerful and important painting in the process. KM

Gabriele Münter (German, 1877–1962). *Boating*, 1910. Oil on canvas. 49 1/4 x 29 inches. Gift of Mrs. Harry Lynde Bradley (M1977.128).

Lovis Corinth
Portrait of Dr. Karl Schwarz, 1916

Lovis Corinth was one of the leading German artists of the first quarter of the twentieth century. Though his paintings include a wide range of subjects—allegorical, mythological, and biblical themes, landscapes, nudes, and still lifes—he was an especially gifted portraitist, profoundly engaged with his own upper-class, intellectual, and cultural milieu.

By 1916 when Corinth created this portrait, he was fifty-eight and at the height of his career, having just been elected president of the august artists' association the Berlin Secession. The sitter is Dr. Karl Schwarz, the young art historian who was preparing the catalogue raisonné of Corinth's graphic work, published in 1917. Greatly impressed by Schwarz's serious and aristocratic bearing, Corinth asked him to bring his white waistcoat, "valuable" chain and ring, hat, stick, and briefcase to the sitting. He then executed this penetrating portrait with a heavily charged paintbrush and a bold attention to color and surface reminiscent of the nineteenth-century French artists Gustave Courbet and Edouard Manet. While Corinth's psychologically probing pictures and brash painterly style later connected him with the German Expressionists, he always maintained a distance from the avant-garde, claiming instead his close relationship to traditional German painting and representation. KM

Lovis Corinth (German, 1858–1925). *Portrait of Dr. Karl Schwarz,* 1916. Oil on canvas. 41 3/8 x 31 9/16 inches. Gift of Thomas Corinth (M1953.9).

Ernst Ludwig Kirchner
Street on the Schöneberg City Park, 1912–13

When Ernest Ludwig Kirchner moved to Berlin from Dresden in 1911, he was impressed with the power and excitement of the metropolis. At the time he was associated with the German Expressionist group Brücke (Bridge), whose artists used familiar places, people, and experiences as the subjects of their challenging new art. In *Street on the Schöneberg City Park*, Kirchner depicted a typical street corner situated on the city park in the Berlin precinct of Schöneberg. Rather than focusing on the trees and picturesque monuments of the park itself (a portion of which is merely suggested at the right), Kirchner turned his eye towards the vast urban landscape of streets and buildings, which appear to tower over the trees on the Innsbrucker-strasse. This view offered him the opportunity to experiment with the effects of deep perspective on the two-

dimensional plane, an interest that related to similar concerns of the Cubists during the same period.

Dominating the composition are two gray, bulging buildings, masses of concrete that are as frantically rendered as the anonymous pedestrians on the street. Contrary to latter-day interpretations, these formal distortions do not reflect a sense of alienation or anxiety on Kirchner's part, but rather a sense of energy and excitement with what the new forms and spaces of the city could mean to his art. With his signature almost dissolved into the rapidly brushed curb at the left, *Street on the Schöneberg City Park* is a testament to Kirchner's profound fascination with the city, painted in a way that would reflect its starkly modern and dynamic existence. KM

Ernst Ludwig Kirchner (German, 1880–1938). *Street on the Schöneberg City Park,* 1912–13. Oil on canvas. 47 5/8 x 59 3/8 inches. Gift of Mrs. Harry Lynde Bradley (M1964.55).

Wassily Kandinsky
Fragment I for Composition VII (Center), 1913

Between 1910 and 1913, the Russian artist Wassily Kandinsky created seven monumental "Compositions," each more complex and abstract than the one before it. At the time Kandinsky was a leading force in the Munich art world, where he was searching to move beyond the strictures of representation into a more spiritual realm of color, line, and shape. In 1912, along with the German artist Franz Marc, he edited the almanac of *Der Blaue Reiter* (The Blue Rider), a compilation of writings and images by artists, musicians, and scholars that forecast a spiritual revolution in art whose effects would be felt for decades to come.

Fragment I for Composition VII (Center) is one of over thirty preparatory works for Kandinsky's last great "Composition," *Composition VII*, now in the Tretiakov Gallery in Moscow. The study is a finished painting in its own right, a detailed analysis of the complicated relationships of color and movement found in the crucial center section of *Composition VII*. As in all his paintings, Kandinsky began with a single theme or a compilation of themes that were close to his heart, such as Russian folktales or biblical subjects, and stripped them down until only their most essential vibrations remained. *Composition VII* has been said to incorporate themes of the Resurrection, the Last Judgment, the Deluge, and the Garden of Love. Indeed, one can still decipher traces of these motifs in this preliminary work—the figure in the boat at the upper left, the central mountain tilted on its side with a deep blue sky behind it, the bark with twin oars at the center right. While it is tempting to want to read Kandinsky's paintings in terms of these representational motifs, they should always remain simply one more layer in the complex symphony of color and form meant to play upon the inner soul of the viewer. KM

Wassily Kandinsky (Russian, 1866–1944). *Fragment I for Composition VII (Center)*, 1913. Oil on canvas. 34 15/16 x 39 7/16 inches. Gift of Mrs. Harry Lynde Bradley (M1958.12).

Alexander Archipenko
Boxers (La Lutte or The Fight), 1914

Sculptor Alexander Archipenko believed that an artist's most precious faculty is invention, a guiding credo that likely can be traced to his father, a Russian inventor and engineer. Archipenko's art training began in 1902 in the city where he was born, at the Kiev School of Art. In 1906 he moved to Moscow and in 1908 to Paris, where he associated with the city's avant-garde artists after leaving the Ecole des Beaux-Arts after only two weeks because of its conservatism. In Paris he met Fernand Léger as well as a number of other artists engaged in Cubism, exhibited his sculpture regularly at the Salon des Indépendants and the Salon d'Automne, and eventually became part of the breakaway Cubist group the Section d'Or. His work was also included in the notable Armory Show in New York in 1913.

Boxers, which was acquired from the artist's widow, is the seventh of eight casts. Although the composition is abstract, the title makes clear that the confrontational forms represent two figures locked in a tense struggle. Its use of concave and convex structures to embrace open space and create a harmonious construct exemplifies a revolutionary sculptural approach that is considered to be the artist's most significant artistic contribution. The polished surface and converging forms of *Boxers* reflect and redirect light, challenging the viewer to determine whether the figures' limbs are protruding or receding. The reductive nature of the figures, which is characteristic of Cubist paintings, resembles a stylistic orientation toward African and Iberian art, in which clear, massive forms dominate. In its expressive and energetic composition, however, *Boxers* deviates from Cubist theory. BF

Alexander Archipenko (American, b. Russia, 1887–1964). *Boxers (La Lutte* or *The Fight),* 1914. Bronze. 24 1/2 x 15 x 18 inches. Purchase, Virginia Booth Vogel Acquisition Fund (M1983.189).

František Kupka
Shades of Violet, 1919

František Kupka has been associated with early abstraction and with Orphism, the art of painting with elements that have a direct relationship to music. Although Kupka included musical terms in his titles and nonrepresentational forms in his paintings, which were influenced by his strong interest in Eastern philosophy, spiritualism, and the metaphysical, the artist strongly resisted categorization and sought to remain an independent thinker. In addition to studying art at the academies of Prague and Vienna and science at the Sorbonne, Kupka worked as a fashion designer and an illustrator. While residing in Paris during the early part of the twentieth century, he became acquainted with many leaders of the avant-garde, such as Jacques Villon, Fernand Léger, Juan Gris, Marcel Duchamp, Jean Metzinger, and Alexander Archipenko, but the ideas of his fellow European artists did not influence him. The natural world was his inspiration, and Kupka's goal in creating art was to express the sublime he found in natural forms.

Shades of Violet, a colorful array of organic patterns that resemble rock and cloud formations, reflects the artist's aspiration. It has been suggested that Kupka's summers in Brittany, where he studied and painted the rocky outcroppings along the coast, inspired the forms in *Shades of Violet*. Here Kupka also employed his innovative fragmenting of space through color, derived from his strong interest in color theory. He used red, a color that theoretically jumps forward from the canvas, and blue, a color that recedes, to create an interplay of spatial relationships. Although the work is believed to have been painted in 1919, Kupka rarely dated paintings at the time of execution, so precise dates remain uncertain. BF

František Kupka (Czechoslovakian, 1871–1957). *Shades of Violet*, 1919. Oil on canvas. 32 3/4 x 42 3/4 inches. Gift of Mr. and Mrs. Charles Zadok (M1954.1).

Joan Miró
Le Fou du roi (The King's Jester), 1926

Inspired by dreams and fantasies, Joan Miró's art is spontaneous, yet well considered and finely wrought. "Rather than setting out to paint something," he explained, "I begin painting and as I paint, the picture begins to assert itself." Like his friend the Surrealist poet André Breton, Miró allowed his subconscious to suggest fresh creative avenues before proceeding in a carefully calculated manner. Filled with grotesque anthropomorphic figures—often playful and innocent, but at times powerful and frightening—Miró's pictures are private dramas laden with complex and ambiguous meaning.

From 1925 through 1927, Miró painted more than 100 works characterized by a predominant open space in which a few shapes or figures seemingly float. The artist's most Surrealist paintings, these works, exemplified by *The King's Jester*, were in part the product of hallucinations brought on by hunger during a period of extreme poverty. The figure in this painting is rendered in a childlike fashion; the broad field of color breaks out of the restrictive bold charcoal outline, and the dots representing the eyes are disproportional and uneven. The apparent simplicity of the image, however, is undermined by the inherent ambiguity of the individual elements. The black triangle representing the body of the figure could also be a mountain or volcano, the eye dots could be rocks, and the jester's cap could be a flame or cockscomb—all perhaps references to the rural Catalan life that was a great source of inspiration in Miró's work. The title word *fou* in French, interpreted as jester, can also imply the notion of the fool as madman, relating to the Surrealists' admiration for the imaginative powers of the insane. MA

Joan Miró (Spanish, 1893–1983). *Le Fou du roi (The King's Jester)*, 1926. Oil, pencil, and charcoal on canvas. 45 x 57 fi inches. Gift of Mr. and Mrs. Maurice W. Berger (M1966.142).

Marcel Breuer
Reclining Chair, designed 1932

Marcel Breuer was one of the most influential and innovative architects and designers of the twentieth century. He enrolled as a student at the famous German school of design the Bauhaus in 1920 and was appointed master of the furniture workshop five years later. Breuer's experimental use of modern materials in furniture design was reflective of the Bauhaus's integration of art, craft, and industry. Inspired by the strength and light weight of steel, Breuer designed his first metal chair, the tubular steel "Wassily" chair, in 1925. Its phenomenal success encouraged the use of metal, a decidedly modern material, in a wide range of furniture designs.

In addition to his work with steel, Breuer experimented with aluminum designs, but was somewhat discouraged by aluminum's greater expense and problematic welding. Nevertheless, at the urging of the Swiss firm Embru Werke, he submitted five designs, likely including this reclining lounge chair, to the 1933 International Competition of the Best Aluminum Chair, sponsored by the Alliance Aluminum Cie of France. Breuer's designs were awarded two first prizes, one from each of the two juries presiding over the competition. The recliner's design features aluminum (in other versions, steel or wood) horizontal slats bolted to the contoured frame, which would have been covered with an upholstered pad for greater comfort. Though this model was handmade, the design was intended for mass-production, an intention hindered in part by limited demand and the diversion of metal for war preparations in Europe. In October 1935, Breuer moved to England where, at the suggestion of architect Walter Gropius, he translated his metal designs to plywood for the newly established Isokon Furniture Company. JVC

Marcel Breuer (German, b. Hungary, 1902–1981). *Reclining Chair*, designed 1932. Produced by hand in 1933 by Embru Werke, Rüti, Switzerland. Aluminum and wood. 29 1/4 x 23 1/2 x 41 inches. Gift of Friends of Art (M1992.241).

Pierre Bonnard

View from the Artist's Studio, Le Cannet (Vue de l'atélier du Midi, Le Cannet), 1945

Pierre Bonnard's art reflects his life-long love for and sensitivity to color. During the 1890s Bonnard was associated with the Nabis (Hebrew for prophets), a group of artists who rejected academicism and touted the decorative qualities of art, which they applied to painting, printmaking, and the decorative arts Though no uniform style emerged from the group, they shared an enthusiasm for Japanese prints and the pictorial theories of French painter Paul Gauguin. Bonnard was especially drawn to the prints which, he said, "showed me that color alone will suffice to express all one wants to see." He began to incorporate their flat fields of color, tilted perspective, and arbitrary placement of figures into his own work, earning the nickname "Nabi très japonard," or "the very Japanese Nabi," from his associates.

Though these early influences are evident throughout his career, Bonnard eventually parted from the Nabis in the early twentieth century. Conscious of the ever-changing currents in French art at the time, he decided to maintain his independence in order to draw upon many sources without being restricted by any single philosophy. His sketchlike brushwork is notably similar to that of the Impressionists, yet his paintings are filled not with natural light, but an emotive use of color similar to that of the Fauves and the Post-Impressionists, though less violent.

Soon after the turn of the century, Bonnard began to take extended holidays in the South of France. In 1926 he purchased "Le Bosquet" ("The Grove"), a small home in Le Cannet, a village on the Côte d'Azur, where he and his wife, Marthe, spent the majority of their remaining years. The over 300 interiors, landscapes, and bathers Bonnard painted there are infused with Mediterranean light and colors ranging from marine blues and greens to golds, maroons, oranges, and purples. Painted just two years before Bonnard's death, *View from the Artist's Studio* is an important work from this late period. Not bound by literal color, Bonnard applied thin layers of intense, vibrant hues to the large canvas. The composition dissolves into a dazzling surface, bordering on abstraction, yet still retains the overall impression of the landscape. The scene is bathed in atmospheric light, most intense over a field of pastel blues, greens, pinks, lavenders, and yellows. An expanded horizon and manipulated perspective create an ambiguous sense of depth. A central golden path anchors the composition, working with the dark greens and purples in the background to pull the eye back and up into the blazing orange and maroon sky. JVC

Pierre Bonnard (French, 1867–1947). *View from the Artist's Studio, Le Cannet (Vue de l'atélier du Midi, Le Cannet)*, 1945. Oil on canvas. 37 1/2 x 49 1/2 inches. Gift of Mr. and Mrs. Harry Lynde Bradley (M1952.7).

Pablo Picasso
The Cock of the Liberation, 1944

The exuberant color and energetic brushwork of Pablo Picasso's *The Cock of the Liberation*, gives expression to the exultation of all of France upon their release from fascist tyranny. Long a recognized and potent symbol of the French people, the Gallic cock has here, once again, attained its vibrant splendor. Considered by many the most important artist of the twentieth century, Picasso only infrequently referenced contemporary events, most notably with *Guernica* in 1937. But whereas *Guernica* was a monochromatic and spatially fractured protest, *The Cock of the Liberation* became a cry of victory and optimism. The artist had often used images of animals as symbols in his works and here the cock with its associations to pride, an often ferocious tenacity, and its vociferous heralding of a new day, serves as a strikingly apt totem of endurance, strength, and hope.

The beautiful and complex layering of colors and the active brushwork in this painting are notable as Picasso more customarily employed a limited palette and a more restrained and controlled application of paint. Possibly the Spanish artist was seeking meaning not only in a familiar symbol, but also in the bright, chromatically rich, and emphatically drawn surface—characteristics historically associated with great achievements in French painting. In any case this image serves as an excellent reminder of the artist's protean achievements and his willingness to use and to joy in exploring familiar symbols in combination with the most modern of techniques and approaches. FL

Pablo Picasso (Spanish, 1881–1973). *The Cock of the Liberation*, 1944. Oil on canvas. 39 1/2 x 31 3/4 inches. Gift of Mrs. Harry Lynde Bradley (M1959.372).

Alberto Giacometti
Large Seated Woman (Grande Femme assise), 1958

Alberto Giacometti is considered one of the most influential European artists of the twentieth century. While his early sculptures of the 1920s and 1930s are associated with Cubism and Surrealism, Giacometti rejected the strict dogma associated with these movements, preferring instead to concentrate on his personal struggle with the visual perception of mass and spatial relationships between the human form and its environment. In order to apprehend a person as a whole, Giacometti placed the figure at a distance, resulting in blurred facial features and other distinguishing characteristics. By 1945 he had abandoned the traditional use of a model in the studio, choosing instead to work from memory. His expressionistically modeled figures became anonymous and emaciated, tenuously maintaining their form against an encroaching space.

During the 1950s, Giacometti returned to the practice of using a model in search of natural representation. His wife, Annette, sat for many of his female forms of this period, including the *Large Seated Woman* of 1958. The second of six casts, this bronze sculpture retains the elongated, slender proportions that emerged a decade earlier, although the facial features are now clearly defined. The half-length woman sits with impeccable posture and her hands neatly folded in her lap; she stares directly ahead with a blank, unrevealing expression. Her weight is supported by a beam that rises from a rectangular base and disappears beneath her torso—an unconventional base that makes the heavy bronze figure appear to float in space. JVC

Alberto Giacometti (Swiss, 1901–1966). *Large Seated Woman (Grande Femme assise)*, 1958. Bronze. 32 1/2 x 8 x 12 inches. Gift of Mrs. Harry Lynde Bradley (M1964.52).

Early Twentieth-Century American Painting, Sculpture, and Decorative Arts

The Milwaukee Art Museum's extensive collections of early twentieth-century American art reflect the museum's involvement with the introduction of modern art in this country. As early as 1914, just one year after the historic Armory Show in New York, the Milwaukee Art Society presented "The Modern Spirit," an exhibition that included works by Duchamp, Léger, and Manierre Dawson's painting *Prognostic*, eventually acquired by the museum in 1967. In 1918 the newly renamed

Milwaukee Art Institute followed with an exhibition of American Modernists such as Sheeler and Demuth. The next year, Board of Trustees President Samuel O. Buckner donated his collection of European and American paintings, the first major gift to the Milwaukee Art Institute. Henri's *Dutch Joe* and Hassam's *The Bathers* were part of this gift. The next large donation of early modern American painting, including works by Dove and O'Keeffe, came in 1957 from Mrs. Edward C. Wehr.

An important collection of works by the School of the Eight—Robert Henri and seven of his associates who exhibited together in 1908—came to the Milwaukee Art Museum from the Donald B. Abert family. A total of eighteen paintings given between 1965 and 1987 include Henri's *The Art Student (Miss Josephine Nivison)*, Glackens's *Breezy Day, Tugboats, New York Harbor*, and Prendergast's *Picnic by the Sea*. Other important sources of works from this period include the established Layton Collection, which acquired Bellows's *Sawdust Trail* in 1964 and the Niedecken *Combination Table* in 1993, while masterpieces by Avery and O'Keeffe have entered the museum through the long-standing Mrs. Harry Lynde Bradley Collection. Modern American decorative arts are highlighted by a strong collection of 1950s and

1960s design, including works by the Eames, Eero Saarinen, and several rare works by Noguchi.

The museum also has in its holdings two important archives of prominent artists with Wisconsin ties. In 1945 the Milwaukee Art Institute organized "When Democracy Builds," a retrospective exhibition of Frank Lloyd Wright that broke all previous attendance records for the institution. Continued interest in Wright's work led to the acquisition in 1976 of the Prairie School Archives, consisting of drawings and documents from collaborative projects between Wright and Milwaukee interior designer George Mann Niedecken. In 1997 the museum acquired the archive of Brooks Stevens, a major twentieth-century industrial designer who was based in Milwaukee and is best known for his work on the Miller Beer logo and the Excalibur car. The archive was a gift of the Stevens family and the Milwaukee Institute of Art and Design, which previously held Stevens's models, drawings, photographs, and business records.

Future plans include a focus on continuing to acquire works by African-American artists from this period, complementing existing holdings of works by Jones and Tanner, among others. MA

Robert Henri
The Art Student (Miss Josephine Nivison), 1906

Well respected as both an artist and teacher, Robert Henri was a driving force in American art at the turn of the century. He encouraged his students and colleagues to experiment in their search for a democratic style that reflected urban America. As a direct challenge to the conservative elitism of the National Academy of Arts, Henri organized an independent exhibition in 1908 at the Macbeth Galleries in New York that featured the realist painters subsequently known as The Eight. The exhibition opened the door for future independent exhibitions promoting American modern art, such as the Armory Show of 1913.

In addition to urban scenes, Henri excelled at portraiture. Inspired by seventeenth-century Dutch and Spanish genre painters, he rejected nineteenth-century conventions of society portraiture in favor of painting immigrants, children, artists, and entertainers in their everyday garb or in the costume of their profession. *The Art Student*, painted just two years prior to the Macbeth exhibition, is an exemplary portrait that Henri proudly exhibited at least seven times in 1906–1908. The stark background and dark smock of Josephine Nivison (one of Henri's students) are painted with long, loose brush strokes. Swift, animated strokes enliven her face and those parts of her dress that appear from under her painter's smock. Henri paid particularly close attention to the facial features in an effort to convey the sitter's psychological state. As if caught at a moment of rest, a disheveled yet dignified artist stands slouched with her brushes at her side and her smock casually sliding off her shoulders. JVC

Robert Henri (American, 1865–1929). *The Art Student (Miss Josephine Nivison)*, 1906. Oil on canvas. 77 1/4 x 38 1/2 inches. Purchase (M1965.34).

William Glackens
Breezy Day, Tugboats, New York Harbor, ca. 1910

Best known as a member of the group of American realist painters The Eight, William Glackens began his artistic career as a successful illustrator in Philadelphia. Admired for his ability to memorize a specific time and place, Glackens was able to transfer his illustrative skills to the canvas. His paintings of New York parks, harbors, theaters, and other public spaces are embedded with narrative cues that enable the viewer to readily identify the location. In addition to its identifying title, the harbor scene of *Breezy Day, Tugboats, New York Harbor* is differentiated by the Statue of Liberty in the distance and the emerging city skyline on the horizon.

Breezy Day, Tugboats represents a shift in Glackens's style. His early works, done around the turn of the century, are painted with the dark, earthy colors of the Dutch Old Masters and in a style indebted to late nineteenth-century French artists, especially Edouard Manet. Trips to Europe in 1906 and 1909, combined with the influence of associates Ernest Lawson and Maurice Prendergast, led Glackens gradually to adopt a brighter palette similar to that of Pierre-Auguste Renoir. The full transition is evident in *Breezy Day, Tugboats*: the choppy water is painted with short, quick strokes of bright blue and white over murky greens and maroons, while the luminous sky is a shower of diagonal pastel pinks, blues, and greens. With a few strokes of matching paint, the boats' reflections are integrated into the water. The liberal application of the paint overall leaves a wonderfully textured surface, most pronounced in the puffs of smoke rising from the tugboats and connecting sky and water. JVC

William Glackens (American, 1870–1938). *Breezy Day, Tugboats, New York Harbor*, ca. 1910. Oil on canvas. 26 x 31 3/4 inches. Gift of Mr. and Mrs. Donald B. Abert and Mrs. Barbara Abert Tooman (M1974.230).

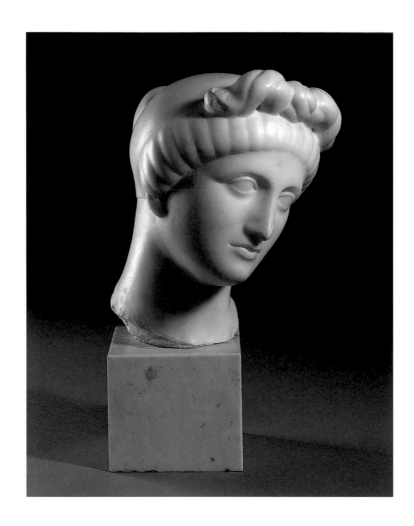

Elie Nadelman
Classical Head with Headdress, 1908–1909

Elie Nadelman is considered one of the pioneers of modern art. Before moving to the United States from his native Poland, Nadelman lived in Munich and in Paris, where he met Picasso and was influential in the early development of Cubism. His work was included in the 1913 Armory Show in New York, the momentous exhibition that first introduced European modern art to the American public. Nadelman moved to New York in 1914 and began exhibiting his work at Alfred Stieglitz's "291" gallery. He soon established himself as a prominent member of the New York art world and his influence can be seen in the work of various American artists including George Bellows and Gaston Lachaise. Nadelman's own later work was informed by his interest in American folk art, of which he amassed a large and significant collection.

Nadelman's paramount concern in his sculpture was form. His reduction of the human figure to basic geometric shapes such as cylinders, ovals, and planes coincided with early experiments in abstraction by Picasso and Braque in their development of the Cubist movement in painting. *Classical Head with Headdress*, one of a series of elegant, white marble sculptures carved by Nadelman between 1905 and 1911 when he was living in Paris, exemplifies this distillation of form. While Nadelman presented the head as though it was a fragment, and the work's idealized, generic features and classical S-form headdress recall antique sculpture, the sculpture is unmistakably modern in its simplification of surface and volumes. MA

Elie Nadelman (American, b. Poland, 1882–1946). *Classical Head with Headdress*, 1908–1909. Marble. 14 x 8 x 12 inches. Purchase, Virginia Booth Vogel Acquisition Fund (M1979.15).

Gorham Manufacturing Co.
Martelé Three-Handled Cup and Stand, ca. 1910

This beautifully hand-wrought cup and stand is an exquisite example of Martelé silver, a line of luxury objects produced by the Gorham Manufacturing Company from 1897 to 1912. Guided by the principles of the Arts and Crafts movement, mainly the rejection of mass-production and the ennoblement of the craftsman, the Martelé line was developed under the artistic direction of William C. Codman, an English silversmith brought to Gorham by its director Edward Holbrook in 1891. The teams of designers and silversmiths who developed the Martelé line adhered to three basic principles: each piece should be hammered and decorated by hand (*martelé* means "hammered" in French); there should be an intimate connection between the designer and the craftsman; and pieces should be designed in a style "of its own century." At the turn of the century, that style was Art Nouveau, distinguished by its fluid lines and swirling, organic ornament.

Following these tenets, Gorham produced objects in a uniquely American style of silversmithing that bridged the gap between the English Arts and Crafts movement and continental Art Nouveau. This oversized, bulbous cup features an intricate design of sweeping water lilies and twisting leaves outlined with black silver sulfide residue, the result of intentional oxidation. The design is chased from a soft, hammered surface with what Gorham advertised as a "soft mist texture." The three loop handles that turn out from the circular rim are echoed in the wavy, spreading foot and stand. Though it was a financial and artistic success, the Martelé line was relatively short-lived. By the second decade of the twentieth century, these opulent pieces were out of fashion. The line was discontinued and resurrected only for a few private commissions into the 1930s. JVC

Gorham Manufacturing Co. (Providence, Rhode Island, founded 1831). *Martelé Three-Handled Cup and Stand*, ca. 1910. Silver. Cup H. 11 inches, dia. 6 7/8 inches; stand H. 1 1/2 inches, dia. 11 1/8 inches. Gift of Warren Gilson (M1995.517a,b).

Maurice B. Prendergast
Picnic by the Sea, 1913–15

Reared in Boston, Maurice Prendergast began his formal training at the Académie Julian in Paris in 1891. During his three years in Paris with his brother Charles, also a gifted artist, he was exposed to Whistler and Japanese prints, Impressionist bourgeois subjects, Art Nouveau, and the Post-Impressionism of Seurat, Gauguin, and the Nabis. Upon his return to Boston in 1894, he produced watercolors, monotypes, and oil paintings frequently depicting crowds enjoying themselves in parks or at the seashore. Though he showed with the group The Eight in 1908 and shared their interest in urban subjects and a generally anti-academic attitude, Prendergast's high-keyed, quasi-abstract style was resolutely modern and established him as one of America's most important early Modernists. His paintings became increasingly stylized: the subjects more Arcadian, the brush strokes heavier, and the color patterns almost a tapestry of mosaiclike marks.

Emblematic of Prendergast's late style, the idyllic *Picnic by the Sea* is reminiscent of Puvis de Chavannes or Cézanne, punctuated, however, by the central figure in a contemporary striped bathing costume. The banded composition recalls aspects of Seurat or Gauguin, while the broad strokes evoke Matisse and the Fauves. Nevertheless, from all these influences, Prendergast made something uniquely his own— gently otherworldly, decoratively patterned, and rich with jewellike color. Prendergast often reworked his paintings over a period of time and the upper register of *Picnic by the Sea* reveals an underpainting suggesting a grove of trees. The process of painting over such a background into a banded sky may explain the generally blue-green tonality of this work. Interestingly, the patterned, gilded frame was provided by his brother Charles, in whose collection the painting remained for many years. RB

Maurice B. Prendergast (American, 1858–1924). *Picnic by the Sea*, 1913–15. Oil on canvas. 23 x 32 inches. Gift of the Donald B. Abert Family in His Memory, by Exchange (M1986.49).

George Bellows
The Sawdust Trail, 1916

Growing up in Columbus, Ohio, George Bellows was a talented artist and a star baseball player. In his senior year at Ohio State University in 1904, he received numerous offers to play in the major leagues, but chose instead to pursue an art career. He moved to New York, where he studied at the New York School of Art under Robert Henri, the leader of the Ashcan School, disdainfully named for the group's chosen subject matter—gritty scenes of contemporary urban life. Bellows's urban themes, realist style, and dark palette of his early work were directly linked to Henri's influence. He was profoundly affected by the 1913 Armory Show, where the work of Picasso, van Gogh, Matisse, and other European Modernists was first introduced to an American audience. Bellows incorporated into his own work the contemporary theories of color and design practiced by these artists; his palette brightened and color became an organizing element in his compositions. By the end of his career, Bellows had established himself as one of the greatest American artists of his time.

In 1915 Bellows accompanied radical writer John Reed to Philadelphia to cover evangelist Billy Sunday's revival meetings for a magazine. Based on drawings made for the story, Bellows painted *The Sawdust Trail.* Bellows thought Sunday was "the worst thing that ever happened to America…the death to imagination, to spirituality, to art!" The "sawdust trail" refers both to the convert's path to the altar and Sunday's cross-country evangelical circuit. In the painting, Billy Sunday is reaching down from the stage, grasping a convert's hand while attendees are theatrically overcome with rapture. MA

George Bellows (American, 1882–1925). *The Sawdust Trail,* 1916. Oil on canvas. 63 x 45 1/8 inches. Purchase, Layton Art Collection (L1964.7).

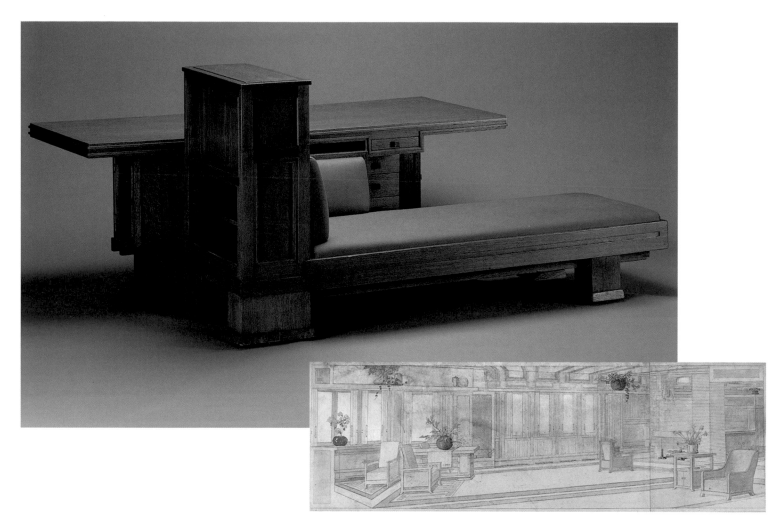

George Mann Niedecken
Combination Table-Couch-Desk-Lamp (lamp missing), 1910–11
Presentation drawing of the living room, Frederick Robie House, Chicago, 1909–10

The Milwaukee interior decorator George Mann Niedecken is best known for his work with Frank Lloyd Wright, whose Prairie style homes exemplify their shared ideal of an integrated, organic architecture. Initially a delineator and muralist for the Wright Studio, Niedecken became one of the architect's most trusted collaborators, designing furniture, textiles, and lighting for eleven of Wright's houses between 1907 and 1918.

For the Edward Irving House's broad, uninterrupted living room, Niedecken created massive furniture that divided and anchored the space while subtly echoing the overall form of the house. This ingenious combination piece stood in front of a huge brick fireplace, forming a freestanding inglenook.

Its multiple functions allowed Niedecken to retain the openness of Wright's plan without sacrificing comfort or utility.

Whether working for an architect or directly with his own clients, Niedecken created presentation drawings to articulate his vision for an interior. This drawing for Wright's Robie House reveals his sensitive draftsmanship and remarkable ability to harmonize disparate elements.

Extensive records from Niedecken's firm are preserved in the museum's Prairie Archives and may be viewed by appointment. The archive also holds material related to many architects and designers of the Prairie School. JC

George Mann Niedecken (American, 1878–1945). *Combination Table-Couch-Desk-Lamp (lamp missing)*, 1910–11. Designed for the Edward Irving House, Decatur, Illinois. Oak with reproduction upholstery. 43 x 84 x 58 inches . Purchase, Layton Art Collection (L1993.3). *Presentation drawing of the living room, Frederick Robie House, Chicago*, 1909–10. Pencil and watercolor on paper. 10 1/4 x 31 1/4 inches. Prairie Archives (PA1977.1.1).

Arthur Dove
Sunrise, 1924

Running parallel to the pragmatism and down-to-earth realism that are often associated with American society is a current of idealism and transcendentalism. In the first three decades of the twentieth century, it was this second strain that held sway over a number of American artists. Arthur Dove, along with his contemporaries associated with the photographer and New York gallery owner Alfred Stieglitz, posited that a painting should express an idea, not necessarily present a recognizable image. One of the earliest practitioners of nonobjective abstraction in painting, Dove sought to depict the ideas contained in the world, not the world's specific and particular forms.

The artist once said that "the most important thing is the statement of color," and it was primarily through color that he searched for the essential characteristics of the nature that was so often the subject of his work. *Sunrise* presents continuous waves of color, radiating outward like ripples on a pond. Such suggestive movement releases the image from the role of picturing a sunrise and allows viewers to sense the temporal and spiritual, as well as the visual, qualities of the quickly changing light. At the same time the clarity and sureness of the artist's touch give this painted "idea" a physical solidity. Though often seen in relation to the spiritual and mystical experiments in abstraction that were being carried on by Wassily Kandinsky in Europe, Dove's investigations into abstraction have a more material base that links him to an earlier generation of American landscape artists, such as the Luminists and the Hudson River School. FL

Arthur Dove (American, 1880–1946). *Sunrise*, 1924. Oil on plywood. 18/x 20 7/8 inches. Gift of Mrs. Edward L. Wehr (M1960.32).

Gaston Lachaise
Standing Woman, 1932

Sculptor Gaston Lachaise learned craftsmanship from his father, a dedicated cabinetmaker. Born in Paris, Lachaise studied at the Ecole Bernard Palissy and the Académie National de Beaux-Arts, and despite his youth, exhibited his work in the Paris Salons of 1899, 1901, 1902, and 1904. While a student, he fell in love with Isabel Nagle, a Canadian-American. He moved to Boston in 1906 to be with her; the two married in 1915, after her divorce from her first husband. In Boston, Lachaise worked with sculptor Henry Hudson Kitson, and through Isabel's son Edward, met several Harvard University students who would later be associated with *The Dial*, an arts magazine that advocated Lachaise's work and provided him with financial support. In 1912 Lachaise followed Kitson to New York, where he also became an assistant to sculptor Paul Manship. He was included in the 1913 Armory Show and had his first solo exhibition at the Bourgeois Gallery in 1918. In 1935, eight months before the artist's untimely death from acute leukemia, The Museum of Modern Art gave him a retrospective.

Milwaukee's *Standing Woman*, or *Heroic Woman*, is the fourth of eight casts made in 1980; the single cast made during the artist's lifetime has been on display at The Museum of Modern Art since the 1940s. *Standing Woman* demonstrates Lachaise's fascination with the female figure and his desire to express its power through the exaggeration of physical attributes. The inspiration for this piece, and many of Lachaise's female figures, was his wife, Isabel. According to Gerald Nordland, the Milwaukee Art Museum's director when the sculpture was acquired in 1980, *Standing Woman* "is the embodiment of the artist's lifelong effort to express the imperious goddess quality in the heroic scale." BF

Gaston Lachaise (American, 1882–1935). *Standing Woman*, 1932. Bronze. 88 1/2 x 41 1/2 x 24 3/4 inches. Purchase, Virginia Booth Vogel Acquisition Fund (M1980.172).

Lois Mailou Jones
The Ascent of Ethiopia, 1932

Born in Boston and trained in a number of the city's leading art schools, Lois Mailou Jones had just begun her long teaching career at Howard University in Washington, D.C., when she painted perhaps her most significant early work, *The Ascent of Ethiopia*. Exhibited in the final Harmon Foundation annual in 1933, it helped to launch her career; Jones went on to study and work in Paris, Africa, and Haiti, synthesizing these diverse influences into stylistic variations that evoke her African-American heritage.

The Ascent of Ethiopia reflects the young artist coming under the influence of significant African-American artists of the period, such as Meta Warwick Fuller and Aaron Douglas. Fuller had acted as something of a mentor to Jones, and her bronze sculpture *The Awakening of Ethiopia* (ca. 1914) shows a partially mummy-wrapped Egyptian queen awakening to a consciousness of her civilization's past glory. While this African queen seems a direct precedent for the profile figure in Jones's painting, the latter's concentric geometric patterns and graduated tones suggest the impact of Douglas's Cubist-inspired work. The most highly geometricized work of Jones's early period, *The Ascent of Ethiopia* reflects both the stylization of Art Deco (as well as the popular indigo color of the period) and her extensive training and practice in textile design. The work clearly presents the great achievements of past African cultures as the basis for the then-current flowering of African-American culture, particularly in the arts, called the Harlem Renaissance. Through both her African-inspired stylization and her consciously proud content, Jones created an icon of African-American cultural heritage that speaks not only to her time, but also to future generations. RB

Lois Mailou Jones (American, 1906–1998). *The Ascent of Ethiopia*, 1932. Oil on canvas. 23 1/2 x 17 1/4 inches. Purchase, African-American Art Acquisition Fund and matching funds from Suzanne and Richard Pieper, with additional support from Arthur and Dorothy Nelle Sanders (M1993.191).

Brooks Stevens
Model for the Plankinton "Land-Yacht," ca. 1936
Interior Perspective of the "Jetstream" Pontoon Boat, 1959

The youngest Charter Fellow of the American Society of Industrial Designers, Brooks Stevens began his career in the early 1930s, when streamlined trains and sleek, chromed appliances epitomized glamour and modernity. The "land-yacht" he designed for the young millionaire William Woods Plankinton, Jr., drew crowds and press photographers on its regular traverse between New York, Milwaukee, and California, with extended detours for hunting and fishing. The trailer slept six and was designed for self-sufficiency, with a kitchen, bathroom and shower, living room, radio and telephone; bunks for the chauffeur and cook were in the tractor. Its aerodynamic form, reinforced by the soft, sweeping lines of the grille, fenders, and two-toned body panels, gave the massive conveyance an air of ease and speed. A brilliant expression of wealth and stylish independence, the land-yacht was a staple in Stevens's early publicity photographs.

Stevens's firm designed everything from product logos and kitchenware to outboard motors and office interiors, but his first love was transportation design. His extensive work for Evinrude Motors included a series of concept boats like the 1959 *Jetstream*, an imaginative exercise in combining high-speed performance with "family boat" design. Its pontoons were to be raised at normal speeds, then lowered to reach full velocity without additional horsepower. True to its name, the *Jetstream*'s luxurious interior is styled much like an aircraft, with a steering column, crash pad, panoramic windshield, and bucket seats. Like the land-yacht, it exuded comfort and class, offering a burnished image of the good life to affluent consumers.

The Brooks Stevens Archive at the Milwaukee Art Museum includes extensive photographic documentation of the firm's designs as well as correspondence, clipping files, blueprints, sketches, and presentation renderings. It is available to researchers by appointment. JC

Brooks Stevens (American, 1911–1995). *Model for the Plankinton "Land-Yacht,"* ca. 1936. Designed for William Woods Plankinton, Jr. Painted wood, aluminum, stainless steel, and wire. 7 x 9 3/8 x 37 inches. *Interior Perspective of the "Jetstream" Pontoon Boat,* 1959. Designed for Evinrude Motors, Milwaukee. Colored pencil and gouache on paper. 19 x 25 1/4 inches. Gifts of the Brooks Stevens Family and the Milwaukee Institute of Art and Design (M1997.232 and M1997.265.3).

Ben Shahn
Jesus Exalted in Song, 1939

Ben Shahn's art tells stories. "Like my father and grandfather," the artist said, "I am a good storyteller." Born in Lithuania, Shahn moved to Brooklyn, New York, when he was eight. While attending high school at night, he worked as a lithographer's apprentice. Between 1919 and 1922, he enrolled in classes at New York University, City College of New York, and the National Academy of Design. Upon completion of school he toured Europe, where he developed an appreciation of the work of Paul Cézanne. In 1929 Shahn produced a series of watercolors depicting the Dreyfus Affair, a notorious trial in which a Jewish French artillery officer was unjustly condemned. Shahn's narrative skills caught the attention of Diego Rivera, who hired the aspiring artist to assist on his Rockefeller Center mural project in 1933. Subsequently, Shahn established his own career and received a number of public mural commissions.

Although many consider him America's foremost Social Realist painter, the artist saw himself as expressing personal, not societal, views.

Jesus Exalted in Song is one of Shahn's "Sunday paintings"— that is, he painted it on the one day of the week he did not devote to commissions. Overlaying the fundamentally realist approach are exaggerated facial features that reflect Shahn's interest in the work of German Expressionist George Grosz. The relaxed woman in the foreground, the serious man in the center, and the bored man picking at his nose in the background create a visual dialogue of expressions. Like many of Shahn's paintings, *Jesus Exalted in Song* records a range of human emotions and reactions, allowing viewers to interpret the story on a number of levels. BF

Ben Shahn (American, 1898–1969). *Jesus Exalted in Song,* 1939. Tempera on cardboard on hardboard. 22 x 33 inches. Purchase (M1948.1).

Milton Avery
Red Rock Falls, 1947

In an age in which many of his contemporaries were seeking the heroic and the monumental, Milton Avery unabashedly embraced the lyrical and pastoral in both his content and technique. Unlike other American painters, rather than turning to the infinite expanse of the landscape or the mighty cataracts of the Niagara River, Avery found his quiet but powerful subject matter in the rolling hills of New England and the almost placid flow of smaller, though nonetheless beautiful, waterfalls of local tributaries.

At first glance *Red Rock Falls* appears almost childlike in its simplicity. Broad planes of predominantly warm hues, pieced together like a jigsaw puzzle, suggest the most rudimentary of landscape forms. Sky, water, and land masses are blocked out on the surface with the most economical of means. On closer inspection delicate modulations of scumbled color add a sense of luminosity to the scene. Edges seem to blur with slight chromatic oscillation. Pinks, blues, and violets collect, swirl, and then dissipate, like the quiet eddies of the stream. Scratches on the painted canvas affirm the decorative quality of the two-dimensional surface. Eschewing the *bravura* slash of the heavily loaded brush, Avery slowed down to a quiet and patient contemplation of subtle nuances in both his observation and execution. Careful study of *Red Rock Falls* reveals why artists such as Mark Rothko and Helen Frankenthaler found in Avery what Rothko once called his "inner power which can be achieved only by those gifted with magical means, by those born to sing." FL

Milton Avery (American, 1885–1965). *Red Rock Falls*, 1947. Oil on canvas. 33 7/8 x 43 7/8 inches. Gift of Mrs. Harry Lynde Bradley (M1977.70).

Isamu Noguchi
Sofa and Ottoman, ca. 1950

Isamu Noguchi is most celebrated for his sculpture and serene, austere "stone gardens," yet his furniture and lighting designs have become icons of the post-World War II American home. However influential, his forays into product design were limited in number. Throughout his career Noguchi's primary ambition was the integration of sculpture into a harmoniously planned landscape. As his reputation as an artist grew, this concern gradually led him away from design.

Herman Miller's collections featured Noguchi's furniture from 1945 to 1951, and all of his designs for the company reflect an uncompromising sculptural approach. Noguchi's form-language was deeply influenced by the work of Constantin Brancusi, Joan Miró, and Jean Arp, although he himself credited the traditional Japanese respect for natural form rather than other artists. His regard for the ideas of the American visionary architect R. Buckminster Fuller, who sought to describe the essential structures of the universe, reinforced his response to Brancusi's smooth, reductive forms. The influence of Miró's and Arp's biomorphic Surrealism can be traced in many of Noguchi's sculptures from the late 1930s and early 1940s, and it is their vocabulary of parabolic curves and interlocking forms that informed his furniture designs. This sensuous, elegant sofa and ottoman extend Noguchi's fascination with taut, arching curves into the lush realm of upholstery. Its low profile is well attuned to the open-plan homes of the 1950s, and its soft undulations would subtly enliven the spare lines of Modernist interiors. The sofa's form also suggests the precise, clipped waves of shrubbery in traditional Japanese gardens, which Noguchi greatly admired. JC

Isamu Noguchi (American, 1904–1988). *Sofa and Ottoman*, ca. 1950. Produced by Herman Miller, Inc., Zeeland, Michigan. Maple laminate with replaced wool-blend upholstery. Sofa 30 x 114 x 45 inches; ottoman 15 x 53 x 31 inches. Gift of Gilbert and J. Dorothy Palay (M1990.60.1, 2).

Georgia O'Keeffe
Poppies, 1950

Although associated with New York because of her professional and marital relationship with the pioneering, avant-garde art dealer and photographer Alfred Stieglitz, and with the environs of Santa Fe that became her home and the inspiration and subject of much of her art, Georgia O'Keeffe was a Midwesterner. She was born in Spring Green, Wisconsin, and attended high school in Madison before moving with her family to Virginia. Her formal studies were in Chicago and especially New York with Arthur Wesley Dow, whose principles of abstract design were influenced by his studies of the art of China and Japan. O'Keeffe was recognized early by Stieglitz as creating a formally advanced art that verged on abstraction, though she never abandoned her deep response to and observation of nature; by the 1950s both her art and her person had come to embody the independent American spirit.

O'Keeffe painted her first mature flower subjects in 1919. Despite her insistence that the scale of the flowers was intended simply to focus the viewer's attention, their imagery was repeatedly discussed in psychosexual terms—a viewpoint she consistently rejected. Employing her largest typical format for *Poppies,* O'Keeffe set the forms of the flowers with their contrasting centers and petals whirling against a Southwestern blue sky. The fecund enfolding of the petals, their skyward levitation, and their enveloping scale suggest the generative forces of nature, O'Keeffe's life-long theme. RB

Georgia O'Keeffe (American, 1887–1986). *Poppies,* 1950. Oil on canvas. 36 x 30 inches. Gift of Mrs. Harry Lynde Bradley (M1977.133).

Stuart Davis
Stele, 1956

Stuart Davis fully subscribed to his teacher Robert Henri's belief that everyday life was a proper subject for artists. Seeking a style that could express the modern experience, Davis combined the aesthetic lessons of Cubism with the vernacular imagery of the United States in the early and mid-twentieth century. The rhythms of jazz, the dynamic energy of the urban environment, the bright and emphatic color of gasoline stations and chain store façades, all served as source material for Davis's brand of Modernism.

Stele presents a stark and graphic series of "signs" that Davis put together to represent the modern urban environment. This painted version of a stele—an ancient stone megalith that served as a gravestone or marker commemorating the life of an individual of some stature within society—makes reference, however, not to a person, but to the values and style of the times themselves. Using the elements and processes specific to painting (line, color, shape, texture), Davis emphasized the uncompromising edges of an urban geometry. Floating spirals and circles establish a sense of rhythm and beat as well as an abstract visual composition. The palette is strictly limited and stylized; the contrasting and uninflected hues imply the harsh equivalents of artificial light. The word "Tabac," the French sign for a tobacconist's shop, is a reminder that in 1928 Davis went to Paris, where he spent eighteen months absorbing the lessons of European Modernism. FL

Stuart Davis (American, 1894–1964). *Stele,* 1956. Oil on canvas. 52 1/4 x 40 1/8 inches. Gift of Mr. and Mrs. Harry Lynde Bradley (M1963.129).

Contemporary Art

Contemporary art has always been a central focus of the Milwaukee Art Museum: both the Layton Art Gallery and the Milwaukee Art Institute actively collected the art of their time. With their reorganization as the Milwaukee Art Center in 1957, the museum's major support group, Friends of Art, was formed, choosing as its first purchases works by Ben Nicholson and Henry Moore. The Milwaukee Art Center also quickly became known for originating contemporary exhibitions, many

of which traveled nationally, such as "Pop Art: the American Tradition" (1965), "Aspects of a New Realism" (1969), and "Emergence and Progression: Six Contemporary Artists" (1979). That tradition has continued into the Milwaukee Art Museum with exhibitions such as "New Figuration in America" (1982), "Warhol/Beuys/Polke" (1987), "Word as Image: American Art 1960–1990" (1990), and "Identity Crises: Self-Portraiture at the End of the Century" (1997). From the 1960s to the present, the institution has also organized many one-person exhibitions of contemporary artists, including Botero, Twombly, Pearlstein, Winsor, and Nutt, and hosted major traveling retrospectives of Thiebaud, Martin, and Tansey, among others.

A natural corollary of this very active exhibition program has been the achievement of a comprehensive collection of contemporary art, particularly American art, from 1960 to the present. The collection today has strong representation of most major movements and directions since the 1960s: Pop Art, Minimalism, Post-Minimalism, Conceptual Art, New Realism, Neo-Expressionism, and the political and personal statements of the 1990s. It also includes important regional statements by Chicago and Wisconsin-area artists.

Key to this strength has been the extraordinary generosity of donors and museum support groups. The collection of Mrs. Henry Lynde Bradley, added to by her daughter Jane Bradley Pettit, brought works ranging from Rothko, Hofmann, David Smith, and Diebenkorn, to Warhol, Katz, and Shapiro. The exceptional commitment of the Friends of Art has resulted in acquisitions by Calder, Motherwell, Stella, Irwin, Rothenberg, and, joining with other funds, Johns. The Contemporary Art Society, through its biennial art auction, has made significant contributions of more recent works by artists such as Schnabel, Puryear, Viola, Gober, and Kiki Smith. A strong commitment to the craft media is reflected in works by Voulkos, Littleton, Chihuly, and Sheila Hicks, and major gifts of recent glass sculpture thanks to the Sheldon Barnett Family and Don and Carol Wiiken. Contemporary decorative arts, too, is a continuing part of the collection, with important pieces by Sottsass, Gehry, and Starck.

The contemporary art collections seek both to continue the traditions of the museum's founding institutions and to assure that the cultural meanings and relevancies that can be drawn from earlier portions of the collection can also be found through the art of today. RB

Mark Rothko
Green, Red, Blue, 1955

At age ten, Mark Rothko immigrated with his family to America from Dvinsk, Russia. He attended Yale University and the Art Students League in New York, and worked for the WPA in the 1930s. By the early 1940s he was part of a group of artists in New York, eventually known as the Abstract Expressionists, who sought to convey deeply emotional states through abstract means. Rothko was particularly close to Clyfford Still, Adolph Gottlieb, and Barnett Newman; like them, he sought to communicate through broad areas of color rather than activated brushwork. Affected by Surrealist-inspired interest in myth, Friedrich Nietzsche's *Birth of Tragedy*, the horrors of World War II and the Holocaust, and the emerging philosophy of Existentialism, Rothko formulated the notion that art must be "tragic"—an attempt at transcendence in the face of inevitable death.

Having developed by 1950 the basic formal elements of his compositions, Rothko worked for the next two decades with a format of fluttering rectangles of color set against a fluid background. His works of the early to mid–1950s have a relatively high-keyed color range, although the goal was always to communicate a sense of the evanescence of life. *Green, Red, Blue* is unusual in Rothko's output in that it incorporates three distinct colors. However, these sharper colors, with their variation in tone, texture, and their delicately brushed edges, create a luminescence and a subtle movement typical of all Rothko's works. The rectangles seem to advance or recede, grow or submerge into the background, forever poised on the very edge of existence. Despite his desire for a transcendent art, by the early 1960s Rothko's vision turned somber and the paintings grew darker and less animated. In 1970, perhaps succumbing to his tragic world-view, the artist took his own life. RB

Mark Rothko (American, 1903–1970). *Green, Red, Blue*, 1955. Oil on canvas. 81 1/2 x 77 3/4 inches. Gift of Mrs. Harry Lynde Bradley (M1977.140).

Hans Hofmann
Dew and Dusk, 1957

For many American artists, Hans Hofmann was the primary conduit for transmitting the styles and theories of early twentieth-century European Modernism to the United States. Born in Germany in 1880, Hofmann studied art in Paris between 1903 and 1914. There he became aware of the works and experiments of the most renowned modern artists, including Picasso, Braque, and Matisse. Having established an art school in Munich in 1915, by the time he arrived in the United States in 1932, he was an accomplished teacher and theorist of modern art. He conveyed to a younger generation of American artists a liberating and challenging excitement, enthusiasm, and sense of seriousness.

Hofmann believed artists should understand and master the particular effects of the formal elements of painting. One of his central lessons revolved around how various colors appear to recede into and project outward from the surface of a painting, without what Hofmann considered outmoded conventions of illusionistic spatial depth, such as linear and atmospheric perspective. This "push and pull," as he termed it, was one of the primary ways to create a painting that offers viewers a dynamic experience of a work of art that transcends a particular time, place, and subject matter. Unlike his Cubist predecessors, whom he particularly admired, Hofmann came to make paintings with no recognizable subject matter, such as *Dew and Dusk*. Despite its descriptive title, here viewers are confronted with a dynamic arrangement of colors, lines, brush strokes, and shapes that have their own existence. Paintings such as this have had an enormous influence on a variety of twentieth-century artists ranging from Abstract Expressionists to Minimalists. FL

Hans Hofmann (American, b. Germany, 1880–1966). *Dew and Dusk*, 1957. Oil on canvas. 61 1/2 x 53 1/8 inches. Gift of Mrs. Harry Lynde Bradley (M1964.53).

Helen Frankenthaler
Hotel Cro-Magnon, 1958

Invariably associated with the landscape, because of their majestic sweep and "natural" forms, Helen Frankenthaler's paintings came to embody the United States' sense of wide open spaces, its almost palpable sense of light—a frequent subject in nineteenth-century American art—and an almost literal image of freedom. The lack of physical texture, a ubiquitous characteristic of Abstract Expressionism, allows paintings like *Hotel Cro-Magnon* to seem to embody an almost infinite depth, as light appears to emit out of, as much as fall onto, the surface of the work.

Frankenthaler's method of pouring thinned, flowing paint onto a canvas lying flat on the studio floor allowed the artist to achieve a monumentality and sense of scale that seemed logistically impossible with more traditional easel painting techniques. In *Hotel Cro-Magnon* viewers are drawn into a world of energy and grand gestures. Calligraphic strokes and energetic splashes suggest the cosmos coming into being, while forms reminiscent of mountains and vales begin to jell. Yet at the same time, grand sweeping gestures are countered by precise touches and concentrated splatters, some applied directly with the artist's fingers and hands. Dense areas of stain are no more important than the areas of the bare canvas. Such equilibrium between empty and full, large and small, order and chaos might remind one of oriental brush painting, but Frankenthaler's majesty of scale and almost boundless energy are undoubtedly a product of her exposure to and assimilation of American painting in the late 1940s and early 1950s. FL

Helen Frankenthaler (American, b. 1928). *Hotel Cro-Magnon*, 1958. Oil on canvas. 67 x 80 inches. Gift of Mrs. Harry Lynde Bradley (M1966.153).

Richard Diebenkorn
Ocean Park #16, 1968

The painter Richard Diebenkorn was an individualist whose California studio was far removed from the New York art world that dominated American modern art after World War II. His geographic separation, combined with his reluctance to align himself with any dogma or artistic movement, afforded him the freedom of self-discovery. By the mid–1950s, he had abandoned Abstract Expressionism in favor of a reductive figural style. He returned to abstraction in 1967, the same year he moved his home and studio to a section of Santa Monica called Ocean Park. There he began the *Ocean Park* series of large-scale, numbered color abstractions that spans three decades. The artist's coastal surroundings are reflected in the blues, greens, grays, and earth tones that dominate this series.

In each of the oversized paintings in the *Ocean Park* series, Diebenkorn played with predominantly horizontal and vertical planes of atmospheric color to achieve the illusion of depth. His geometrically structured compositions emerge from the canvas, the result of trial and error. Diebenkorn explained, "I begin the picture and wait for it to talk back to me." His process, including drawing, overpainting, scraping, erasures, and wash, is left exposed and becomes an integral part of the finished work. This is particularly true of *Ocean Park #16*, with its translucent, sketchlike surface that seems to float upon an entirely different painting. The red, pink, and blue "X" in the upper right quadrant is an atypical form in the *Ocean Park* series. In this painting it functions as a scaffolding that unites the strong vertical elements of the composition. JVC

Richard Diebenkorn (American, 1922–1993). *Ocean Park #16*, 1968. Oil on canvas. 92 1/2 x 75 3/8 inches. Gift of Jane Bradley Pettit (M1974.218).

Roy Lichtenstein
Crying Girl, 1964

Mechanical reproduction, construction, and materials were all central to the art of American Pop artist Roy Lichtenstein. While it was with hand-painted canvases of cartoon characters and consumer items that Lichtenstein broke onto the New York art scene in 1961, it was his multiples, his exactly reproducible images, that most radically challenged the idea of modern art and artistic production. Concurrently with artists such as Andy Warhol and Tom Wesselmann, Lichtenstein forged an art that spoke to the new popular culture and consciousness of America in the 1960s.

Made in 1964, *Crying Girl* was one of Lichtenstein's first forays into the production of enamel on steel multiples. Using his distinctive comic-strip imagery—here, the false sentiment of a crying, albeit still glamorous, girl—Lichtenstein sent a full-sized drawing to a commercial enamel factory, which made five exact duplicates of the image in the hard-edged precision of steel construction. This "style of industrialization," as Lichtenstein called it, returned his popular, comic-book imagery to the realm of commerce and mass production, eliminating all traces of the artist's hand in favor of an uncompromisingly exact, reproductive image. Rigid black-and-white outlines, benday dots, and unmodulated primary colors—all hallmarks of commercial printing—reinforce the image's origin in mechanical culture. Purchased from Lichtenstein's famed New York dealer Leo Castelli in 1964, *Crying Girl* attests to the Milwaukee Art Museum's early and prescient awareness of the importance to twentieth-century art of Roy Lichtenstein's work—and Pop Art and production methods in particular. KM

Roy Lichtenstein (American, 1923–1997). *Crying Girl*, 1964. Enamel on steel. 46 1/8 x 46 1/8 inches. Purchase (M1965.18).

David Smith
Cubi IV, 1963

While most of his contemporaries were seeking the meaning and effects found in painting, David Smith believed that sculpture offered an unprecedented opportunity for engaging viewers in a most direct and physical way. Using the industrial techniques he had learned while working in an automotive factory in the late 1920s and during World War II in a locomotive plant, Smith sought in his art the heroic scale, direct expression of materials, movement, power, and even what he called the "brutality" that he had experienced in industry. Assembling, rather than carving or casting, works such as *Cubi IV*, Smith wished to deny the art historical associations of both material and process that declared an object a work of art. Ironically by 1960 his works had become lyrical displays of surface reflections and an almost weightless balance of simple geometric forms.

The swirling stainless-steel sheen of the surface of *Cubi IV* and the balletic grace of its forms activate the surrounding space. As a part of a series of twenty-eight similar sculptures, *Cubi IV* is one of Smith's many variations on the themes of weight and balance, yet the work stands fully on its own. Viewers are enticed to move around the piece, regarding the interplay of positive and negative shapes. Caught and fractured light is dispersed by the drill-ground swirls of steel, ever changing with a shift in position and viewpoint. The industrial associations of the material and the process (welding) give way to what one critic, seeking to connect Smith to his Abstract Expressionist peers working in two dimensions, called "drawing in space." FL

David Smith (American, 1906–1965). *Cubi IV*, 1963. Stainless steel. H. 90 inches. Gift of Mrs. Harry Lynde Bradley (M1977.144).

Ellsworth Kelly
Red, Yellow, Blue II, 1965

The primary colors of *Red, Yellow, Blue II* give viewers a hint that Ellsworth Kelly is interested in the most elemental aspects of viewing and experiencing a work of art. Each 82-by-57 1/2-inch panel is an uninflected field of pure hue. Removed from any representational function, each panel, though hanging on the wall like a conventional easel painting, becomes an object, as much akin to sculpture as to painting. Kelly stripped away narrative, representation, even some of the fundamental qualities associated with painting, such as line and shape, to focus our attention on color and scale. If made smaller, the rectangles would appear to be color patches; if larger, they would surround the viewer in an environment of a specific hue.

Such simple but subtle adjustments derive from the artist's desire to reeducate viewers of modern art as to some of the basic questions regarding optical experience. As did many of his generation, Kelly thought that some viewers had become distracted by artists' biographies, critical theories, and a certain degree of marketplace hype. He sought to reestablish the primacy of the physical/optical experience. How, for instance, does proximity affect our reading of the piece? What of context, such as the changing light of the gallery space, or the effect of shadows cast by another viewer in the gallery? Can shape and color be so wedded as to be inseparable? For Kelly, such questions have been fundamental to his studies as an artist and rather than emphasizing facile, bravura gesture, he has shared these studio "secrets" with viewers. FL

Ellsworth Kelly (American, b. 1923). *Red, Yellow, Blue II*, 1965. Oil on canvas. 82 x 185 inches overall. Gift of Mrs. Harry Lynde Bradley (M1977.113a-c).

Donald Judd
Untitled, 1966–68

Donald Judd believed that artists should strive to create a visible and rational order that would find its expression in a clarity of material and a simple economy of form. Eschewing the obvious signs of process so important to a previous generation of artists and often thought of as indicative of an artist's "style," Judd brought a sleek, manufactured quality to his works. His Minimalist forms emphasize balance, repetition, size, scale relationships, surface characteristics, and space.

In *Untitled*, Judd pared sculpture down to essential characteristics: serial repetition of individual units, reflective surfaces, and the rhythmic regularity of each part. Devoid of any evidence of the artist's hand, *Untitled* insists on being experienced not as a personal statement, but as an objective investigation into the purely formal elements of line, color,

shape, texture, and pattern. *Untitled* rewards such concentrated looking with a subtle but nonetheless wondrous display of reflections, subtle shifts of color, and an increased perception of the space of the work. The repetition of forms allows viewers to see between the units, or in some cases through them, thereby emphasizing how an object intrudes on the viewer's space and conversely how a viewer may intrude on the space of a work. The machined surfaces shift consideration from the uniqueness of a work of art to a recognition of the quality of the surfaces themselves. Essential questions arise concerning the nature of sculpture and the context of its display. Ironically, though rooted in a careful and considered theoretical and philosophical complexity, Judd's objects offer an almost precognitive experience that one critic dubbed "the objectness" of modern art.
FL

Donald Judd (American, 1928–1994). *Untitled*, 1966–68. Stainless steel and plexiglass, in six parts. 34 x 244 x 34 inches overall. Purchase, Layton Art Collection (L1970.25).

Chuck Close
Nancy, 1968

Trained at Yale University, Chuck Close was aware of the tradition of serial, abstract work that began at that school with the teachings of Joseph Albers. By the mid–1960s Close began working from photographs and attempting to tie aspects of the imagery and scale of Pop Art to the reductive, systematic techniques of Minimalism. In 1968 he began a series of "heads," large portraits painted in black and white. At the time the work was called Photo-Realist and grouped with that of artists such as Malcolm Morley, Richard Estes, Robert Bechtle, and others who were seen as the heirs of Pop Art in their use of banal subjects, but also relied on photo-derived techniques to question the nature of art in the manner of the simultaneously developing Minimalist and Conceptual artists.

Nancy, the second painting in the "heads" series, depicts the sculptor Nancy Graves, a friend from student years at Yale. Close's procedure was to take a straightforward photograph, grid it into small squares, then enlarge the image as accurately as possible onto a canvas. The hugely scaled painting seems made up of various marks, but at the proper viewing distance, it "snaps into focus" based on the camera focus in the photographic source. The focus here is sharpest on the eyes while the tip of the nose and the background hair move slightly out of definition. Close managed to achieve a new, systematic approach to portraiture, a distinctive process of image-making (or reproduction), and a new sense of space in painting, one based on photographic focus. Furthermore, their scale and detail give these portraits a distanced but unsettling presence. The Milwaukee Art Museum is fortunate also to have in its collection the photographic study for *Nancy*. RB

Chuck Close (American, b. 1940). *Nancy*, 1968. Acrylic on canvas. 108 3/8 x 82 1/4 inches. Gift of Herbert H. Kohl Charities, Inc. (M1983.207).

Robert Smithson
Non-Site: Line of Wreckage, Bayonne, New Jersey, 1968

Throughout his relatively brief career (he died in 1973 at the age of thirty-five), Robert Smithson evidenced a concern for loss, waste, entropy, and reclamation. Fascinated by the ability of art to focus attention on the mundane and overlooked, the artist sought to reinvigorate materials and spaces that had been exhausted by development, decline, pollution, and urban sprawl.

In his *Non-Site* pieces, Smithson brought the flotsam of industrialization into the museum and gallery space. Massive fragments of spent and cracked concrete, crated in an open aluminum framework, at first appear to function like the simple material objects that many of Smithson's contemporaries, such as Carl Andre and Tony Smith, had presented in formal exhibition spaces. On closer examination, however,

Smithson's *Non-Site: Line of Wreckage, Bayonne, New Jersey* exhibits remnants of a previous function. Chunks of asphalt adhere to the fractured, man-made boulders. Photographs and a map documenting the source of this rubble contribute to a consideration of more than just the formal qualities of the objects, referencing a site in the *real* world. The title of the series, *Non-Site,* likewise shifts the viewer's attention to a space that is neither inside the gallery nor located at the origin of the materials, suggesting instead the underlying long process or cycle of concept, manufacture, function, disassembly, and reuse. Smithson's astute assimilation of the strategies of Minimalism, Process Art, Earth Art, and Conceptual Art was unique among the competing movements and tactics of the art of the 1960s and 1970s. FL

Robert Smithson (American, 1938–1973). *Non-Site: Line of Wreckage, Bayonne, New Jersey,* 1968. Painted aluminum, broken concrete, framed map, and three framed photo-panels. Sculpture 59 x 70 x 12 1/2 inches; photographs 3 1/2 x 49 inches each. Purchase, National Endowment for the Arts Matching Funds (M1969.65).

Eva Hesse
Right After, 1969

The work of Eva Hesse can be seen as a kind of counter to that of many of her contemporaries associated with Minimalism. Whereas the Minimalists sought a clear, impersonal, and reductive sculpture, Hesse embraced contingency, the steady and nuanced repetition of forms suggestive of natural accretion, and a comforting envelope of subtle surface textures and natural colors. Additionally, unlike many of her peers whose works and comments assumed a rational seriousness, Hesse frequently called her own work "absurd" and "ludicrous." Hesse did resemble her contemporaries, however, in often eschewing the single sculptural object in favor of a field of multiple objects or forms within an environment. *Right After* is an inviting web, a tangled network of strands seemingly covered with dew or a light glaze of ice. Though employing the most modern of materials such as resins, latex, or, as here, fiberglass, Hesse achieved the appearance of natural objects. The surfaces of the works are almost absorbed by the ambient light and their apparently random arrangement throughout the space of the gallery affirms their presence quietly, with patient reserve.

Although her work exerted considerable influence, Hesse's career was very brief. It was on a trip to Germany in 1964, following her studies at Yale University, that she found her particular style. During and after 1969, her work was executed under the shadow of a postoperative, incurable brain tumor. Though by this time she was confined to a wheelchair, works such as *Right After* suggest an almost infinite space and a free and spontaneous play with form and mystery. FL

Eva Hesse (American, b. Germany, 1936–1970). *Right After*, 1969. Fiberglass. 60 x 216 x 48 inches. Gift of Friends of Art (M1970.27).

Agnes Martin
Untitled #10, 1977

One of the mantras of modernity is "less is more" and the work of Agnes Martin appears to embody this dictum. Reacting to the energy and verve of post–World War II American painting, when she moved to New York in 1957, Martin sought to slow viewers down. She countered the frenetic gestures and chromatic riot of Abstract Expressionism with a nuanced and subtle touch and a quiet, patient, and regular ordering of the surface of her canvases. As in many forms of self-referential, pure painting, *Untitled #10*, typical of Martin's works, reveals itself slowly through time and study. The rigorous order of the grid gives way to faint quavering lines, ghostly, almost tentative, traces of precision. The physical processes of perception—the reality of light on the retina—are called into question. Viewers are swallowed by atmosphere, unsettled in their sense of surety and self, in a way analogous to how a Buddhist koan turns a simple question into a infinite regression into reason and logic.

Though she painted in a representational mode for over three decades, Martin, with an interest in Eastern mysticism, came to believe that reality is rooted not in the forms of nature, but in being absorbed into the experience of nature. Ironically she finds this spiritual union in the regularity of the grid, an ordered field that is the subject matter of her work, but, because of its universality, is not really a subject matter at all. Intentionally practicing an art that eludes verbal explication, Martin seeks to find the place where the visual arts operate on their own terms of perception, vision, and a resolute acceptance of objectness. FL

Agnes Martin (American, b. Canada, 1912–2004). *Untitled #10*, 1977. India ink and graphite over gesso on canvas. 72 x 72 1/8 inches. Gift of Friends of Art (M1981.6).

Jasper Johns
Untitled, 1984

Primarily self-taught, Jasper Johns burst on the New York scene in the mid–1950s with richly painted images of everyday subjects: targets, numbers, and the American flag—imagery selected from the flow of life—"things the mind already knows." His cool treatment of common subjects was seen as a repudiation of the emotional subjectivity of the Abstract Expressionists and pointed toward the development in the early 1960s of Pop Art.

Untitled comes from some twenty-five years later when Johns began introducing into his work encoded but personal and emotionally charged content. *Untitled* begins with two borrowed images: on the left is a portion of one of his prints of a double flag in green and orange; on the right is an image by W. E. Hill, published in *Puck* in 1915, entitled *My Wife and My Mother-in-Law*. One of a number of perceptual puzzles that appear in Johns's work, Hill's image reads alternatively as a young woman with a ribbon around her neck or a sharp-chinned, broken-nosed old harridan. Further visual puzzles include the illusionistic nail with shadow borrowed from a Georges Braque Cubist painting and the playful drips that place the taped images behind the painted background. In the densely painted background, Johns makes a most poignant reference to the passage of time and the fragility of life, incorporating a motif common to his works of the period: a small section of Matthias Grünewald's *Isenheim Altarpiece* (1512–16). The section depicts one of the demons afflicted with boils, but inverted, reversed, and obscured in the hatchlike patterns derived from Edvard Munch's *Between the Clock and the Bed*, another allegory of time and death. This encoded symbolism, so typical of Johns's multivalent meanings, becomes a moving meditation on art, time, and mortality. RB

Jasper Johns (American, b. 1930). *Untitled*, 1984. Oil on canvas. 75 x 50 inches. Purchase, Friends of Art, Contemporary Art Society, and Virginia Booth Vogel Acquisition Fund (M1993.1).

Ettore Sottsass, Jr.
Murmansk Centerpiece, 1982

Trained originally as an architect, Ettore Sottsass began designing professionally immediately following the Second World War. In the 1950s he gained international recognition for his designs for the Italian office supply company Olivetti. By the 1960s he was experimenting with unconventional forms, a bright spectrum of colors, and inventive biomorphic patterns. This "antidesign" or "Postmodern" approach disregarded the principles of Modernist design proffered by the leaders of the Bauhaus and the International Style, such as Walter Gropius and Le Corbusier. Sottsass' ideas express a renewed interest in ornament and a fresh, whimsical approach to design.

In 1980 Sottsass founded Memphis with like-minded designers Michele de Lucchi, Alessandro Mendini, Andrea Branzi, and Paola Navone. The group aimed to create playful, mass-produced objects such as chairs, lamps, bookcases, and dressers that eliminated historical references. In Sottsass' *Murmansk Centerpiece*, a shallow silver bowl supported by six zig-zag legs, the ornate decoration of its eighteenth- and nineteenth-century predecessors has been eliminated. Light bounces off the smooth silver surfaces in all directions, creating an exciting visual energy. Though Sottsass advocated design for the masses, the use of a costly material such as sterling silver restricts this piece to the luxury market. JVC

Ettore Sottsass, Jr. (Italian, b. Austria, 1917–2007). *Murmansk Centerpiece*, 1982. Made for Memphis, Milano, by Rossi e Arandi Monticello Conte Otto, Vicenza, Italy. Sterling silver. H. 11 3/4 inches; dia. 13 3/4 inches. Gift of Daniel Morris and Kathlene Morris-Solomon in loving memory of their parents, Richard and Marion Morris (M1997.220a, b).

Harvey Littleton
Lemon/Red Crown, 1989

Initially trained as a ceramist, Harvey Littleton became a pioneer in the Studio Glass movement. The son of the director of research at Corning Glassworks in Corning, New York, Littleton helped to bring glass out of the factory and into the artist's studio. During two landmark workshop sessions in 1962 at The Toledo Museum of Art in Ohio, Littleton used fiberglass marbles with a low melting point, developed by Dominick Labino, to demonstrate how to melt glass in a kiln significantly smaller than the glass furnaces used in factories. In 1963 he established the first Studio Glass curriculum at the University of Wisconsin, Madison. Through his vision, leadership, and teaching, Studio Glass has achieved a prominent position in the world of contemporary art.

Littleton's works range from functional vessels to purely sculptural forms, reflecting his continual experimentation with glass. *Lemon/Red Crown*, one of a series created by Littleton in the 1980s, consists of twelve alternately large and small pieces of glass assembled in a circle to form the shape of a crown. The larger vertical pieces bend gently into the center of the assemblage and then out again, with the ends twisted to varying degrees. These bends and twists emulate the fluid nature of hot glass caught in motion. The cut and polished ends of each piece reveal a cross-section of concentric circles, formed by eighteen layers of clear, cased glass, some of which have been overlaid with black, orange-red, pale yellow, red, and white. The light sparkling around and through the colors and form animates the composition so that it is never still. JVC

Harvey Littleton (American, b. 1922). *Lemon/Red Crown*, 1989. Blown and drawn glass cut and polished. H. 15 3/4 inches. Gift of Peter and Grace Friend, Mr. and Mrs. Wayne J. Roper, Laurence and Judy Eiseman, Dr. and Mrs. Jurgen Herrmann, Dr. and Mrs. Leander Jennings, Nita Soref, Marilyn and Orren Bradley, Mr. and Mrs. Frank J. Pelisek, Dr. and Mrs. Robert Mann, Burton C. and Charlotte Zucker, James Brachman, Mr. and Mrs. John F. Monroe, Mr. and Mrs. Donald Wiiken, Elmer L. Winter, Mr. and Mrs. Stuart Goldfarb, Mr. Ben W. Heineman, Mr. and Mrs. Norman Hyman, Janey and Douglas MacNeil, and Friends (M1990.5).

Anselm Kiefer
Midgard, 1982–85

Born and reared in German's Donaueschingen region, Anselm Kiefer was deeply impressed by the Black and Oden forests. Even before studying with Joseph Beuys from 1971 to 1973, Kiefer had produced art with a specifically German point of view; some controversial works from 1969 questioned Germany's Nazi past. Drawing from Norse mythology, Wagnerian opera, the Nazi period, theology, biblical history, and alchemy, in the 1970s he developed a figurative style that sought to convey a sense of history, philosophical context, and spiritual or moral outlook. In 1980 Kiefer began producing monumental Neo-Expressionist paintings exploring the grand themes of German history and identity.

Midgard is one of a series of paintings that examine the Norse legend of the serpent Midgard, one of the monstrous children of the evil god Loki, son of Odin, who are fated to battle the gods at Ragnarök (the German Götterdämmerung [twilight of the gods])—when the universe will be destroyed, leading to the creation of a new heaven and earth in which gods and men live in harmony. Borrowing directly the Norse image of Midgard, Kiefer employed a painted, collaged element to depict the snake encircling a rocklike earth. The rock may also represent stones in the alchemical sense as sent from heaven. The burned and scarred setting, typical of Kiefer's works, includes the suggestion of a colonnade, perhaps a reference to the Roman occupation of Germany. The multilayered iconography and the grand, even theatrical, scale of Kiefer's work evoke a strong sense of terrible destruction and subsequent regeneration—and their meaning both within Germany's historic consciousness and recent past. RB

Anselm Kiefer (German, b. 1945). *Midgard*, 1982–85. Oil, emulsion, and acrylic on photographic linen mounted on canvas. 110 x 149 inches. Gift of Friends of Art (M1987.1).

Gerhard Richter
Atem (Breath), 1989

It is easy simply to be engulfed by the liquid veils of color or swallowed by the almost infinite space of the chromatic waterfall of *Atem* (*Breath*), but Gerhard Richter's painting should not be seen in isolation from his ongoing investigations into the efficacy of painting and art in the late twentieth century. In an environment fueled by the notion of artistic advancement and innovation, *Atem*, executed in 1989, does not add new vocabulary to abstract, process-oriented painting, but bears witness to an artist sincerely searching to find ways in which color, form, and process can still have resonance and meaning in a world saturated with reproductions and easily recognized symbols.

Atem is one of a number of abstract paintings that Richter has executed since 1976 that are not ironic commentaries on the exhaustion, or even the death, of painting, as some critics have claimed. Instead, the artist states that he sincerely, and without guile, has sought to experiment with both the language of color and form and the possible meanings of pouring, dripping, and flowing paint. Undeniably this painting, done in the waning years of the twentieth century, still manifests the nuance of touch, subtle surface effects, and atmosphere that bespeak the value of abstract painting. The surface richness and textural complexity are healthy counters to the reductivism of much late twentieth-century art; and the unabashed pleasure of the brilliant color repudiates the cool detachment that has become a familiar sign of Postmodernism. Unapologetic and optimistic, *Atem* refuses to abrogate for the sake of intellectual theory the personal, humanistic, and spiritual tradition that is an important strain of modern painting. FL

Gerhard Richter (German, b. 1932). *Atem* (*Breath*), 1989. Oil on canvas. 118 x 98 1/4 inches. Gift of Norman and Donna Hodgson, by exchange (M1990.13).

Julian Schnabel
Claudio al Mandrione (zona rosa), 1985–86

Born in New York but reared in Brownsville, Texas, then graduating from the University of Houston and the Whitney Museum's Independent Study Program, Julian Schnabel experienced a variety of cultural situations. Reinforced by travel in Europe and an interest in artists ranging from the architect Antonio Gaudí to Joseph Beuys, Gerhard Richter, and Sigmar Polke, Schnabel began to develop paintings with heavily worked surfaces and layered, multivalent imagery. His early works often have a histor-icist quality, with imagery suggesting saints and martyrs perhaps drawn from the Mexican religious art that would have been readily accessible in Texas. In late 1979 Schnabel emerged as a sensation upon the New York art scene with an exhibition of paintings on supports covered in shards of broken crockery. These works fractured not only the planar surface, but also, with their quasi-religious and highly personal imagery, the systemic, analytical, "factual" approach to subject matter that prevailed during the 1970s. This approach to both facture and subject became known in both its European and American variants as Neo-Expressionism.

Claudio al Mandrione (zona rosa), a painting from Schnabel's fully mature period in the 1980s, stands as an exemplar of both his unusual surface treatment and his multireferential subject matter. As in much of his work, the referents are personal and autobiographical as well as universal. Painted shortly after a trip to Rome in 1985, the work refers to a visit to a friend living in the so-called red zone (Communist) part of the city. Other references range from the rendering of a sculptural couple from an ancient Etruscan sarcophagus in one of the city's museums to letter-ing suggestive of both classical Roman inscriptions and today's graffiti. The broken plates themselves convey the archaeological layers of the Eternal City. *Claudio al Mandrione (zona rosa)* reflects the common themes of Schnabel's work: the fragments of history and everyday life, the destructive (smashing) and reconstructive (painting) process of creation itself, and the fluid mixture of all these elements in the artist's consciousness—all in a work of over-whelming physical and emotional power. RB

Julian Schnabel (American, b. 1951). *Claudio al Mandrione (zona rosa)*, 1985–86. Oil and plates on wood with Bondo. 114 x 228 inches. Gift of Contemporary Art Society (M1986.76).

Bill Viola
Science of the Heart, 1983

Bill Viola employs electronic media and installation, particularly video, in conjunction with carefully structured environments within the gallery space, as a way to engage viewers on a variety of sensory levels. To accomplish this, Viola does not use the video screen simply as a surface on which to present a narrative, but incorporates sound, the phosphorescent glow of the video image, movement, and video's capacity to both speed up and slow down normal time to heighten viewers' awareness of time, space, and the contingency of life.

Science of the Heart is a darkened room occupied by a brass bed which is illuminated by a dramatic spotlight. Over the head of the bed is projected a large video image of a beat-ing heart. As the work unfolds over time, the heart gradually quickens its beat and then slows to absolute stillness. Powerful waves of sound amplified by hidden speakers resonate within the viewer's body. The beating heart, audible, visible, and both a medical and symbolic evidence of life, hovering over the bed, elicits associations to birth, love, sleep, and finally even death. As the video cycles, viewers sense the infinite counting of lives lived, the poignant fragility of life, and the regeneration that is a part of nature. Like the implicit irony of its title, which juxtaposes rationality and the symbolic site of our emotions, *Science of the Heart* leaves us with both a sense of mortality and a sense of optimism and hope. FL

Bill Viola (American, b. 1951). *Science of the Heart*, 1983. Video installation, with sound. Dimensions variable. Gift of Contemporary Art Society in honor of its 15th Anniversary (M1997.57.1-.45).

Martin Puryear
Maroon, 1987–88

Maroon, along with many of Martin Puryear's other works, seems to be an object of some specific, but unknown, function. The emphatic clarity of form and the exquisite attention to craftsmanship suggest something more than a purely formal interest. Like many of the objects that the artist encountered as a Peace Corps volunteer in West Africa, *Maroon* evinces a careful and considered construction. The precise layering of wire mesh, the tight fit of the wooden planking, and the even layering of tar all speak from a tradition that values the handmade and the useful. At the same time, the suggested function is never revealed. Like an object from an unfamiliar culture, *Maroon* seduces viewers with its sheer formal monumentality and encourages reverie regarding its purpose and possibly even its ritualistic power.

By revitalizing the role of craftsmanship, Puryear reintroduced the human element into the production of art. Unlike the seemingly machine-produced objects of much modern sculpture, *Maroon* affirms the controlled and controlling hand. There is a loving regularity to the surface, a calming assurance in its biomorphic swell and solidity. But rather than simply appropriating forms from other, especially African, cultures, Puryear found the comforting assurance located in the works of Constantin Brancusi and Jean Arp, artists associated with the most advanced movements in Western modern art and deeply influential on an American culture rich with a variety of influences and traditions. FL

Martin Puryear (American, b. 1941). *Maroon*, 1987–88. Steel, wire mesh, wood, and tar. 76 x 120 x 78 inches. Gift of Contemporary Art Society (M1991.24).

Kiki Smith
Honeywax, 1995

Kiki Smith has used the human form as a metaphor in her work since the early 1980s. She is associated with the resurgence of "body art," an outgrowth of the 1960s Happenings movement in which many artists, feeling that painting and object-making had reached their Minimalist end, began using their own bodies as the subject on display. Smith's treatment of the human form, however, is nontraditional and frequently confrontational. Responding to the metaphorical possibilities of mankind faced with violence and deadly diseases, Smith exposes the body from the inside out, as a system of flesh, bones, organs, and fluids—imperfect, yet beautiful. Her highly expressive and sometimes explicit images often present the human figure as flayed or fragmented, a stark reminder of the frailty of the physical body and psychological condition.

Smith is best known for her life-size figures created from iron, paper, wax, and other materials. *Honeywax*, for example, appears almost transparent, as if the pink flecks of color indigenous to the beeswax are actually veins or tendons just below the surface of the skin. The creases and bumps that cover the figure, consequences of the modeling process, translate into the subtle imperfections inherent in the human body. The work refers both to life, through the figure's birthlike fetal position, and death, in its stillness reminiscent of figures unearthed from the ancient city of Pompeii. MA

Kiki Smith (American, b. 1954). *Honeywax*, 1995. Beeswax. 15 1/2 x 36 x 20 inches. Gift of the Contemporary Art Society (M1996.5).

Robert Gober
Untitled, 1997

Since the mid-1980s, Robert Gober has been at the forefront of a generation of artists who have revitalized the tradition of representational sculpture. Gober's unusual lexicon of hand-crafted sculptures includes common household objects marked by surreal twists or wild mutations—doors that turn in on themselves, leaning beds, X-shaped cribs. These works raise questions about childhood and domesticity and how they contribute to our psychological make-up. More recently, Gober has made several wax sculptures of sections of the human body. These forms, too, were created with sometimes bizarre variations and often merged body parts with domestic objects, such as legs with drains.

Throughout his career, Gober has grouped his sculptures together in installations, as seen in this untitled work. An open suitcase with a grate inserted in its base leads to a brick shaft below the floor. Extending through the shaft are four wax legs—two adult male and two children's—bathing in a pool of water, an allusion to baptism. The adult legs are cast from the artist's own legs and enhanced with actual hair inserted (with a tweezer) into the shins. The water in the pool is kept in constant motion as it swirls by the legs and other cast elements, including seaweed, seashells, and coins. Like much of Gober's work, this dual-level installation explores the dynamic between the conscious world (what is immediately apparent) and the subconscious (those things lurking beneath the surface). DS

Robert Gober (American, b. 1954). *Untitled,* 1997. Leather, wood, forged iron, cast plastics, bronze, silk, satin, steel, wax, human hair, brick, fiberglass, urethane, paint, lead, motors, and water. Overall 122 1/2 x 104 x 75 inches. Gift of Contemporary Art Society, with additional funds from Donna and Donald Baumgartner, Terry A. Hueneke, Marianne and Sheldon B. Lubar, James and Joanne Murphy, Bud and Sue Selig, and Lynde B. Uihlein (M1999.48).

Prints and Drawings

Prints and drawings constitute a large and significant portion of the collections of the Milwaukee Art Museum. Brought together because of their shared status as works on paper, they reflect a diverse response to the creation and dissemination of art, from the unique and individualistic mark-making of drawings to the inherent multiplicity and reproducibility of prints. Drawings—a term that covers a wide range of autographic works from pen-and-ink sketches to finished watercolors, pastels, and collages—have been a part of the permanent collection since 1916, when Frederick Layton gave a selection of nineteenth-century American and English watercolors to the Layton Art Gallery. Soon after, in 1924, a distinguished group of 235 Old Master prints from the estate of Gertrude Nunnemacher Schuchardt, including works by Dürer and Rembrandt, initiated the museum's print collection.

Important donations continued to enrich the museum's collections throughout the decades, including Mrs. William D. Vogel's 1947 contribution of a major pastel by Picasso, the first gift to inaugurate the museum at the new Milwaukee War Memorial; the 1954 bequest of Renaissance and Baroque drawings and prints from Max E. Friedmann and Elinore Weinhold Friedmann; and the donation of important drawings and prints by artists such as Degas, Toulouse-Lautrec, Nolde, and Klee from the collection of Mrs. Harry Lynde Bradley.

Not until the late 1970s, however, did acquisitions and exhibitions of works on paper begin to accelerate, in part because of a renaissance in printmaking in the United States as well as the museum's founding of a department specifically for prints, drawings, and photographs. Acquisition funds, such as those contributed by Gertrude Nunnemacher Schuchardt, Howard Zetteler, Ethel K. Hockerman, and Marjorie Tiefenthaler, have allowed the museum to acquire significant works from all periods, culminating in the 1990s purchase of many important nineteenth-century German prints and drawings with support from the René von Schleinitz Memorial Fund. The 1981 formation of Print Forum, a museum-sponsored support group, gave acquisitions and programs a new focus and provided a venue for enthusiasts and collectors of works on paper. The establishment of the Prairie Archives in 1976 and the Landfall Press Archive in 1992 added significant bodies of work devoted to architectural design and contemporary printmaking.

Present-day acquisitions and activities continue to make this area one of the most dynamic in the museum. Recent purchases of drawings and collages, such as those by Robert and Carrà, as well as gifts of important drawings by Ruscha and Tansey, have made the last decade a crucial period of collecting for the museum. In addition, the newly renovated Richard and Ethel Herzfeld Print, Drawing and Photography Study Center confirms the growing awareness and appreciation of the museum's extraordinary collection of over 11,000 works on paper. KM

Albrecht Dürer
Melancholia I, 1514

Melancholia I is a masterpiece of the German Renaissance artist Albrecht Dürer, one of the greatest printmakers in the history of art. It is an extraordinary tour-de-force in the refined art of engraving and one of Dürer's most renowned and enigmatic works. Considerable debate has focused on the meaning of the massive, winged figure who sits amidst a cacophony of objects and mysterious symbols. According to the great Dürer scholar Erwin Panofsky, she embodies two previously distinct pictorial types: one of the four human temperaments, the "melancholic," distinguished by her general inactivity and brooding demeanor; and the personification of Geometry, one of the seven Liberal Arts, with all the tools of architecture and carpentry surrounding her. With this combination, Dürer offered a unique vision of the artist-genius, one devoted to the highest ideals of scientific and artistic perfection forever constrained by the limitations of human frailty.

As with many other Dürer prints, *Melancholia I* was reprinted for centuries after the artist's death, producing scores of inferior impressions that show the wear-and-tear of the delicate lines on the original copper plate. Thus, it is important to view early impressions of the print, preferably when Dürer himself was there to ink and print the plate and choose the exact weight and color of the paper. In addition to being a superb impression, the Milwaukee Art Museum's *Melancholia I* has a unique element in its printing, a subtle wiping of ink left on the garment just below the angel's left knee. This suggests that Dürer was experimenting with this particular impression, trying out a nuance that would give the leg a more voluminous appearance. Once part of the collection of the Earl Spencer of England, this impression therefore is a rare version of one of the most important prints in the history of art. KM

Albrecht Dürer (German, 1471–1528). *Melancholia I*, 1514. Engraving. 9 5/16 x 7 1/4 inches. Gift of Mrs. Albert O. Trostel, Jr. (M1967.6).

Andrea Boscoli
Armida Abandoned by Rinaldo, ca. 1600

Jerusalem Liberated, Torquato Tasso's grand and entertaining epic of the First Crusade published in 1581, fired the imagination of readers for generations. This drawing by Andrea Boscoli, an artist for the Medici court in Florence, illustrates the conclusion of Tasso's story of the affair between the pagan sorceress Armida and the Christian knight Rinaldo. Bewitched by Armida's seductive charms, Rinaldo is imprisoned in her enchanted garden, located on a rocky and deserted island. Armida unwittingly falls in love with him; when he is rescued, she destroys her mountaintop palace in a fury and vows revenge.

A poet as well as a painter, Boscoli conceived *Armida Abandoned by Rinaldo* as a visual equivalent to Tasso's poetry. The sinuous line, elongated form, and dramatic light and dark in this drawing masterfully convey Tasso's theatrical imagery and expressive tale. This work, one of several drawings Boscoli made to illustrate *Jerusalem Liberated*, is closely related to two in the Ashmolean Museum, Oxford, England, depicting Armida pleading with Rinaldo to stay. *Armida Abandoned by Rinaldo* illustrates several episodes immediately following (canto 16, stanzas 63–67). At the left Armida, feeling betrayed and despised, ponders her fate as Rinaldo's ship sails away. "Quivering still with rage," she then flees from the shore, "eyes twisted, face aflame, and tresses scattered." While Boscoli admirably conveyed the heroic action of Tasso's narrative—a moral tale of the triumph of virtue over passion—the power of this drawing lies in the expression of Armida's tortured feelings, an emotion that inspires empathy in the viewer. TM

Andrea Boscoli (Italian, ca. 1560–1607). *Armida Abandoned by Rinaldo*, ca. 1600. Pen and brown ink with brown and gray wash over red chalk. 5 7/8 x 8 7/16 inches. Bequest of Max E. and Elinore Weinhold Friedmann (M1954.13).

Jacques Callot
The Fair at Impruneta (First Plate), 1620

Jacques Callot executed *The Fair at Impruneta*, one of his most virtuoso works in etching, during his tenure as a court artist in Florence for Cosimo II de' Medici, Grand Duke of Tuscany. Depicting an autumn market in a small Tuscan village during the Feast Day of Saint Luke, the print is a virtual lexicon of society. Elegant and effete aristocrats mingle with ruffians, cripples, and animals. Merchants hawk their wares while a snake charmer mesmerizes onlookers and guards hoist a criminal on the *strappado*. Such traditional religious festivities, as well as the outdoor spectacles organized by the Medici court, were immensely popular events attended by every manner of individual. Recording them in full detail, Callot appealed to a ready market.

Callot was an exceedingly methodical artist. He made over 200 preparatory sketches, some of them from life, for figures in *The Fair at Impruneta*, and a number of large compositional drawings in ink wash to develop the effects of light and dark. To achieve the dramatic *chiaroscuro* that makes this work one of the artist's most extraordinary prints, Callot etched some lines briefly and lightly, while deepening and widening others by a longer immersion in the acid. Callot also used to full aesthetic advantage in this print a special stylus that he invented, which allowed him to draw with sweeping and swelling strokes. TM

Jacques Callot (French, 1592–1635). *The Fair at Impruneta (First Plate)*, 1620. Etching. Plate 16 7/8 x 26 3/8 inches; sheet 17 11/16 x 27 inches. Purchase, with funds from Ethel K. Hockerman, from the collection of Philip and Dorothy Pearlstein (M2000.124).

Rembrandt van Rijn
Landscape with a Cottage and a Large Tree, 1641

Landscape with a Cottage and a Large Tree is one of Rembrandt van Rijn's most spectacular landscape etchings. It depicts the landscape around his hometown of Amsterdam, a subject treated by Rembrandt in twenty-seven prints between 1640 and 1653. In each image Rembrandt observed the characteristic traits of the Dutch countryside—the broad expanses of flat land dotted with trees and windmills, rustic cottages, wavering rivers and fields—with the landmarks of the city only hinted at in the distance. As a humanist influenced by Dutch Protestant reform movements and scientific empiricism, Rembrandt always regarded the world in terms of its human component, the simple ways that people lived in and worked the land and nature. Thus, landscapes such as this one are always seen from the perspective of someone actually standing on the site, a person such as Rembrandt, rooted in the world around him.

In this richly printed etching, Rembrandt allowed us both an intimate view of a rural homestead and a powerful sweep of flat landscape marked by a steeple and windmill on the horizon. The foreground is dominated by a tree and two cottages, which appear as if hewn from the overgrown brush surrounding them. Closely observed details, such as the barrel and rack and the two people at the door, are as woven into the fabric of the scene as the reeds along the banks of the small river. In contrast, the wide landscape is marked by an airiness set off by a daring expanse of white paper. It is this stark juxtaposition of intimacy and immensity that makes Rembrandt's etchings such monuments of seventeenth-century printmaking. KM

Rembrandt van Rijn (Dutch, 1606–1669). *Landscape with a Cottage and a Large Tree*, 1641. Etching. 5 11/16 x 13 1/16 inches.
Gertrude Nunnemacher Schuchardt Collection, presented by William H. Schuchardt (M1924.165).

Canaletto
The Portico with the Lantern, 1741–46

During the eighteenth century young men of rank and fashion finished their education by traveling on a Grand Tour of Europe. Venice, a favorite destination, was admired for its charming location and splendid architecture. Souvenir pictures, topographical depictions as well as imaginary *vedute ideale*, were in great demand. One of the most successful artists in these genres was the painter Giovanni Antonio Canal, known as Canaletto. Canaletto began his career as a set designer, but by 1730 he had come to the attention of the British collector, art dealer, and future Venetian Consul, Joseph Smith, who became his chief patron. When the outbreak in 1741 of the War of the Austrian Succession brought tourism in Venice to a virtual halt, Smith continued to support Canaletto with commissions and, most notably, encouraged the artist to take up etching.

Although Canaletto made only thirty-four etchings, he handled the medium brilliantly. Avoiding the convention of cross-hatching to produce shadows, he drew parallel strokes with the etching needle and left prominent areas of blank paper in his prints to convey a sense of the region's brilliant light. A number of his prints, like his paintings, represent actual Venetian sites, but most are highly imaginative landscapes of the Venetian lagoon and mainland. *The Portico with the Lantern* is one of Canaletto's most fantastic compositions. He transformed the city's flat site into a multilevel world with abrupt depressions and craggy prominences replete with crumbling temples and monuments that are more typical of ancient Roman architecture than the vernacular Gothic of Venice. It speaks of the romantic fascination of the times for classical culture—Herculaneum, sister city to Pompeii, had been uncovered only a few years before—and the current notion that invention and fantasy were the heart of artistic genius. TM

Canaletto (Giovanni Antonio Canal) (Italian, 1697–1768). *The Portico with the Lantern*, 1741–46. Etching. 11 13/16 x 17 1/16 inches. Bequest of Howard L. Zetteler in memory of his wife, Evelyn H. Zetteler (M1984.10).

Hubert Robert
Landscape with a Broken Fence Near Rome, ca. 1763

Hubert Robert traveled to Rome in 1754 to attend the French Academy where he was joined two years later by his compatriot Jean-Honoré Fragonard. The two artists often sketched together in the Italian countryside and many of their red chalk drawings include similar or even identical scenes. Robert's life-long taste for depicting ancient ruins and architectural views was certainly established at this early point in his career. In 1765 he returned to Paris to become one of the leading landscape painters of his day, and in later years he designed gardens in the newly fashionable naturalistic manner. Robert is an important forbear of the later Romantic artists, and his work marks a progression of the genre from a relatively minor position in eighteenth-century academic art to one of the most important themes in French painting of the nineteenth century.

This large and beautifully worked drawing belongs to a small, distinct series Robert executed in the early 1760s when he and Fragonard were working in the Roman Campagna. These drawings are distinguished by their rhythmic renderings of an unruly, organic landscape and a vigorous handling of red chalk. In this sheet Robert focused on a broken rail fence and tall, overlapping trees with arching branches that spread across the surface of the paper. The faintly drawn tower in the distance provides contrasting depth within the otherwise shallow composition. The surface pattern of silhouetted trees—executed rapidly in loops and sawtooth lines—links this work to other red chalk landscape drawings now in the Musée des Beaux-Arts, Valence (France); The Museum of Fine Arts, Boston; and the Graphische Sammlung Albertina, Vienna. Two of three sheets in Valence are dated 1763, which is most likely the date of this work as well. LW

Hubert Robert (French, 1733–1808). *Landscape with a Broken Fence Near Rome*, ca. 1763. Red chalk. 13 x 17 1/2 inches. Purchase, with funds from the Heller Foundation, Inc., Marjorie Tiefenthaler Bequest, a gift in memory of Alice Kadish, and the A. D. Robertson Family (M1998.510).

Philipp Otto Runge
Morning and Evening, 1803–1805

Among the greatest and rarest of German Romantic prints is Philipp Otto Runge's extraordinary series *Times of Day*, created between 1803 and 1805. Along with Caspar David Friedrich, Runge was one of the leading advocates of a renewal of the arts in Germany, focusing on allegories of nature as the vehicle through which God and the sublime could be grasped on earth. Completed only five years before his death at the age of thirty-three, the *Times of Day* constitutes one of Runge's crowning achievements, the synthesis of art, music, nature, and architecture into one all-encompassing program, or *Gesamtkunstwerk*. Consisting of four line etchings, *Morning*, *Evening*, *Day*, and *Night*, the prints use the symbolism of flowers to suggest the unity of God, nature, and the human condition, an idea derived from the seventeenth-century mystic Jakob Böhme. *Morning* depicts the white lily, the symbol of light, scattering the rosebuds of dawn, while *Evening* reanimates the roses as the

lily sinks into the clouds. Naked children, as symbols of human innocence, accompany the spectacle on a host of musical instruments. *Day* and *Night* focus on the female personifications of Earthly Abundance and Night and the symbolic activities of children, all surrounded by a plethora of flowers and plants.

Runge entrusted his drawings for these engravings to a team of professional printmakers, who etched and engraved each plate for publication. Detailed construction drawings show how the compositions were based on strict mathematical principles, elevating the science of architecture and geometry to the level of religion. Little understood at the time of publication, the *Times of Day* came to symbolize the highest of German Romantic ideals and the pinnacle of ambitious graphic production. KM

Philipp Otto Runge (German, 1777–1810). *Morning* and *Evening* from the series *Times of Day*, 1803–1805, 2nd ed. 1807. Two of four etching and engravings. Each 31 3/8 x 21 7/8 inches. Purchase, René von Schleinitz Memorial Fund (M1996.338.1-.4).

Karl Friedrich Schinkel
A Gothic Cathedral behind Trees, ca. 1813–15

Karl Friedrich Schinkel was initially trained in architecture, but devoted much of his career to painting and lithography. In 1810 King Friedrich Wilhelm III appointed him to the royal building commission, in which capacity he was a major planner of new building taking place in Berlin following Napoleon's expulsion from Prussia. He designed several of the city's landmarks, including the Altes Museum and the municipal theater. Although he executed these buildings in the Neoclassical style, considered appropriate for institutions of learning and culture, he and his royal patrons were particularly interested in the revival of German Gothic as an expression of nationalism.

This watercolor of a medieval cathedral—a fantastic composition of lofty spires delicately rendered in pencil, pen, and pale blue wash—was part of a folio of Schinkel's sketches preserved until recently by his descendents. One of the most finely finished in the folio, it is similar in theme to several paintings Schinkel executed in 1813–15, now in the Nationalgalerie in Berlin. After Napoleon's invasion of the German states in 1806, Schinkel became preoccupied with the theme of an ideal medieval church as a symbol of Prussia's political and cultural preeminence. He was further encouraged by King Wilhelm III's memorandum of January 1815 urging Prussian artists to develop concepts for a national cathedral in celebration of the victorious end to the Wars of Liberation. Although financial backing never materialized, Schinkel made numerous designs for a building to be erected on the outskirts of Berlin. The museum's drawing depicts a towering Gothic structure set within a wild forest of ancient oaks which convey a sense of time through growth, decline, and rebirth. It is a perfect expression of the Romantic ideal of the unification of art and nature, and serves as a symbol of the glories of the old Holy Roman Empire and hopes for Prussia's future. TM

Karl Friedrich Schinkel (German, 1781–1841). *A Gothic Cathedral behind Trees*, ca. 1813–15. Pencil, pen, gray ink, and watercolor. 9 5/8 x 8 7/8 inches. Purchase, René von Schleinitz Memorial Fund (M1995.285).

Francisco de Goya
The Daring of Martincho in the Ring at Saragossa, 1815–16

Francisco de Goya's passion for bullfighting is evident in the more than 125 paintings, drawings, and prints he made on the subject. Considering bullfighting to be both a sport and an art, Goya savored the subtle pleasures of well-executed *suertes*, or movements in the ring. He was troubled, however, by the apparent decline in ethical practices at the time because bulls were routinely overtired and matadors often resorted to cheap tricks to amuse audiences.

Goya's greatest tribute to bullfighting is *La Tauromaquia*. This compelling series of thirty-three etchings and aquatints, of which the museum owns an entire first-edition set, chronicles the development of the bullfight from its earliest beginnings to its modern form. Plate 18 shows the famous matador Martincho, seated with feet shackled, close to the gate from which the bull charges. Behind the barrier— drawn in a dizzying angle of perspective that heightens the palpable tension of the moment—spectators nervously anticipate an uncertain and fateful outcome. Goya has drawn us from the anonymous mass of onlookers into the very center of the ring to experience directly a desperate and lonely battle of life and death. *La Tauromaquia*, Goya's most subtle, yet challenging work, depicts brutal as well as glorious moments in which man is never shown as victorious and his animal opponent is always lively and intelligent. TM

Francisco de Goya (Spanish, 1746–1828). *The Daring of Martincho in the Ring at Saragossa*, from *La Tauromaquia*, 1815–16. Etchings, drypoints, and aquatints. Each 9 5/8 x 13 13/16 inches. Bequest of Howard L. Zetteler in memory of his wife, Evelyn H. Zetteler (M1983.204.1-.33).

Edgar Degas
La Causerie (Conversation at the Race-track), ca. 1885

Edgar Degas was a passionate observer of nineteenth-century Parisian life. Dancers, bathers, sportsmen, and friends all became subjects of Degas's search for a unique vision of modernity, one that would bring together daily life and a deep commitment to art and draftsmanship. Often his subjects were women caught in between the primping and posturing that defined their increasing public presence in society. *La Causerie (Conversation at the Race-track)* is one of a series of breathtaking pastels that Degas created from the mid–1880s to the early 1890s of women leaning over a railing at a race-track and absorbed in casual conversation. Here, Degas eliminated any suggestion of the equestrian context in favor of the unassuming poses of the three women, each defined by a vigorous black underdrawing. The composition is bisected by a red railing that runs diagonally from side to side, taking its cue from Japanese art, which often thrust figures into shallow, flat spaces and seemingly awkward poses.

The middle figure in *La Causerie* has been identified as Degas's friend the American artist Mary Cassatt, who often posed for him in millinery shops and other public places. However, the woman at the left also resembles Cassatt, suggesting that, as in other pastels of this period, Degas had her pose in similar clothes for all three figures, thereby merely affecting an observed scene in favor of a staged composition. The most striking difference between each figure is the vibrant colors of the veils that adorn their bonnets, an opportunity to employ to astonishing effect the sumptuous hues and textures of pastel crayons. KM

Edgar Degas (French, 1834–1917). *La Causerie (Conversation at the Race-track)*, ca. 1885. Pastel. 27 1/2 x 27 9/16 inches. Gift of Harry Lynde Bradley (M1957.20).

Henri de Toulouse-Lautrec
Moulin Rouge—La Goulue, 1891

Moulin Rouge—La Goulue is arguably the most famous poster
of the 1890s. Its unusual composition and bawdy subject
matter established its creator, Henri de Toulouse-Lautrec,
as one of the most talented and daring artists of Paris.
Commissioned in 1891 by the famous Montmartre night-
club the Moulin Rouge (Red Mill), the poster was Toulouse-
Lautrec's first foray into modern advertising and his first
experiment with the popular new medium of color lithogra-
phy. Unlike another poster designer, Jules Chéret, whose
images of blushing coquettes had defined French advertis-
ing to date, Toulouse-Lautrec showed the raucous antics of
the cabaret's star performers, La Goulue (The Glutton) and
her partner, Valentin le Désossé (Valentin the Boneless),
in a most shocking and unflattering way.

Clearly, the main attraction of the show, boldly revealed at
the center of the composition, was La Goulue's performance
of the *chahut*, the high-kicking dance that offered uninhibited
views of her underclothes, if she wore any at all. Yellow
globes of electric chandeliers sway above and seemingly in
front of the scene, while the audience appears in silhouette,
a nod to the popular shadow-plays of the day. Indeed,
these flattened perspectives and unconventional poses
reflect the influence of Japanese art, which during the nine-
teenth century streamed into France in the form of cheap
color prints. Toulouse-Lautrec's massive poster required
three sheets of paper to print the image; the Milwaukee
Art Museum's impression is missing the top section, which
was recreated with a modern watercolor reconstruction.
Moulin Rouge—La Goulue came to symbolize the height of
Parisian decadence and Toulouse-Lautrec's uncommon
mastery of a new, sensational imagery. KM

Henri de Toulouse-Lautrec (French, 1864–1901). *Moulin Rouge—La Goulue*,
1891. Color lithograph with watercolor reconstruction. 76 7/16 x 47 5/8
inches. Gift of Mrs. Harry Lynde Bradley (M1977.47).

Odilon Redon
Vase of Flowers, 1900–16

Although he worked in a number of different materials, the alluring, chalklike medium of pastel served as a perfect means for the French Symbolist artist Odilon Redon to express his imaginative and frequently intense visions and interpretations of nature. In the dark *Noirs* drawings of the 1870s–90s, Redon created private landscapes inhabited by angels, centaurs, devils, and grotesque insects. Then, from 1900 until his death in 1916, he turned to the seemingly conventional and modest subject of flowers. Although the serene lyricism and seductively lush color of these late works contrast with the melancholy of the *Noirs*, they, too, are transformations of nature into dreamlike worlds.

The ethereal flowers depicted in this pastel seem scarcely more real or substantive than those painted on the vase. Their petals are as delicate as butterfly wings and look as if they are about to flutter away. Like many other still-life artists since antiquity, Redon delved beneath the surface of his subject to reveal the fleeting and fragile beauty of living things. What appears to be a celebration of nature is simultaneously an exposure of the reality of time. Although shown in their prime, the flowers in this drawing will ultimately wither and die, changing from one state to another. TM

Odilon Redon (French, 1840–1916). *Vase of Flowers*, 1900–16. Pastel. 35 x 28 inches. Purchase, Marjorie Tiefenthaler Bequest, and partial gift of Louise Uihlein Snell Fund of the Milwaukee Foundation (M1996.37).

Carlo Carrà
Portrait of Marinetti, 1914

From 1910 to 1915, Italian Futurism was one of the leading forces in avant-garde art and theory. Founded by the poet Filippo Tommaso Marinetti, who wrote the first Futurist Manifesto in 1909, the movement advocated a decisive break with the past, looking instead towards the future and specifically the machine for inspiration. What began as a literary phenomenon soon spread to the visual arts, with artists such as Umberto Boccioni and Carlo Carrà searching for increasingly provocative ways to express the dynamism, speed, and movement of modern experience.

Carrà's 1914 collage *Portrait of Marinetti* clearly sets Marinetti at the center of the Futurist maelstrom. Based on an earlier portrait of Marinetti painted by Carrà in 1911, it depicts the poet with his pen, inkwell, and paper in the throes of writing one of his many manifestos, as the words "Manifesti del Futurismo" at the right indicate. The collage extends Marinetti's theories into new territory in which fragments of literary texts and paint combine to create a picture of profound disruption. Here, like in the *papier collé* Cubist collages of Pablo Picasso, Carrà inserted a "new reality" into the picture, pasting actual pieces of newsprint into the illusionary space of the picture plane. Developing what Marinetti called *parole in libertà*, or words-in-freedom, Carrà used conflicting nouns, expressive typography, and onomatopoeic devices to effect the noises and forces of modern life and to destroy any sense of continuity within the composition. The collage becomes an assault upon the traditional values in art and provides a crucial link to the literary provocations of the Dadaists and Surrealists.

Portrait of Marinetti was first owned by Giovanni Papini, editor of the leading Futurist periodical *Lacerba*, where many of Marinetti's manifestos were first published. Indeed, most of the words and texts used here were cut from the pages of *Lacerba*, a word which itself appears three times in the composition. KM

Carlo Carrà (Italian, 1881–1966). *Portrait of Marinetti*, 1914. Ink, watercolor, gouache, and collage. 27 7/8 x 15 7/8 inches. Gift of Friends of Art (M1982.1).

Karl Schmidt-Rottluff
Heads II, 1911

Woodcut was the leading printmaking medium employed by the Brücke, one of the most important avant-garde groups to emerge in Germany during the early 1900s. From 1905 to 1913, the year the group disbanded, the founders of the Brücke, including Ernst Ludwig Kirchner, Erich Heckel, and Karl Schmidt-Rottluff, favored this traditional German medium, which allowed unprecedented expressivity and experimentation in mark-making, inking, and printing.

Schmidt-Rottluff's arresting woodcut *Heads II* depicts two heads, one boldly frontal and the other in three-quarters view, with only the suggestion of bodies underneath. The exact relationship between the figures, their identities, and even their genders are subordinated to the overall composition, which is unified through the expressive use of the wood block. When printed, the grains, splinters, and gouges give a raw texture to the stark black-and-white fields, which are reminiscent of Jugendstil, or Art Nouveau, prints. Like all of Schmidt-Rottluff's woodcuts between 1906 and 1912, *Heads II* was printed by hand by the artist himself, allowing him full control over the inking and selective pressure of the printing without the aid of a professional printer or mechanical press. This gives *Heads II*, which most likely comes from an edition of fewer than ten, an immediacy and an integrity that were hallmarks of Brücke printmaking. KM

Karl Schmidt-Rottluff (German, 1884–1976). *Heads II*, 1911. Woodcut. 23 5/8 x 19 5/8 inches. Purchase, Gertrude Nunnemacher Schuchardt Fund, presented by William H. Schuchardt (M1963.52).

Pablo Picasso
Heroic Head, 1921

When Pablo Picasso's pastel *Heroic Head* arrived in Milwaukee in 1947, it was immediately heralded as a symbol of a new civic and cultural era. As the first permanent gift of an important artwork to the projected Milwaukee War Memorial, it signaled the city's deep commitment to Modernism, as did Eero Saarinen's proposal for a stunning new building for the lakefront, not completed until 1957. At the time, Picasso was the most renowned artist in the world, a master who had dominated the course of modern art ever since his founding of Cubism in Paris around 1910. By 1920 his art had shifted away from the fractured surfaces and perspectives of Cubism towards a more refined classicism defined by images of nude female bathers and monumental heads. French writer Jean Cocteau called the

general renewal of interest in classical models in the early 1920s a "return to order" following the chaos of World War I.

Heroic Head is one of several pastels created during the summer of 1921, when Picasso was living in Fontainebleau, home of the famed palace of the French monarchy. With its deep terra cotta color and solid, three-dimensional appearance, it appears as if modeled directly from the clay of the earth, the strong, simple features chiseled from a hard, porous rock. Rendered in soft, warm pastels, *Heroic Head* points towards a new classicism in modern art while recalling the sculptural and pictorial traditions of Picasso's Mediterranean homeland. KM

Pablo Picasso (Spanish, 1881–1973). *Heroic Head*, 1921. Pastel. 25 1/2 x 19 5/8 inches. Gift of Mrs. William D. Vogel (W1947.2).

Diego Rivera
Profile of an Indian Woman with Lilacs, 1938

When Diego Rivera returned to Mexico in 1921, after having lived in the midst of the Parisian avant-garde for more than a decade, he was smitten with the indigenous culture of his homeland: "It was as if I were being born anew. In everything I saw a potential masterpiece…." The murals illustrating the history and folkways of Mexico, which he executed for several government buildings over the next fifteen years, earned him recognition as the preeminent artist of a native mural movement promoting the ideals of the Mexican Revolution. Although Rivera was a long-time member of the Communist Party, his art transcends propaganda and conveys a deep respect for all humanity. His monumental frescoes, easel paintings and drawings are an art for the masses, a vehicle for his people to rediscover their heritage.

When public commissions failed to come his way in the late 1930s, Rivera devoted his time to planning a museum of Pre-Columbian artifacts and to making drawings and watercolors of the Mexican landscape and its inhabitants. *Profile of an Indian Woman with Lilacs* is one of several drawings depicting Indians carrying flowers that Rivera made in 1938, the year that he and his friends Leon Trotsky and André Breton toured native villages in the province of Michoacan. In this drawing, Rivera rendered the model's ruddy skin and her fragrant bouquet with poetic tenderness, while he proudly drew attention to her Meso-American ancestry by emphasizing her profile with a dark line. This ancient lineage, coupled with the vital force of nature, is a recurring theme in Rivera's art. For Rivera, Mexico's ethnic peoples were living reminders of an ideal past, a world he aspired to re-create in his art. TM

Diego Rivera (Mexican, 1886–1957). *Profile of an Indian Woman with Lilacs*, 1938. Charcoal and pastel. 24 7/8 x 18 3/4 inches. Gift of Mr. and Mrs. Richard E. Vogt (M1980.139).

Arshile Gorky
Untitled (Study for The Liver is the Cock's Comb), 1943

For Arshile Gorky, 1940 to 1947 were the breakthrough years. An Armenian immigrant, Gorky arrived in the United States around 1920 with a passion for the Old Masters and a desire to emulate their extraordinary mastery of drawing. Works by Picasso, Cézanne, Matisse, and Miró were equally important in Gorky's search for his own brand of Modernist art. By the early 1940s, less than a decade before his suicide in 1948, Gorky finally achieved his goal. *Untitled (Study for The Liver is the Cock's Comb)* is one of a series of remarkable drawings he created during this fertile period. Identified by the artist's dealer, Julien Levy, as a study for one of his greatest paintings, *The Liver is the Cock's Comb* of 1944, the drawing bears little resemblance to its namesake, offering instead what may be considered a preliminary rendering of the painting's vast structure, forceful vitality, and blatant eroticism. As in the painting, Gorky depicted within a horizontal format sexually suggestive imagery defined by levitating, biomorphic forms, but offered here a more ambivalent relationship between figure and ground marked by bold patches of color and fine-tuned arabesques.

Drawings such as this one were the foundation of Gorky's art, the place where direct observation of nature and spontaneous lines were free to roam. Gorky was one of the few artists of his time to draw his studies from nature, "looking into the grass" to magnify details of plants and insects. He would then juxtapose these organic forms with highly erotic imagery, allowing the imagination to turn from nature to the most personal expressions of sexual desire and memory. For Gorky as for other young artists who linked Surrealism with Abstract Expressionism in the 1940s, the early work of the Russian artist Wassily Kandinsky was an enormous influence, here noticeable in Gorky's desire to construct monumental abstractions from deeply symbolic and suggestive components. KM

Arshile Gorky (American, b. Armenia, 1904–1948). *Untitled (Study for The Liver is the Cock's Comb)*, 1943. Pencil and wax crayon. 20 x 26 inches. Partial and promised gift of Herbert and Virginia Lust (M2000.3).

Romare Bearden
The Street, 1964

In 1963—the same year that Martin Luther King, Jr., presented his "I Have a Dream" speech to nearly a quarter of a million marchers in Washington, D.C.—Romare Bearden and thirteen fellow African-American artists met in Bearden's New York studio to debate the nature of "the Negro image" in contemporary art. Although they did not agree as to whether or not essential racial qualities existed, they planned an exhibition for the following year exploring the theme of "black and white." Bearden suggested that the group collaborate on a collage, but ultimately he pursued the idea on his own, fashioning a series of pictures constructed from images he clipped from newspapers, magazines, and his vast store of art reproductions.

In October 1964, Bearden exhibited twenty-one of these works, including this collage, at Cordier and Ekstrom Gallery in New York. Concerned that "the Negro was becoming too much of an abstraction" in political discourse that focused exclusively on African heritage, he chose to depict the daily rituals and common experiences of families like his own who migrated from the rural South to the urban North during the 1920s–50s. In *The Street*, people bustle along a crowded sidewalk in Harlem, the New York neighborhood where Bearden grew up and the center of a vibrant jazz and blues community. A songwriter himself, Bearden believed that the improvisational process of assembling collages from fragmented and disparate components was like making music. Structured yet fluid, like a jazz composition, *The Street* draws its energy from the pulse of urban life. TM

Romare Bearden (American, 1912–1988). *The Street*, 1964. Collage. 12 7/8 x 15 3/8 inches. Gift of Friends of Art and the African American Art Acquisition Fund (M1996.52).

Andy Warhol
Marilyn, 1967

Andy Warhol, the quintessential Pop artist, observed that "America started the tradition where the richest consumers buy essentially the same things as the poorest. You can be watching TV and see Coca-Cola, and you know the President drinks Coke, Liz Taylor drinks Coke, and just think, you can drink Coke too." Ever the voyeur of mass culture, Warhol the artist and Warhol the individual sought the fruits of the American Dream, yet continually challenged the assumptions inherent in this ideal. He was fascinated with glitzy pop icons such as Elvis Presley, Jackie Kennedy, and Marilyn Monroe, whose private lives were often at odds with the public personas they so brilliantly projected. Warhol never depicted his subjects from life, but rather appropriated precoded images from the mass media. His art collapsed the distinction between high style and commercial product, and functioned, as Lawrence Alloway,

the British critic who coined the term "Pop Art," put it, as signs and sign-systems.

The *Marilyn* portfolio, executed five years after the tragic death of this Hollywood sex goddess, consists of a single image repeated in seductive variations in which hair, eye shadow, and lipstick become the woman. These prints are executed in screenprint, a medium Warhol favored whether making unique "paintings" on canvas or multiple editions on paper. This commercial process, commonly used to print packages and clothing, challenged the Western notion of individual artistic genius. Yet, in *Marilyn*, Warhol subverted the mechanical nature of the process by printing screens off-register and using unconventional, even shocking, colors to make Monroe appear dazzling and sedate, frazzled and assured, glamorous and gaudy. TM

Andy Warhol (American, 1928–1987). *Marilyn*, 1967. Portfolio of ten screenprints. Each 36 x 36 inches. Purchase (M1968.6a-j).

Ed Ruscha
Eye, 1971

Edward Ruscha has been a pioneer in the exploration of the emotive power and abstract quality of text. Sly and possessing matter-of-fact charisma, his art uses placement of words, materials, and iconography to exploit the subtle, and often enigmatic, nature of language. In his early paintings, Ruscha juxtaposed emotionally charged place names, such as Vicksburg and Dublin, with commercial imagery, and explored semantics in seminal works in which words are rendered to suggest the sounds associated with them. Ruscha continued to explore aspects of syntax in a series of drawings, including this work, dating from the mid–1960s to the early 1970s, depicting words as thin ribbons floating on featureless backgrounds. During this period he was experimenting with unconventional materials for drawings and prints, including mustard, tobacco, berry juices, facial cream, and Pepto-Bismol, as well as the gunpowder used here. The potentially explosive nature of gunpowder lends a wry sense of danger to these delicate works and belies their subtle conceptual underpinnings.

The seemingly unrelated words featured in the series— "lips," "raw," "motor," "air," "eye," "optics," among others— form peculiar and unexpected relationships when viewed together, an experience Ruscha compares to reading disparate signs and billboards from a speeding car. Ruscha is fascinated with the visual chaos of Los Angeles's commercial strips, and frequently features elements of the city's sprawling landscape in his art. The elongated format of *Eye* and other works in the series refers to the expansive horizon of Southern California and, as Ruscha also notes, the arrangement of one's eyes and the structure of words and sentences. TM

Ed Ruscha (American, b. 1937). *Eye*, 1971. Pastel and gunpowder over pencil. 11 1/2 x 29 1/16 inches. Gift of Reva and Philip Shovers (M1999.198).

Brice Marden
Zen Study 3, 1990–91

In the early 1980s, New York painter and printmaker Brice Marden was in a mid-life crisis. In his art he felt he had exhausted the creative possibilities of Minimalism, an austere and reductive geometric style he had explored since college. In his personal life increasing use of drugs and alcohol were causing him to feel aimless. Happily he found new spiritual and artistic inspiration in Eastern art and literature, particularly Taoist poetry and Chinese calligraphy. Chinese is a conceptual language in which individual characters or clusters of characters, functioning as ideographs, are placed on top of or beside one another. Marden's subsequent work presents rhythmic loops drawn in columns from right to left as in the manner of Chinese writing. Working spontaneously and intuitively, yet thoughtfully and with restraint, he turned his art-making into a form of meditation.

For the six prints of the *Cold Mountain Series*, Marden drew with sticks dipped in sugar solution on etching plates with an aquatint ground. He began by drawing five sets of marks organized in four columns, then joined the columns to form layered, cursive webs. This format mimics the form used in his poetry by the Tang Dynasty writer Cold Mountain, for whom Marden named his series: four couplets, each consisting of five characters. As in these poems, the elements in Marden's visual equivalent can be read alone or as a unified work. TM

Brice Marden (American, b. 1938). *Zen Study 3* from *Cold Mountain Series, Zen Studies 1-6*, 1990–91. Etchings and aquatints. 20 5/8 x 27 inches each. Gift of Friends of Art (M1992.136.3).

Mark Tansey
Study for Bridge over the Cartesian Gap, 1990

Mark Tansey's working drawing for the 1990 painting *Bridge over the Cartesian Gap* (private collection) treats the relationship between image and text in contemporary art-making. It depicts a huge stone bridge spanning an enormous space identified by Tansey as the "Cartesian Gap," the conceptual divide that separates systems of knowledge in conflict as envisioned by the seventeenth-century philosopher René Descartes. Embedded within the very structure of the bridge is an underlined text from the book *Blindness and Insight* by the Belgian philosopher Paul de Man, a leading voice in Deconstructionist theory of the 1980s. De Man and other pioneering literary critics such as Jacques Derrida sought to redress the conflict between written and representational discourses in systems of signification. The fact that one cannot read the text incorporated in Tansey's image underscores the inadequacy of words as representations of things.

Tansey's work focuses on such questions regarding the limits of representation and the myths of art-making and creativity. An avid collector of art reproductions, media photographs, and illustrations, as well as a voracious reader of theory and philosophy, Tansey assembles his art from an enormous archive of texts and pictures, emphasizing the way that images are constructed and transformed through art and culture. For drawings such as this one, which act as working studies toward more finished paintings, Tansey uses a photocopy machine to juxtapose images and text found in his archives. In this composite of an illustration of artillerymen and Tansey's own underscored copy of de Man's essay, the toner deposited on the paper from the photocopier has been erased and reworked to produce an image that blurs the distinctions between original and copy, handmade and reproduction. The result is a drawing that redefines the sources of inspiration and creativity for an artist working at the end of the twentieth century. KM

Mark Tansey (American, b. 1949). *Study for Bridge over the Cartesian Gap*, 1990. Toner and carbon crayon. 8 1/2 x 11 inches. Gift of Marianne and Sheldon B. Lubar (M2001.14).

Kara Walker
A Means to an End...A Shadow Drama in Five Acts, 1995

The art of Kara Walker taps into a legacy of American slavery and racism that many find hard to face. As a young African-American woman living in Georgia, Walker found some of the historical archetypes of race relations in the South barely concealed beneath the surface of polite society, swept aside or simply avoided because of their intense volatility and provocation. Instead of ignoring overt expressions of racial hatred, Walker confronts them head-on, using the language and heritage of slavery and miscegenation as the means to explode these highly taboo subjects. Her work recalls the historical period of the antebellum South when relations between master and slave often revolved around extremes of violence and sexuality.

In *A Means to an End . . . A Shadow Drama in Five Acts*, one of the artist's first prints, Walker employed artistic precedents that recall the era of slavery while at the same time creating an uncomfortable division between elegance and revulsion. As in much of her work, Walker used the model of cut-paper silhouettes, a nineteenth-century genre of amateur art reserved for drawing rooms and children's pastimes. The delicacy and refinement of Walker's figures are juxtaposed against a brutal narrative that begins with a child suckling at its mother's breast and ends with a white slave master choking a little girl. The panorama format, which recalls the narrative cycloramas of the Civil War era, leads us through a fractured series of vignettes subtitled "the beginning," "the hunt," "the chase," "the plunge," and "the end." Calling this "a shadow drama in five acts," Walker has played with the concepts of illusion and substance, fantasy and historicity, indeed even simply the dichotomies of black and white, that continue to inform our stereotypes of race relations in this country. Her conceptual integrity and technical sophistication allow Walker's images to emerge from the darkened recesses of racial hatred toward a new, more challenging and critical response to our American heritage. KM

Kara Walker (American, b. 1969). *A Means to an End...A Shadow Drama in Five Acts*, 1995. Hard-ground etching and aquatint on five sheets. 35 x 120 inches. Landfall Press Archive, Gift of Jack Lemon (LP1996.11.1-.5).

Photographs

In 1957 the Milwaukee Art Museum purchased six photographs from an Edward Weston exhibition held at the Milwaukee Art Institute, a predecessor of the museum. In the early 1970s, Dr. and Mrs. Sheldon Barnett augmented this modest beginning with seminal works by Abbott, Bourke-White, Callahan, W. Eugene Smith, Steichen, and others. The photography department officially began in 1978 with the appointment of a curator and the establishment of a photography gallery. That same

year, Robert Mann generously donated seventy vintage prints by Hine; fifty-three works by such artists as Baltz, Kertész, Siskind, and Winogrand were acquired with matching funds provided by the National Endowment for the Arts and Friends of Art, a Milwaukee Art Museum support group. Of particular significance during the great expansion in the 1980s were 200 news and documentary photographs presented by individuals from across the country in memory of Edward Farber, a Milwaukee news photographer and pioneer in flash photography. In 1986 Floyd and Josephine Segel donated what remains the collection's largest and most enduring contribution: 342 works by modern and contemporary masters such as Arbus, Brandt, Brassaï, Cartier-Bresson, Doisneau, Mapplethorpe, and Penn. Today the collection has grown to more than 2,000 pictures spanning the entire history of the medium.

In 1989 the museum's photography holdings became more accessible to scholars and the public with the opening of the Print, Drawing and Photography Study Room. This facility recently has been relocated and greatly improved with funds provided by the Ethel and Richard Herzfeld Foundation, whose demonstrated significant commitment to the photography department since 1990 has allowed the

museum to acquire more than 100 masterworks by artists such as Atget, Frank, Gursky, Käsebier, and Fox Talbot. Also during the last ten years, many Wisconsin artists—Jay Atterberry, Steven Foster, and Tom Uttech, among others— have generously donated many works to the collection, enabling the museum to represent significant developments in the field close to home.

The Milwaukee Art Museum's active exhibition program showcases acknowledged masters of photography, as well as provocative new developments. Since 1980 the museum has shown hundreds of photographers, including Adams, Arbus, Matthew Barney, the Bechers, Bennett, Groover, Hockney, Lange, Sally Mann, Rodchenko, Sherman, Strand, and Wegman. The Milwaukee Art Museum organized the first museum exhibitions in the United States of the German artists Gursky and the Blumes. The ongoing contemporary art series Currents has presented the work of Sugimoto and other photographers, and the New Wisconsin Photography series has introduced many new talents in the field. As the photography program moves into its third decade, the Milwaukee Art Museum has become a photographic research collection distinguished as a regional and national resource. TB

Thomas Annan
Close, No. 46 Saltmarket, 1868

In 1868 the trustees of the Glasgow City Improvement Act commissioned Thomas Annan to document the city's infamous slums as part of its redevelopment plans for this growing industrial center. The narrow alleys and interior courtyards along Saltmarket Street, known as wynds and closes, were home to Irish immigrants fleeing the potato famine and Scottish Highlanders working in the city's textile mills, chemical factories, and iron foundries. Citizens in the wealthier West End, some of them absentee landowners in the center city, were alarmed by the decay, crime, and disease in the old quarter, yet venerated its historic associations with the founding of the city. Beginning in 1868 the improvement commission tore down large tracts of property, widened streets, and encouraged developers to build improved housing. But when economic depression threatened their efforts ten years later, they distributed one hundred sets of Annan's photographs to concerned citizens and members of the City Council to bolster new support.

Unlike photographer-reformer John Thomson, who documented London's poor about the same time, or police photographer Jacob Riis, who successfully led a campaign for tenement reform in New York late in the century, Annan had no social agenda. He was a consummate commercial photographer of urban and architectural views, and was particularly known for his printing establishment which specialized in the new process of carbon printing. Annan's pictures of Glasgow document a marginalized population ensconced in tenements or going about their lives in the narrow, dank, often wet streets. Although the neighborhoods are now gone, Annan's photographs maintain their silence and mournful beauty. TM

Thomas Annan (Scottish, 1829–1887). *Close, No. 46 Saltmarket*, 1868. From the series *Photographs of Old Closes, Streets & c., taken 1868–1877*, 1878–79. Albumen silver print from glass negative. 11 x 9 inches. Purchase, Richard and Ethel Herzfeld Foundation Acquisition Fund (M1995.302).

H. H. (Henry Hamilton) Bennett
Lone Rock with Canoe, Wisconsin Dells, 1880s–90s

Unlike many of the landscape photographers of the late nineteenth and early twentieth centuries who traveled to work for the government or the railroads, Henry Hamilton Bennett devoted his entire life to photographing his neighborhood. Though he traveled occasionally to photograph in other places in the Midwest, all of his great pictures were made within a few miles of his house.

In *Lone Rock with Canoe, Wisconsin Dells*, a typical Bennett photograph, a canoe is poised within the serenity of a scene. Nature is in repose, tranquil and domesticated. Bennett used his proximity and intimacy with his subject to his advantage. He made this same picture over and over again, expressing his desire for a place in nature that was no more foreign than his back yard, that was benevolently ordered and accommodating to human longing for comfort and satisfaction. TB

H. H. (Henry Hamilton) Bennett (American, 1843–1908). *Lone Rock with Canoe, Wisconsin Dells*, 1880s–90s. Gelatin silver on printing-out paper. 15 1/8 x 20 1/4 inches. Gift of H. H. Bennett Studio Foundation, Inc. (M1993.118).

Edward Steichen
Pool, Milwaukee, ca. 1899

Edward Steichen made this photograph while he was still a teenager in Milwaukee, Wisconsin. The soft impressionism of *Pool, Milwaukee* was very much a part of its time. Steichen muted this image first by moving the camera during the exposure and then by making a dark, brooding print on soft platinum paper. No details were left to distract the viewer from the essential beauty of nature. By contemporary standards, the *Pool's* luscious expressionism and uncensored sentiment seem restrained; the muted luminosity of this small and intimate natural world is elegant and mysterious. This photograph is simply beautiful and resonates with our yearning for the sublime.

At the time, the assumption underlying the image was that for photography to be art, it had to be less like a photograph and more like a painting. This painterly, "pictorialist," approach to photography was the first self-conscious art movement in the medium. Pictorialism was soon challenged—and vanquished—by Modernists led by Steichen's friend Alfred Stieglitz, who proclaimed that photography had to be photography before it could be art. The Modernists' photographs stripped away the pretense and sentiments of art in favor of a sharp and detailed collection of facts, recording the surfaces rather than illustrating a deeper sense of the subject. Today, this early work of Edward Steichen has acquired new meaning apart from documenting a transitory movement in the history of photography. His original impulse, to extend the range and possibilities of the medium, survives art history. TB

Edward Steichen (American, b. Luxembourg, 1879–1973). *Pool, Milwaukee*, ca. 1899. Platinum print. 7 13/16 x 6 1/8 inches. Purchase, Richard and Ethel Herzfeld Foundation Acquisition Fund (M1993.85).

Alfred Stieglitz
Portrait of Georgia O'Keeffe, 1922

The photographer Alfred Stieglitz was a bold and prominent champion of modern art in Europe and the United States. In addition to his own achievement in photography, Stieglitz introduced American audiences to avant-garde European artists such as Henri Matisse, Henri Rousseau, and Constantin Brancusi. Around the turn of the century, he began to mount exhibitions, many at his New York galleries "291" and An American Place, featuring emerging American artists at a time when American artists were struggling to establish their own national identity. The changing modern aesthetic is evident in Stieglitz's own work from the mid- to late teens as he shifted from a pictorial style, or one that imitates painting, to "straight photography," a style that involves little to no manipulation of the negative. Stieglitz came to view the latter as more honest and true to the medium, thus elevating the status of photography as an art form in its own right.

While Stieglitz made numerous portraits throughout his career, no individual was more photographed by him than the artist Georgia O'Keeffe. Stieglitz began aggressively to promote O'Keeffe's work soon after meeting her in 1917. That same year he began *Portrait*, a series of nearly three hundred photographs of O'Keeffe's face, hands, and body taken over a twenty-year period. These intimate portraits, including this early one from 1918, are the result of an artistic collaboration between O'Keeffe and Stieglitz, who eventually married in 1924. Stieglitz decided upon the final composition and lighting while O'Keeffe maintained control of her persona, often performing before the camera. In this portrait an unabashed O'Keeffe stares deep into the camera's lens, her face tightly framed by her dark coat and hat that fill the composition. JVC

Alfred Stieglitz (American, 1864–1946). *Portrait of Georgia O'Keeffe*, 1922. Palladium print. 9 7/8 x 7 5/8 inches. Gift of Earl A. and Catherine V. Krueger, Jane Bradley Pettit Foundation and Friends of Art (M1997.52).

Walker Evans
View of Easton, Pennsylvania, ca. 1935–36

Walker Evans was one of the most influential documentary photographers of the twentieth century; his images have become American icons. From the time Evans acquired his first camera in 1928, he found his sense of purpose in creating photographs based on literal representation. His oeuvre includes numerous poignant portraits and equally revealing images of places. Evans had a special affinity for American vernacular architecture, including everything from Southern plantation mansions to weather-worn shacks. From 1935 to 1938 he worked for the Farm Security Administration, an agency formed by the Roosevelt administration to document American life during the Great Depression. During these prolific years, Evans held fast to his personal goal of "pure record, not propaganda."

While on assignment for the FSA, Evans traveled through Pennsylvania, making stops in industrial towns such as

Bethlehem and Easton. This *View of Easton, Pennsylvania* is cropped from a larger 8-by-10-inch negative and printed on postcard stock, which was widely available at the time. An avid collector of postcards, Evans frequently used the reduced format to experiment with fragments of a larger image. Here, a cluster of buildings has been isolated from its context, an expansive cityscape of the steel town. Crowded lots are framed by power lines threaded between poles that rise among the trees. The bright afternoon sun casts long shadows and accentuates the sharp contrasts between the white frame houses and their dark roofs. People and automotive vehicles are conspicuously absent from this small corner of urban America. Even though the title identifies a specific location, this scene could be found in any small, industrial American town in the mid–1930s. JVC

Walker Evans (American, 1903–1975). *View of Easton, Pennsylvania*, ca. 1935–36. Gelatin silver print. 3 3/8 x 5 3/8 inches. Purchase, Richard and Ethel Herzfeld Foundation Acquisition Fund (M1994.68).

Edward Weston
Bad Water, Death Valley, 1938

Edward Weston made *Bad Water, Death Valley* and many other pictures in California where the horizons are long and the space is clear and deep. With its pure lines, luminous atmosphere, and spatial drama, the West was an ideal subject for a number of photographers. Weston was drawn to this spare landscape because he could precisely transpose his subject into a coherent photograph. Like many Modernists, he was interested in how the photograph could itself be more authentic and real. He was a founding member of the Group *f*/64, which advocated sharp photographs rather than the blurry painterly images of the day (*f*/64 is the smallest aperture on most cameras that gives a picture

the greatest depth of focus). But Weston was not just applying a camera technique: a Weston photograph is an exposition on the pristine nature of qualities of photography.

Bad Water, Death Valley is free of extraneous elements of any kind. The pellucidity of this scene is mirrored by the clarity of Weston's technique and vision. He was not only trying to reveal the essence of his subject through abstraction and formal elegance, but by refining the formal elements of this image, he was seeking to make nature and art equal. TB

Edward Weston (American, 1886–1958). *Bad Water, Death Valley*, 1938. Gelatin silver print. 7 1/2 x 9 5/8 inches. Purchase, in memory of Herbert Dwight (M1957.51).

Robert Frank
Times Square, New York, 1958

When Robert Frank moved from Paris to New York in 1947, he was fascinated, even troubled, by the pace and complexity of the city. Initially he made fashion and editorial photographs for magazines, then pursued independent projects, including photographing the activity he encountered on the streets of New York. *Times Square, New York* is from a series Frank made during random walks and rides on the city's transit system. This richly layered image, seen here in a rare vintage exhibition print, depicts a bible held by a street preacher, an American flag, a public bomb shelter sign, a romantic couple, and a movie marquee. A compendium of symbols of our preoccupation with country, family, and religion, it is an index to American popular culture.

Frank pursued this theme in an earlier and better-known series, *The Americans,* published the same year he made *Times Square.* With the support of a Guggenheim Fellowship, Frank drove coast to coast across some thirty states, photographing diners, gas stations, and other roadside places. He depicted the country, then just emerging from McCarthyism, as an outsider, a voyeur of American culture. Many critics at the time were disturbed by the seeming ugliness of the pictures. Others, such as the Beat poet Jack Kerouac, were moved by the emotional resonance of Frank's photographs—his spontaneity, innovation, and ability to describe, as Kerouac put it, the EVERYTHING-ness of his subjects. Kerouac proved correct: Frank's work subsequently has influenced generations of photographers and filmmakers, and has helped define the visual and emotional grammar of our time. TM

Robert Frank (American, b. Switzerland, 1924). *Times Square, New York,* 1958. Gelatin silver print. 16 7/8 x 12 inches. Ethel and Richard Herzfeld Collection (M1990.86).

Robert Adams
Outdoor Theater and Cheyenne Mountain, 1968

Robert Adams' unvarnished scenes of suburban forms infiltrating the postwar western landscape injected a strong dose of reality into perceptions of the American West. Nevertheless, while he admits traces of rapid land development inside the frame of his images, these elements appear not as anomalies but as part of the natural process of social development. In *Outdoor Theater and Cheyenne Mountain*, the screen of a drive-in movie theater grows out of a mountainside and speaker stands recall cacti. The key is Adams' stringent rendering of light, which identifies the transient element as man—not his environment. LH

Robert Adams (American, b. 1937). *Outdoor Theater and Cheyenne Mountain*, 1968. Gelatin silver print. 5 15/16 x 5 15/16 inches. Purchase (M1983.242).

William Eggleston
Huntsville, Alabama, 1978

When the photograph *Huntsville, Alabama* was first shown at The Museum of Modern Art in New York, it was widely noted that William Eggleston's pictures were in color and artless. At the time color photography was still considered an amateur's medium that did not have the capacity for artistic expression; Eggleston's photographs seemed more like snapshots that were too insouciant to be works of art.

In retrospect it is hard to imagine why color pictures caused so much of a stir. It has since become the medium of choice for most photographers and many artists. Today color photography is so ubiquitous that it is impossible to imagine contemporary art without it.

Eggleston's accomplishment has yet to be equaled. He remains the great colorist of photography. The ordinary man in *Huntsville, Alabama* is cornered in an artificial world where color seems to emerge from the surfaces and hover like the atmosphere itself. The murky yellow wall, burgundy red floor, and bluish acoustic ceiling rotate around the subject's stark white shirt in the middle of the frame. A diffuse light source outside of the frame flattens the tones, mutating the colors. The banality of the setting is striking. Eggleston's casual framing makes the scene even more ordinary, revealing the intense narratives buried in normal life. TB

William Eggleston (American, b. 1939). *Huntsville, Alabama*, 1978. Dye transfer print. 18 1/4 x 12 3/4 inches. Ethel and Richard Herzfeld Collection (M1991.198).

Cindy Sherman
Untitled Film Still #24, 1978

For her series *Untitled Film Stills* (1977–80), Cindy Sherman borrowed from American popular culture, specifically challenging the distinction between art and commerce and addressing the role of women as it had been defined in post-war American society. She turned for inspiration not to art history, but to fashion photography, television, and Hollywood, specifically B-movies. After carefully constructing a scene and positioning herself within it, she often employed the assistance of friends and family to snap the final picture, thus blurring the traditional roles of model and artist.

In each of the series' sixty-nine black-and-white images, Sherman, with the aid of costume and make-up, assumed the role of a 1950s–60s female stereotype, such as a housewife, model, or starlet. Using the pretext of a film still, she represented each woman as isolated and apparently in a state of vulnerability or deep thought. In *Untitled Film Still #24*, Sherman is seated on the waterfront dressed in a scoop-neck black shirt and a pleated skirt. The character, with pouty lips and half-open, heavily made-up eyes, looks wistfully over her shoulder as if searching for someone or something outside the picture. The persona is completely a fabrication of the artist, yet there is something familiar about her and her situation—as if the viewer has already seen this film. The same character and setting are reconfigured in *Untitled Film Still #25*, underscoring the conceit of the movie still, or an image extracted from a larger narrative context. JVC

Cindy Sherman (American, b. 1954). *Untitled Film Still #24*, 1978. Gelatin silver print. 8 x 9 7/16 inches. Gift of Jeffrey Kasch (M1988.174).

Bernd and Hilla Becher
Water Towers (Cylindrical), 1978

The husband and wife team of Hilla and Bernd Becher photograph the same types of things over and over again, in the same light, from the same perspective. Their photographic process is a constant: nothing changes except permutations of the subject. This method reveals how unadorned industrial structures, such as water towers, are shaped by their cost and function. *Water Towers (Cylindrical)* presents the man-made structures as a species, like butterflies; they can be infinitely variable and at the same time bear a family resemblance to each other. Moreover, both are a product of evolution. With their systematic, "scientific" approach, the Bechers are creating a taxonomy of the industrial world.

The Bechers also have a particularly German philosophical position about the way we know the world. Following the German photographer August Sander, who photographed individuals as representatives of something more fundamental—what the philosopher Hegel called "types"—the Bechers take the next inevitable Hegelian step by replacing the individual with a collection of generic examples, their "Typologies," from which we can better understand the "idea" of water towers. The Bechers' and Hegel's position is that there are no things without ideas. This viewpoint is quite different from that of Walker Evans, who thought, like the poet William Carlos Williams, that there are "no ideas but in things." Yet Evans was an important influence on the Bechers. They both looked hard at the world and rendered it with great clarity and grace. TB

Bernd and Hilla Becher (German, Bernd b. 1931, Hilla b. 1934). *Water Towers (Cylindrical)*, 1978. Composite of nine gelatin silver prints. 56 x 40 inches overall. Gift of Herbert H. Kohl Charities, Inc. (M1984.117).

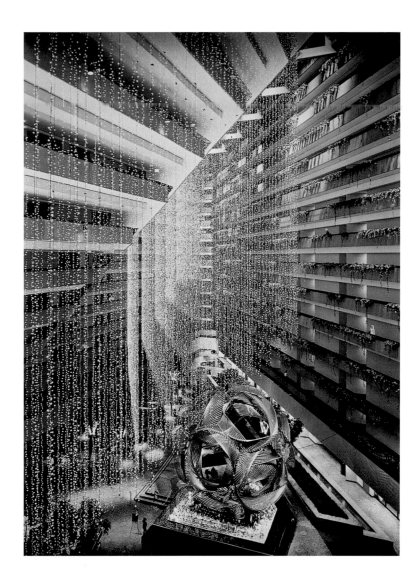

Andreas Gursky
San Francisco, 1998

Like a biologist from another planet, Andreas Gursky assumes the way we inhabit and transform the world conforms to the same laws as any other species and he searches for the most compact, elegant, and economical rendering of his subject. The complete lack of mystery ironically creates a mysterious vacuum: there is a reason for everything yet nothing essential to learn. There is no compulsion even to distinguish between what is organic or synthetic, cultural or natural.

The order and continuity of the hotel lobby atrium presented in *San Francisco*, 1998 are a result of the natural selection of corporations. This vaulted space, defined by a litany of rec-tangles, potted plants, and strings of lights, is a species unto itself. In its sheer mundanity the hotel atrium makes sense to us today precisely because of its meaninglessness. Andreas Gursky's photographs intentionally emphasize the lack of significance of this public space by avoiding any sense of drama and power in his image: any feeling of the transcendence found in cathedrals is deliberately absent.

As a result of this subtraction, we see the structure of our built world with greater clarity. Without the distinctions and gravity that art often brings to its subject, a Gursky photograph makes more sense than our desire for deeper meaning. TB

Andreas Gursky (German, b. 1955). *San Francisco*, 1998. Chromogenic print. 90 x 64 inches. Purchase, Eric C. Stern Fund and Richard and Ethel Herzfeld Foundation Acquisition Fund (M1999.94).

Folk, Self-Taught, and Haitian Art

The Milwaukee Art Museum's commitment to the work of folk and self-taught artists began as early as 1951 with the gifts of two works by Wisconsin artist Anna Louisa Miller. During the 1960s and 1970s, the collection was significantly expanded with the purchase of a number of important works, including a major group of Shaker furniture and objects, an Ammi Philips portrait, a Schimmel eagle, and Kane's *Bust of a Highlander*. A substantial gift in 1981 from the estate of Edgar William and

Bernice Chrysler Garbisch further enhanced the collection's nineteenth-century holdings. That same year the museum organized an exhibition from the collection of Herbert W. Hemphill, Jr., comprised largely of works by twentieth-century and contemporary self-taught artists and now in the Smithsonian American Art Museum. Following the Hemphill exhibition, the museum hosted exhibitions of works by Martin Ramirez and Eugene von Bruenchenhein, two twentieth-century outsider or visionary artists. The 1980s also saw the collection grow significantly in twentieth-century material, culminating in 1989 with the acquisition of the renowned Michael and Julie Hall Collection of American Folk Art. The Hall collection, comprised of some 273 works, remains the largest addition to the folk and self-taught collection. A number of contemporary American works have come into the collection through the kindness of Chicago collectors Ruth and Robert Vogele. And in an effort to explore the limits of the self-taught field, the museum also has begun to acquire a substantial collection of works by European outsider artists, thanks entirely to the vision and gifts of Milwaukee collector Anthony Petullo. Having

established a national reputation for owning and actively pursuing a premier collection of folk and self-taught art, the Milwaukee Art Museum hopes to concentrate on rounding out the collection, including refocusing on nineteenth-century material and acquiring works by important contemporary artists not yet represented.

Complementing the extraordinary collection of works by American and European folk and self-taught artists is the Milwaukee Art Museum's collection of Haitian art. In 1991 the museum received a magnificent gift of some ninety paintings and sculptures from Milwaukee collectors Richard and Erna Flagg. The Flaggs began collecting Haitian art in 1973 and went on to amass one of the world's outstanding twentieth-century Haitian collections. In 1992 the museum organized "A Haitian Celebration: Art and Culture," an exhibition featuring works from the Flagg collection in addition to others from various American and European collections. Future plans include a touring exhibition of the Haitian collection and a comprehensive catalogue. MA

Erastus Salisbury Field
Portrait of a Man and Portrait of a Woman, 1833

Prior to the advent of photography, people relied on portrait painters to capture their likeness and record their class status in a lasting image. Western art history is replete with images of the wealthy and powerful rendered by the most renowned portraitists of the day. In nineteenth-century America, the growing middle class desired the same trappings of genteel life enjoyed by the wealthy, including the documentation of their images for posterity. This created an expanding market for artists such as Erastus Salisbury Field, a self-taught, itinerant painter from Leverett, Massachusetts, who traveled through the Northeast seeking commissions. Completing as many as thirty paintings in a year, Field became one of the most successful portrait artists of the period.

These two unidentified portraits probably were made by Field in 1833 during a trip through Connecticut. They feature the accepted stylistic conventions of the time: the sitter presented against an ambiguous background in an even light in a three-quarter, rather rigid pose, accompanied by a few accessories that implied their social position (for example, the perfume bottle in the woman's hand). The paintings appear to be pendant portraits of a husband and wife, executed with the particular blend of immediacy, charm, and awkwardness that characterizes Field's style. MA

Erastus Salisbury Field (American, 1805–1900). *Portrait of a Man* and *Portrait of a Woman*, 1833. Oil on canvas. 35 1/8 x 29 1/2 inches each. The Michael and Julie Hall Collection of American Folk Art (M1989.202.1, .2).

Wilhelm Schimmel
Eagle, ca. 1880

Wilhelm Schimmel, or "Old Schimmel," as the locals in Cumberland Valley, Pennsylvania, called him, was an itinerant wood carver who immigrated to the United States from Germany shortly after the Civil War. Perhaps the large Pennsylvania-German population in the area enticed him to make this south central part of the state his new home. Schimmel traveled from town to town throughout the region selling his woodcarvings of birds and animals, or trading them for food, drink, and lodging. Most of his sculptures are made of pine, although he carved whatever wood was available, using a common pocketknife as his tool.

This life-sized *Eagle* is one of Schimmel's largest works and possesses the salient characteristics of all Schimmel eagles. The body was carved from a single block of wood in a coarse, sawtooth technique, while the wings, with their individually rendered feathers, were formed from two separate pieces. The beak of the eagle closely resembles that of the parrots that the artist also carved. The claws of the bird are roughly hewn and grasp a woodblock base. The sculpture was painted, as were most of Schimmel's carvings, with a gesso base and bright colors. MA

Wilhelm Schimmel (American, b. Germany, 1817–1890). *Eagle*, ca. 1880. Carved and painted pine. 18 1/4 x 29 1/2 x 14 5/8 inches. Purchase (M1967.124).

American
Pair of Black Figures, ca. 1880

Despite our not knowing the maker or the exact purpose of these figures, their unusual nature and aesthetic quality distinguish them as rare and exceptional works of art. The similarity of their garments and accessories suggests that the figures were created as a pair or as part of a larger group of figures. Their earliest known provenance is Hamilton, Ohio, where they were purchased by an antiques dealer at a porch sale. The backs of the figures are finished, suggesting that they were intended to be viewed in the round and not positioned against a wall. They may have functioned in a funerary context as mortuary trade signs or as ceremonial figures for a lodge hall or fraternal order. The Maltese cross on their tie tacks indicates a possible connection to the fraternal order of the Freemasons. Black fraternal organizations were abundant in late nineteenth-century southern Ohio, and some orders offered burial coverage to members through associations with insurance companies. This relationship has led to speculation that the figures were used in funeral rites. The figure with the clenched fist probably held a staff related to the particular fraternal order or ceremony, and the other figure most likely held a book, perhaps a bible or a lodge manual. The metal loop in their lapels most likely held a freshly cut flower for formal ceremonies.

Pair of Black Figures is attributed to a black artist because rather than the stereotypical caricature of African-Americans that was prevalent at the end of the nineteenth century in America, the figures convey a dignified nobility. They also exhibit characteristics of African sculpture, such as the overall economy of form and the rigid frontal pose. The faces, reminiscent of African masks in their simplicity, have a tranquil expression—a sign of noble character in African sculpture. MA

American. *Pair of Black Figures*, ca. 1880. Painted wood, hemp, plaster, metal, and colored glass buttons, eyes, and jewelry. 53 1/2 x 18 x 19 inches and 56 1/2 x 18 1/2 x 19 inches. The Michael and Julie Hall Collection of American Folk Art was acquired through the gift of Joseph and Ellen Checota, Friends of Art, Jane Bradley Pettit Foundation, Kohler Foundation, Marianne and Sheldon B. Lubar, Joan M. Pick, Evan and Marion Helfaer Foundation, Kenneth and Audrey Ross, with additional support from Donald and Barbara Abert Fund in the Milwaukee Foundation, Donald and Donna Baumgartner, Richard and Erna Flagg, Jane and George Kaiser, the Laskin Family, Stackner Family Foundation, Robert and Jo Ann Wagner, BDO Seidman and Johnson Foundation (M1989.194a, b).

American
The Newsboy, 1888

Eye-catching and immediately identifiable with the product it advertises, *The Newsboy* has all the elements of a successful trade sign. One of the earliest forms of American advertising, trade signs were based on popular British examples developed to attract customers, many of whom were illiterate. Even though literacy rates increased in the late nineteenth century, handmade trade signs continued to flourish.

This trade sign was made by an unknown artist for the *Pawtucket Record*, a weekly newspaper published in Rhode Island between June 1886 and December 1890. From his flapping jacket to his wide-open mouth and upraised arm,

The Newsboy exhibits a trait rarely seen in folk art sculpture—motion. The striding image of a boy hawking the latest edition was often used on the mastheads, publicity, correspondence, and even office façades of many late nineteenth- and early twentieth-century newspapers. In an era of child labor, the hard-working but poorly paid newsboy was a vital component in the profitable operation of a newspaper. Here the newsboy is depicted with replicas of the *Record's* November 13, 1888 issue. Typical of this period, the paper's front page emphasizes commercial goods rather than hard news, a priority of most publishers that reflected their pursuit of ever increasing advertising revenues. MA

American. *The Newsboy*, 1888. Carved, assembled, and painted wood with folded and painted tin. 42 x 30 x 11 inches. The Michael and Julie Hall Collection of American Folk Art (M1989.125).

A. Elmer Crowell
Preening Black Duck, ca. 1910

Wild fowl decoys were first produced by Native Americans as early as 200 A.D. to lure particular species of birds out of the sky in order to be more easily hunted. European settlers adopted the practice. Eventually, in search of a durable decoy that could be reused every season, American hunters in the late eighteenth century began carving birds out of wood. By the late nineteenth century, hunting was becoming less of a subsistence activity and more of a sport. During this period carvers began to experiment with formal and stylistic elements unrelated to the function of decoys.

The combination of function and aesthetic excellence in his birds distinguishes Elmer Crowell as one of the finest carvers of decoys. Born into a family of wild fowl hunters in East Harwich, Massachusetts, Crowell began carving decoys for his own use as a young man. At the age of fifty, he turned to carving full time. Through his life-long interest in hunting, Crowell garnered an intimate knowledge of the appearance and behavior of various wild fowl species, which he faithfully translated into his carvings. This black duck is preening, or cleaning its feathers, which conveys a sense of safety to ducks flying overhead, and also requires a dramatic positioning of the head. The fully carved primary wing feathers and crossed wing tips are characteristic of Crowell's earliest work. While Crowell carved many ornamental birds for a broad mass market, the worn features of this duck clearly indicate that this example was a functioning decoy. MA

A. Elmer Crowell (American, 1862–1952). *Preening Black Duck*, ca. 1910. Cedar, pine, metal loop, paint, nails, glass eyes, and glue. 6 5/8 x 7 x 16 inches. The Michael and Julie Hall Collection of American Folk Art (M1989.259).

John Kane
Bust of a Highlander, ca. 1927–30

John Kane was one of the first self-taught artists of the twentieth century to receive critical acclaim in America. Born in West Calder, Scotland, Kane immigrated with his family to Braddock, Pennsylvania, at the age of nineteen. He worked most of his life as a laborer until an accident in 1891 caused him to lose his left leg. Subsequently, Kane found less strenuous jobs painting houses and boxcars and he began experimenting with color and painting for recreation. Among the subjects he painted on discarded boards were landscapes and Scottish themes. In 1927 one of his paintings was accepted at the Carnegie International exhibition in Pittsburgh; thereafter, Kane's works were widely exhibited in New York and Pittsburgh. The majority of his one hundred and fifty-six recorded oil paintings were completed during the seven years between the Carnegie exhibition and his death in 1934.

The 1970s purchase of *Bust of a Highlander* was an early indicator of the Milwaukee Art Museum's strong commitment to building a folk art collection. Kane's frontal, iconic depiction of the figure gives this Scot a heroic quality indicative of the pride the artist felt in his Scottish heritage. He once remarked that painting the Scotch Highland dress reminded him of "the green pentlands and Edinburgh castle and the Highland soldiers." The awkward perspective seen particularly in the landscape and fortress in the background of this painting is a common characteristic of work by self-taught artists, who typically are more concerned with recording and relaying information than with laboring over pictorial elements such as modeling and depth. MA

John Kane (American, b. Scotland, 1860–1934). *Bust of a Highlander*, ca. 1927–30. Oil on canvas. 34 1/8 x 24 1/4 inches. Purchase (M1973.84).

Morris Hirshfield
Dog and Pups, 1944

Known as one of the major folk artists of this century, Morris Hirshfield was born in Poland and immigrated to the United States at the age of eighteen. He settled in New York and established his own clothing manufacturing business. After poor health forced him to retire in 1937, Hirshfield, like many folk artists, turned to art as a means of occupying his time. But unlike most such artists, by 1943 he had earned a retrospective at The Museum of Modern Art in New York. Because the artist completed a total of only seventy-six works, the majority of which are at The Museum of Modern Art and in a prominent private collection, this important addition to the museum's folk art collection is a rare acquisition.

Hirshfield's paintings are heavily textured and feature strong colors and areas of dense, decorative patterning, no doubt influenced by the fabrics he worked with during his career in the textile business. *Dog and Pups* evinces this technique of dense patterning. The lines of the flowering plant forms suggest the texture of a braided rug, while the soft, plush fur of the dogs is like an angora sweater. The competing patterns in the painting, as well as the awkward positions of the dogs, contribute to the awkward but charming composition that gives much of Hirshfield's work its naïve character. MA

Morris Hirshfield (American, 1872–1946). *Dogs and Pups*, 1944. Oil on canvas. 35 3/4 x 30 inches. Gift of Donna and Donald Baumgartner (M2000.147).

Adolf Wölfli
Breslau, Skt. Adolf-Schloss (Breslau, St. Adolf Castle), 1922

One of the most important so-called outsider artists—individuals who operate on the fringes of society and often in their own mental worlds—Adolf Wölfli was born near Bern, Switzerland. After his mother became ill when he was eight years old, he was sent to live with various farming families where he worked as a farmhand. Prone to acts of violence and sexual aggression, he eventually landed in prison. In 1895 he was diagnosed as schizophrenic and was interned at the Waldau Psychiatric Clinic in Bern, where he remained until his death in 1930.

In his cell at the clinic, Wölfli began composing music, drawing, and writing, activities that were encouraged by the staff as a means of controlling his violent nature. *Breslau, Skt. Adolf-Schloss*, like most of his drawings, illustrates Wölfli's fantastical autobiography in which he assumed the role of Saint Adolf II, a child divinity who embarked upon extraordinary adventures. The anxiety that pervades Wölfli's work is achieved in this drawing through the tension between the linear elements such as the architectural forms and cross-hatched horizontal bands, and the rounded forms such as the clock faces and the abstracted birds. The obsessive detail and delineated borders that mark his drawings reveal Wölfli's desire for organization and control, a trait common among outsider artists. MA

Adolf Wölfli (Swiss, 1864–1930). *Breslau, Skt. Adolf-Schloss (Breslau, St. Adolf Castle)*, 1922. Pencil and colored pencil. 20 x 12 3/4 inches. Gift of Anthony Petullo (M1993.182).

Bill Traylor
Talking Couple, ca. 1940

Bill Traylor was born a slave on the George Traylor planta-
tion near Benton, Alabama. After the 1863 Emancipation
Proclamation Act, he stayed on as a farmhand. In 1938,
after the death of his wife and the Traylors, he moved to
Montgomery where he began to draw while sitting outside
on Monroe Street. A young Montgomery artist, Charles
Shannon, noticed Traylor sitting on a box and working
intently. Shannon befriended him and made regular visits to
see Traylor on Monroe Street, bringing him supplies and a
few dollars each week.

The majority of Traylor's drawings were done on irregularly
shaped cardboard that he found discarded. He drew simple
images from his life on the farm and from his observations
of events on the city street. His drawing technique was
deliberate: using a block of wood as a straight edge, he ren-
dered a basic geometric form and built the rest of the image
around that initial shape. It is this geometric basis that
lends a distinctly modern quality to Traylor's work. The
economy with which Traylor conveyed a narrative is mas-
terful. The two figures in *Talking Couple* seem to be arguing
rather than talking, an interpretation underscored by their
extended arms. Traylor often used brown and black as well
as primary colors, but he did not mix pigments; the purity
of the colors adds to the immediacy of the work. In *Talking
Couple*, the blue hue of the woman demonstrates the artist's
disregard for naturalism. MA

Bill Traylor (American, 1854–1947). *Talking Couple*, ca. 1940. Tempera over pencil on cardboard. 14 7/8 x 12 1/16 inches. The Michael and Julie Hall
Collection of American Folk Art (M1989.236).

Hector Hyppolite
La Dauration l'amour (The Adoration of Love), 1946–48

Hector Hyppolite is one of the best known of the neo-phytes who joined Le Centre d'Art in Port-au-Prince, Haiti, in 1945. A *hougan* (Vodun priest) who received his calling to paint from the *lwas* (spirits), he experienced a fleeting career lasting only three years. He is credited with painting over 150 works within this short time. His unique technique, which included the utilization of chicken feathers as a substitute for paintbrushes and the delicate strokes of his fingers to create a range of densely colored smudged areas or hallowed spaces with thick parabolic edges, distinguishes his style and sets him apart from his peers.

Influenced by his belief in Vodun *lwas* and his knowledge of Catholic saints, Hyppolite's paintings reveal the similarities of these divergent religions. In *La Dauration l'amour*, a title that can be interpreted from its patois to mean "the adoration of love" or "the duration of love," he sought to demonstrate how Christianity and African spirituality share spiritual tenets. Light and dark contrasts accent the central figure. Light serving as a nimbus for the five acolytes reinforces the theme of Jesus as the light of the world. The crucifix functions two-dimensionally as a geometric device dividing the painting vertically into symmetrical sections. The horizontal plane illustrates the belief that Jesus's compassion for the world is broad and outreaching. This comparison of religious beliefs helps to interpret the title. In both religions, faith allows believers to continue their relationship with the spirit, whether that spirit be Jesus or a *lwa*. This relationship is everlasting, endures all, and is imbued with love. SL

Hector Hyppolite (Haitian, 1894–1948). *La Dauration l'amour (The Adoration of Love)*, 1946–48. Oil on board. 29 1/2 x 23 1/2 inches. Gift of Richard and Erna Flagg (M1978.123).

Castera Bazile
Petwo Ceremony Commemorating Bwa Kayiman, 1950

The Haitian Revolution legacy tells of a performance—the Petro ceremony (derived from the messianic figure Don Pedro and pronounced Petwo)—that occurred at Bois Caiman (pronounced Kayiman), a forest near Cape Haitien in northern Haiti. This ritual, in which a *manbo* (Vodun priestess) sacrificed a black pig and partook of his blood, was used to evoke spirits (*lwas*) whose powers are rooted in mystical matters of social and economic significance. This symbolic event served as the impetus for Boukman, a Vodun priest, to declare war on French colonialists. In doing so, he succumbed to the powers of the *lwas*, which ultimately assisted in the dismantling of slavery.

As with most Haitian art, Castera Bazile's painting reflects the fusion between historical context and spiritual revivalism. Imagery is used to capture all aspects of this religious performance and reveal its rebellious undertones. Bazile placed the scene within the confines of a room, suggesting the importance of historical reenactment and reinforcing the clandestine nature of Vodun practices. Vodun iconography is used to intensify the spiritual undergirding of this ritual performance: flags feature *vèvè* drawings, a Kongo cosmogram made out of cornmeal identifies specific *lwas*. A silhouette of Damballah, a *lwa* depicted as the Black Serpent and associated with the rainbow, creeps up the back wall. His presence, in the midst of insurrection, represents the coolness and calculated wisdom of the rebels. Finally, drums evoke emotion as rhythm is used to induce spirit possession and announce revolution. All these elements add to Bazile's interpretation of the factors that contributed to Haiti's independence on January 1, 1804. SL

Castera Bazile (Haitian, 1923–1966). *Petwo Ceremony Commemorating Bwa Kayiman*, 1950. Oil on Masonite. 23 x 19 1/4 inches. Gift of Richard and Erna Flagg (M1991.107).

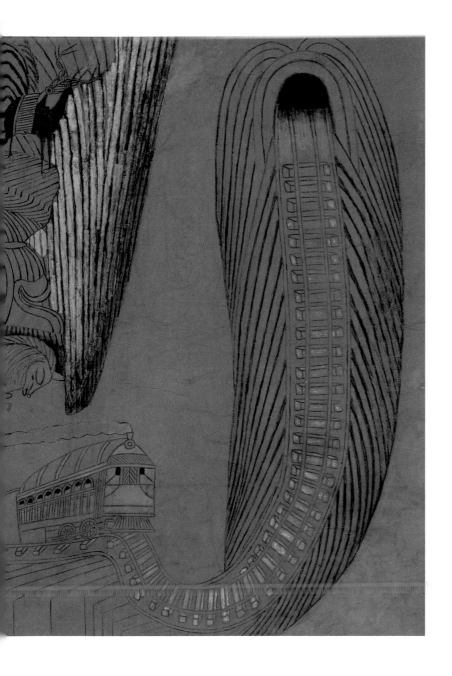

Martín Ramírez
Untitled (Landscape with Train, Church, and Animals), 1950s

Born in the Jalisco province of Mexico in 1885, Martín Ramírez became a laborer on the railroads in the United States. He was institutionalized at a California mental hospital as a "paranoid schizophrenic, deteriorated," and never spoke again. In 1948 he began drawing, using available bits of paper glued together with a paste of mashed potatoes, bread, and saliva. His work was encouraged by a doctor familiar with Dr. Hans Prinzhorn's theories of the therapeutic and aesthetic value of art by mental patients. Ramírez's art ultimately reached a broader audience through the efforts of Chicago artist Jim Nutt, who discovered the work in 1968 while teaching in California.

Of the three hundred or so surviving drawings, the museum's work at more than ten feet in width is one of the largest. It is also a virtual index of the motifs that Ramírez employed most frequently: trains and tunnels; churches and other colonial Mexican architecture; animals, perhaps influenced by the pottery of his native Jalisco province, and a landscape suggested by striated patterns. His other primary subjects were the Virgin as Lady of Guadalupe and soldiers similar to the revolutionary Zapatistas, both memories of his native land. In this drawing, Ramírez's intricate patterning can be seen as reflective of the "will to order" cited by some observers as characteristic of institutionalized or so-called outsider artists. However, it is Ramírez's use of this decorative elaboration to build a powerful composition and a pulsating pictorial space that sets him apart as one of the most compellingly inventive of twentieth-century self-taught artists. RB

Martín Ramírez (American, b. Mexico, 1885–1960). *Untitled (Landscape with Train, Church, and Animals)*, 1950s. Pencil, colored pencil, poster paint, and white paper collage on brown kraft paper. 36 x 130 1/2 inches. Gift of Friends of Art and Jim Nutt and Gladys Nilsson (M1997.113).

Edgar Tolson
Man with Pony, 1958

As a young boy growing up in Wolfe County, Kentucky, Edgar Tolson learned the traditional Appalachian hobby of whittling, a modest beginning for the man who eventually would become Kentucky's most famous woodcarver. Throughout his life Tolson held a variety of jobs, including chair maker, coal miner, farmer, and Baptist preacher. Only in 1957, following a stroke that left his right arm and leg severely impaired, did Tolson begin to devote all of his energy to making art. Carving became for Tolson a form of therapy, as well as an amusement for his children (eighteen in total). Prior to his stroke he carved traditional Appalachian subjects such as birds, snakes, and walking sticks. Once he started carving full-time, however, his subject matter broadened to include political and religious themes, such as the *Fall of Man* series in the Milwaukee Art Museum's collection.

Man with Pony is Tolson's first major work from this period of the late 1950s. It is an allegorical representation of the superiority of man, created in God's image, over the creatures of nature, a fundamental tenet of Tolson's Christian beliefs. The size of the man relative to the horse is greatly exaggerated, and his gesture of one hand on the horse's back and the other holding the rein clearly conveys a sense of power and dominance over the animal. Tolson even contrasted the painting of the two figures; the man is crisply painted with clean, ordered (i.e., rational) lines, while the spots on the horse are blurred and blend together, symbolic of the chaos and randomness of nature. MA

Edgar Tolson (American, 1904–1984). *Man with Pony*, 1958. Carved, assembled, and painted wood. 23 x 11 1/4 x 32 inches. The Michael and Julie Hall Collection of American Folk Art (M1989.314).

Anna Zemánková
Untitled (Blue), ca. 1960s

Growing up in Moravia (present-day Czech Republic), Anna Zemánková had an interest in drawing, but her father discouraged her and suggested instead that she study dentistry. Following her father's advice, Zemánková worked as a dental technician until she married and had a family. In 1948 her family moved to Prague. After her children were grown, she revisited her interest in drawing at the urging of one her sons, himself an artist. Drawing became for Zemánková a means of coping with the bouts of depression that plagued her. She worked in the dawn hours, between four and seven o'clock, because she felt "free from all cares" early in the morning. She described her drawing process as something that was almost beyond her control. Rather, she said, her works "seemed to draw themselves."

The biomorphic plant forms that dominate Zemánková's work fuse botanical fact with pure invention, exemplified by the highly stylized flowering plant depicted in *Untitled (Blue)*. The asymmetry of the image reveals the spontaneity of her drawing technique, as the petals on the left side of the plant bend in order to avoid the encroaching edge of the paper. The intricate detail of the petals relates to Zemánková's interest in embroidery and textile techniques that inform her later works. MA

Anna Zemánková (Moravian, 1908–1986). *Untitled (Blue)*, ca. 1960s. Oil pastel on paper. 35 3/4 x 25 1/2 inches. Gift of Anthony Petullo (M1997.127).

Index